CULTURAL
STUDIES

Volume 11 Number 2 May 1997

T0386204

EDITORIAL STATEMENT

In the ten years since this journal was founded, the field of cultural studies has expanded and flourished. It has at once become broader and more focused, facing as it does the challenges of global economic, cultural and political reconfiguration on the one hand, and of new attacks on the university and intellectual work on the other. As we look forward to the next decade, we expect *Cultural Studies* to continue to contribute to both the expansion and the integration of cultural studies.

With this expectation in mind, the journal seeks work that explores the relation between everyday life, cultural practices, and material, economic, political, geographical and historical contexts; that understands cultural studies as an analytic of social change; that addresses a widening range of topic areas, including post- and neo-colonial relations, the politics of popular culture, issues in nationality, transnationality and globalization, the performance of gendered, sexual and queer identities, and the organization of power around differences in race, class, ethnicity, etc.; that reflects on the changing status of cultural studies; and that pursues the theoretical implications and underpinnings of practical inquiry and critique.

Cultural Studies welcomes work from a variety of theoretical, political and disciplinary perspectives. It assumes that the knowledge formations that make up cultural studies are as historically and geographically contingent as any other cultural practice or configuration and that the work produced within or at its permeable boundaries will therefore be diverse. We hope not only to represent this diversity but to enhance it.

We want to encourage significant intellectual and political experimentation, intervention and dialogue. Some issues will focus on special topics, often not traditionally associated with cultural studies. Occasionally, we will make space to present a body of work representing a specific national, ethnic or disciplinary tradition. Whenever possible, we intend to represent the truly international nature of contemporary work, without ignoring the significant differences that are the result of speaking from and to specific contexts, but we also hope to avoid defining any context as normative. We invite articles, reviews, critiques, photographs and other forms of 'artistic' production, and suggestions for special issues. And we invite readers to comment on the strengths and weaknesses, not only of the project and progress of cultural studies, but of the project and progress of *Cultural Studies* as well.

Lawrence Grossberg
Della Pollock *May 1997*

Contributions should be sent to Professors Lawrence Grossberg and Della Pollock, Dept. of Communication Studies, CB #3285, 113 Bingham Hall, The University of North Carolina at Chapel Hill, Chapel Hill, NC 27599-3285, USA. They should be in triplicate and should conform to the reference system set out in the Notes for Contributors. An abstract of up to 300 words (including 6 keywords) should be included for purposes of review. Submissions undergo blind peer review. Therefore, the author's name, address and e-mail should appear *only* on a detachable cover page and not anywhere else on the manuscript. Every effort will be made to complete the review process within six months of submission. A disk version of the manuscript must be provided in the appropriate software format upon acceptance for publication.

Reviews, and books for review, should be sent to Tim O'Sullivan, School of Arts, de Montfort University, The Gateway, Leicester LE1 9BH; or to Graeme Turner, Dept. of English, University of Queensland, Brisbane, Queensland 4072, Australia; or to Jennifer Daryl Slack, Dept. of Humanities, Michigan Technological University, Houghton, MI 49931, USA.

Transferred to Digital Printing 2004

Advertisements: Enquiries to Routledge Journals,
2 Park Square, Milton Park, Abingdon, Oxon, OX14 4RN

Subscription Rates (calendar year only): UK/EC individuals: £26;
institutions £70; North America: individuals $45; institutions $75; rest of
the world: individuals £28; institutions £75; all rates include postage.
Subscriptions to: Subscriptions Department, Routledge, Cheriton House,
North Way, Andover, Hants SP10 5BE, UK. Tel: +44 (0)1264 342755;
Fax: +44 (0)1264 343005

Periodicals postage paid at Rahway

Single copies available on request.

ISSN 0950–2386

Typeset by Type Study, Scarborough

CONTENTS

▪ARTICLES ▪

ALAN McKEE

'THE ABORIGINAL VERSION OF KEN DONE ...'. BANAL ABORIGINAL IDENTITIES IN AUSTRALIA

ABSTRACT

Histories of representation of Blackness are quite distinct in Australia and in America. Indigenous Australian identities have been consistently 'fatal', in Baudrillard's use of that term. So, while Black American representation includes intensely banal images of middle-class, materialistic individuals, such histories are largely absent in the Australian context. This implies that the few such representations which do occur – and particularly those of everyday game shows such as *Sale of the Century* and *Family Feud* – are particularly important for presenting a trivial, unexciting version of Aboriginality. This also clarifies the distinction between American and Australian versions of Blackness, and suggests that the latter set of representations might be more usefully viewed in relation to Native American rather than Black American images. The status of indigeneity might prove to be more relevant to Australian Aboriginal representation than the previously favoured identity of skin colour (Blackness).

KEYWORDS

Aboriginality; film; television; game shows; banality; Native American

This article explores the ways in which representations of Blackness in Australia are quite specific to that country. Antipodean images of Black Australians are limited in particular ways; influenced by traditions, and forming genealogies quite peculiar to that country. In particular, histories of Blackness in Australia are quite distinct from those in America. The

generic alignments, the 'available discourses' on Blackness (Muecke, 1982) form quite distinct topographies in the two continents.

It is in the gaps that become obvious when these maps are overlaid – in the space between *Sale of the Century* in Australia and *You Bet Your Life* in the USA – that this article positions discussion of fatality in Australian images of the Aboriginal.

Some terms: fatality and banality

It is helpful first to introduce some relevant terms from the work of Jean Baudrillard. One of Baudrillard's projects has been to problematize often simplistic histories of society and representation. In one example, he suggests that cultural theories which insist on the idea that oppressed groups have been denied full subjectivity – have indeed suffered a process of *objectification* – is wrongheaded. Indeed, he suggests that in modern society, *objects* may be in a more powerful situation than are subjects.

As one of the moves in this project of complicating subject/object relations, Baudrillard introduces the terms 'fatality' and 'banality' to produce the idea of the 'fatal object' and the 'banal subject'. This provides a suggestive strategy for describing (in this case) the potential power of objects in our culture (Baudrillard, 1990: 124).

The meanings of these terms can be drawn out beyond their immediate context with some relevance for this argument. The fatal is 'pure event' (Baudrillard, 1990: 72), while the banal is the experience of the everyday. As Meaghan Morris glosses these antonyms, the structure they sustain: 'establishes a tension between everyday life and catastrophic events . . . the exhilarating and the frightful, the emancipatory and the terroristic' (Morris, 1990: 14, 19). To attempt to articulate the full force of this distinction, it is possible to turn to a basis in *meaning*. Banal experiences are part of a *flow*. They are undifferentiated – perhaps meaningless. They demand nothing, except perhaps the question, So what? Ultimately, they are controlled; overseen; in no way dangerous. By contrast, the fatal seems to be a concept which invokes the ideal: the fatal is meaningful, different and differentiated; it is dangerous and unique, and must somehow stand out in the flow of ('everyday') existence.

These terms render obvious links and articulations which might otherwise remain invisible: for, when a history is drawn of Aboriginal representation in Australia, most of the images addressed are, in various ways, *fatal*. When this term is understood in Baudrillard's sense, it provides a way of describing and explaining the variety of images that form the genealogy of Aboriginal representation, simultaneously making clear those areas of culture which remain barren of Aboriginal representation.

Fatal Aboriginal identity 1 – literal fatality

Representations of Aboriginality in Australia have been consistently fatal. In the first instance, this is true in a literal sense. Andrew Lattas has analysed

early newspaper accounts of the Aboriginal in Australia. As he makes clear, in the nineteenth century, the 'available discourses' of the Aboriginal suggest a (literally) fatal set of meanings attaching to the indigene:

> After having killed Thomas Taylor, *The Monitor* (24 December 1826) reports that a party of natives went to the hut of Sherwin, 'which they plundered of everything serviceable to them, and in order to enable his "jin" to carry his portion of the booty, one of the men very deliberately took his infant child from the women, and, holding it by the heels, with the head downwards, struck it against a tree by which its brains were literally dashed out, and the bark of the tree became smeared with blood'.

> (Lattas, 1987: 42)

Lattas suggests that the enabling discourse of Aboriginality in the nineteenth-century settler press was an 'iconography of evil' (ibid.). Such a system of images presents Aborigines as literally fatal: associated not only with death, but with viciousness, savagery and cannibalism – everything that is expelled from white society as being too corporeal (ibid.: 43).

Such an 'iconography of evil' can also be traced into early cinema; and the recurring image of the hostile, tribal Aborigine it engenders may again be fairly described as fatal. Indeed, this seems to be the most common narrative role taken up by Aboriginal characters in the early Australian cinema – whether it be the massed hordes of *The Birth of White Australia* (Walsh, 1928), the kidnappers of *Caloola, or the Adventures of a Jackeroo* (Rolfe, 1911), or the warriors performing their primitive corroboree in *The Kingdom of Twilight* (MacDonald, 1929).[1] The dominance of this hostile savagery in Australian images of the Aboriginal should not be underestimated.

Whereas, for example, American representations of Blackness have involved traditions both of savagery and comic representation, this latter is not a space which has been much available for Australian Aboriginality. A film such as *Trooper O'Brien* (Gavin, 1928), featuring Aboriginality as comic relief, shows that such approaches are possible; but its uniqueness simultaneously makes obvious just what a sparsely occupied genre this is.

The (literally) fatal Aboriginal is not restricted to the distant history of Australian Aboriginal representation: similar treatments are to be found in Australia's cinematic representation of the Aboriginal right up to the present time. Aboriginal people kill (themselves or others) in many Australian films across the decades. Reciting even the best-known films of the Aboriginal confirms this point – literal Aboriginal fatality is presented in *Jedda* (Chauvel, 1955), *The Last Wave* (Weir, 1977), *Walkabout* (Roeg, 1971), *Bitter Springs*, (Smart, 1950) *The Chant of Jimmie Blacksmith* (Schepisi, 1978), *The Fringe Dwellers* (Beresford, 1986), and *Blackfellas* (Ricketson, 1993). If it be suspected that modern filmic Aboriginality is any less threatening than the war-mongering tribes of silent cinema, consider the case of *The Naked Country* (West, 1985). This film presents a particularly vicious portrait of Aboriginal fatality, including an Aboriginal hunter

murdering a white man by spearing him through the neck, and many detailed shots of bodily mutilation, both practised by and done to, Aboriginal Australians.

One strong trend in Australian cinema, then, has been to present Aboriginality as linked with violent death. In this, Aboriginal representation may appear to be linked to the images of Blackness that have been constructed of African Americans – where, for example, Jim Pines' basic taxonomy of Black characters in early American cinema includes 'the knife carrying savage type' (Pines, 1975: 8). However, the potency of Baudrillard's fatality is that it makes clear the relevance of other strands in Australia's representation of the indigene. For Aboriginality in Australia is a central part of the culture's identity in a way that is not true of the American situation. Bob Hodge and Vijay Mishra suggest that Australian identity may involve a 'bastard complex' that ensures the search for cultural legitimacy has often turned to the indigenous inhabitants of the continent (Hodge and Mishra, 1990: 23–7). Where the United States' economy was built on the bodies of African Americans, the Australian imaginary relies rather on the spiritual wealth of the continent's indigenous inhabitants.

Fatal Aboriginal identity 2 — Baudrillardian metaphor

This leads to the second dominant strand in Australian representation of the Aboriginal: the necessary *spirituality* of the continent's indigenous inhabitants. It is here that the invocation of Baudrillard becomes useful. In his sense, this strand of representation – the insistence on Aboriginality in Australia as an intensely spiritual quality – is as 'fatal' as the baby-killers of Lattas's earlier representations. When Gillian Cowlishaw identifies as the 'dominant images' of the Aboriginal, 'savages, noble or ignoble' (Cowlishaw, 1988: 87), the former is no less fatal than the latter – for the meaningfulness of the Aboriginal mystic is 'fatal' as much as is the murderous intent of the bloodthirsty native. Aboriginal spirituality in this model is ideal and transcendent, existing beyond the banal, humdrum existence of everyday (white) life: it is 'the ancient spirituality which the West has lost' (Lattas, 1990–1991: 284).

In the *Body-Shop* 1980s and 1990s, Aboriginal groups around the world have been inscribed into a series of discourses of native meaningfulness. Represented in Australia by 'New Age' magazines such as *Esoterica, Nexus* and *Simply Living*, these discourses of modern spirituality invoke Aboriginality as a centre of non-material meaningfulness. In some strains of environmental discourses, the natives must take their place, inscribed as innately linked to the natural, able to understand and to live with mother earth. The resurgent popularity of Australian Aboriginal art once again points to the desire to discover meaning in ethnicity, to open up the plainness of suburban rooms with miniature vistas of the spirituality beyond.

The aim of all these trends is to be fatal; they hope to transcend, to *matter*, and to *mean*. The spirituality of Aboriginal groups becomes another aspect of the fatal Aboriginality which has proved to be so dominant in Australia's

representations of the indigene. Julie Marcus writes about a wonderful example of this tendency. She describes a group of American crystal spiritualists who believe that Uluru (in their vocabulary, Ayers Rock) is sitting on a giant crystal. The Aboriginal people are co-opted into their belief system as guarantors of its spiritual authenticity (Marcus, 1988).

This image of the spiritual Aborigine is a common one in cinema. *The Last Wave*, for example, presents mystical, magical (and ultimately, unknowable) Aborigines; as does *Where the Green Ants Dream* (Herzog, 1984), with its potently silent Aboriginal mystics. In the film *Initiation* (Deane, 1987), the Aboriginal witch-doctor is a strange but wise man, inhabiting an inscrutable but powerful position of unapproachable knowledge in the narrative. The vanishing Aborigines of *Burke and Wills* (Clifford, 1985) represent an apotheosis of this trend. As the hero of this film watches, the Aboriginal characters literally fade into the landscape: it is undeniable that Aboriginality here is a natural, spiritual part of the landscape – it is visibly true. Another telling example is *The Right Stuff* (Kaufman, 1987). The Aboriginal characters of that film are explicitly constructed as spiritual and anti-technological: as all the technology of NASA fails to protect a returning space craft, the Aborigines of Australia build a magical fire, whose sparks travel high into the stratosphere, to envelop and protect the vessel.

Another interesting set of examples comes in the horror films which form a recent subcycle of Aboriginal films.[2] In these, Aboriginality is often presented as horrific. Such a sublime quality as horror, as Will Rockett suggests in his writing on 'the cinema of cruelty', is closely linked to the transcendence of Baudrillard's 'fatality' (Rockett, 1988: xiv).

Baudrillard's terminology, then, becomes useful as it makes clear that two dominant trends in the representation of Aboriginality – the savage, noble and ignoble – are linked in their concern for *meaning*. Both the murdering Abo of *Jimmie Blacksmith* and the silent sage of *Where the Green Ants Dream* are fatal figures. And as the clustering of images around the 'fatal' becomes obvious, lacunae simultaneously begin to emerge: for it becomes clear that what is lacking in Australia's history of the indigenous population is a space for representations of a *banal* Aboriginality.

The elusive banal

The provocation for this article was the feeling of disorientation that occurred while watching one particularly banal representation of Aboriginality on Australian television. The strangeness of seeing an Aboriginal contestant on the game show *Sale of the Century* made suddenly obvious the lack of such images in Australia's films and television programmes.

A quick overview makes clear that this is indeed an underpopulated area. In Wim Wenders's 1991 film *Until the End of the World*, Ernie Dingo's private detective is quite at home in a suit, and Justine Saunders plays a scientist for the only time in her career. Soap operas have provided some examples. In *Bellbird* (ABC) in the 1960s and *A Country Practice* (JNP) in

the 1980s, Aboriginal actors appeared as lawyers (Bob and Rachel Maza respectively). Indeed, in soaps, Justine Saunders's image seems to demand such banal roles – as a prison psychologist in *Prisoner* (Grundy), and as a judge in *The Flying Doctors* (Crawfords). Occasionally, a representation of an Aboriginal bureaucrat will appear on the ABC current affairs programme *Lateline*. This list is short, simply because there are few examples: occasional current affairs interviews, some soap operas and very few films. Against this diminished oeuvre, the game shows of Australia present a valuable space for the banal Aboriginal.

Game shows in Australia are a particularly iterable (everyday, banal) genre. *Sale of the Century, Family Feud, Wheel of Fortune*, and *The Price is Right* are all scheduled on a daily basis. Aboriginal contestants have appeared several times on these shows. Not surprisingly, no history exists of this particular Aboriginal presence. A sketch can quickly be drawn.

On *Sale of the Century*, for several episodes in November 1993, an Aboriginal contestant called Ted competed, winning at least one episode, and a charming diamond bracelet for his wife. In a later celebrity edition, Aaron Pedersen (an Aboriginal television 'celebrity') also competed. On *Wheel of Fortune* (27 August 1994), Ernie Dingo (Australia's best-known Aborigine) competed and lost. *Family Feud* has featured at least three Aboriginal families in recent history. They appeared in episodes 249, 951 and 1012–13 of that programme. *Man O Man*, a game show in which men were required to humiliate themselves for an eager all-female studio audience, featured 'Karl', an Aboriginal man who danced for their delight. In the sports game show *Gladiators*, a hybrid show, the above-mentioned Aaron Pedersen presented the first series.

Another difference between Australia and America's Blackness immediately becomes clear. In America, Bill Cosby hosts his own game show. Black presenters appear on talk shows and news programmes, all of them manifestations of everyday – banal – television. There is nothing there of the surprise generated in Australia when, in 1991, an Aboriginal man was chosen to host a current affairs programme; when newspapers gushed that 'At 6.30pm, [Stan] Grant will secure his own piece of Australian television history when he becomes the first Aborigine to anchor a national prime-time program' (McLean, 1991). Such excitement would, one suspects, be less comprehensible in modern America. It is for this reason that in a game show Aboriginality is important. It presents a largely unseen Aboriginal identity – one of both indifference and similarity.

This is well illustrated in the opening rituals of the game shows. As John Fiske writes, commenting on the ways in which contestants are positioned by the introductions to game shows:

[Their] individual differences – names, family circumstances, occupations and sometimes personal details such as likes and dislikes, hobbies or ambitions – are given a ritual recitation that moves them from differentiated individuals to equal competitors.

(Fiske, 1987: 265)

This is indeed the trajectory which the Aboriginal presence in *Sale of the Century* and *Wheel of Fortune* follows. In the former, each contestant is introduced with a brief, formalized interview. Pat talks about his golf handicap and his wish to get it down; Amanda focuses on her family (her dream is to take the children to Disneyland). When it comes to Ted's turn, the presenter Glenn Ridge asks him, 'Is it true that you were the first Aboriginal headteacher in Victoria?' Ted makes a modest motion with his hands and nods: Yes, this is true. In such an introduction, Aboriginality is explicitly presented, and rendered banal. It is no longer *really* different: rather, it becomes a part of the game show discourse of trivia.

Similarly, Ernie Dingo is introduced on the celebrity version of *Wheel of Fortune*, with a little banter. 'One of the nicest fellows around, Ernie Dingo . . . nice tie,' says John Burgess. 'Home grown stuff,' says Ernie: 'sort of like the Aboriginal version of Ken Done, 'cept ours has got a lot more colour. . . .' Such an introduction is similar in structure to that of Eric Banner from the comedy programme *Full Frontal* – 'Now you just released a new CD . . . it's doing OK?', asks John Burgess; and for Lynn McGrainger from *Home and Away*: 'I am a mum in real life. I do have a wonderful house husband, who cooks, cleans.' All contestants discuss careers and personal trivia. In these movements, the difference of the contestants is effaced by a series of similar statements. Each inhabits a position rendered banal by repetition.

If difference is indeed effaced in these ways, what 'Aboriginality' remains in these programmes? Certainly, the racial identity of the contestants is stated in blatant labels – 'the Aboriginal version of Ken Done'. It is also visible in one visible signifier – an Aboriginality of skin colour. In their ritualized forms, the competitors appear as game show contestants, and thus entirely equal to other game show contestants. However, in the case of both Ted and Ernie, it is also consistently visible that they are Aboriginal people. While their performances may not involve those cultural elements which are commonly associated with indigenous Australians, they are physically obvious as Aboriginal during the time a viewer sees them on the programme.

To return to the logic of difference in the game show, though, what really makes Ted and Ernie different from the other contestants is *not* their skin colour: rather, it is their ability to guess phrases; to answer questions; and their luck. As Fiske says, initially rendered identical by the rituals of introduction, it is then the purpose of the game to separate them out – but under criteria very different from those usually associated with the Aboriginal.

Money

It is not difficult to see that [the structure of the game show] is an enactment of capitalistic opportunity. Individuals are constructed as different but equal in opportunity. Differences of natural ability are discovered, and the reward is upward mobility into the realm of social power which 'naturally' brings with it material and economic benefits.

(Fiske, 1987: 266)

Game shows are a privileged site of wealth and consumption; and this is a part of the reason why the Aboriginal identities constructed on them can be so banal. Ted represents an Aboriginality that wins a 'beautiful art-deco bracelet . . . eighteen-carat white gold, set with cut diamonds and baguette sapphires. It's valued at $15,000, from Kaminsky Galleries'. Ernie presents an Aboriginality in a suit, spinning the wheel to earn dollars. Aboriginal identities which involve wealth, materialism and glittering jewellery are largely invisible in Australia.

The possession of (reasonable) wealth is certainly one element of a 'banal' identity: as far as that is understood to be a material rather than a spiritual one. Other elements would include middle classness (a normative identity against which the working class and poorer groups are effectively Othered – see Robin Wood, 1984: 169); education (a 'white' achievement which tends to render Aborigines 'inauthentic'[3]), and the trivia of white culture (game shows themselves, and the knowledges upon which they rely). These various elements are banal in that they are associated in Western culture with the antithesis of spirituality – that is, materialist, very 'white' cultures. They are certainly not associated with 'authentic' Aboriginal culture.

The inauthenticity of the banal

Any Aboriginal identities which might partake of these banal elements have been consistently devalued in Australia – by means of ideas of 'authenticity'. This term is mobilized in order to render Aboriginality and banality incommensurable. Such a process involves not only showing Aborigines in exotic, dangerous and Othered ways, but also simultaneously making clear that this is the only correct way in which the Aboriginal can be represented. There seems to be little possibility of an Aboriginal identity which is urban; which is middle class; which exhibits some features of white culture – and yet remains recognizably Aboriginal. Andrew Lattas notes the:

> politics of time whereby the 'real outback Aborigines' assume the idealised and romantic status of an unchanging, authentic past, whilst those Aborigines who have moved into European lifestyles are seen to have developed into inferior and less authentic selves.
>
> (Lattas, 1990–1991: 284)

Deirdre Jordan similarly presents a telling example of the degree to which a white culture can understand Aboriginality only as non-similar. She tells of a Perth magistrate who refused to acknowledge the Aboriginality of a man brought before him, because:

> There's no evidence of him living in a native camp, and he apparently lives at a normal address in Perth. I must also take note of his appearance. He is well dressed and well-presented.
>
> (quoted in Jordan, 1985: 31)

Because of these facts, the magistrate decides that the man is not Aboriginal. As Jordan sums up, 'Aborigines lived on reserves, at not-normal addresses, were badly dressed, and presented only negative characteristics' (ibid.). Certain aspects of white culture are so incommensurable with a perceived Aboriginal identity that to gain the one is to automatically negate the other.

In the realm of academia, discussions of what constitutes an 'authentic' Aboriginal identity have largely involved challenging the terms of such a question.[4] Although the necessary components of an identity – history, political awareness, cultural acceptance – remain in dispute, at least one element of the Aboriginal identity seems clear: sub/urban and middle-class Aboriginal identities do not have the currency, or the discursive visibility, of those geographically and culturally Othered representations of the Aboriginal.

Superbanal/superfatal

If, then, game shows provide one example of a hugely under-represented banal Aboriginal image, what exactly is the potency of such an identity in Australian culture? Baudrillard suggests that if something is insistently signalled as fatal – as important, dangerous and meaningful – then those discourses of fatality run the risk of themselves becoming banal. As Meaghan Morris says: 'Superbanality . . . becomes fatal, and a super fatality would be banal' (Morris, 1990: 19).

Baudrillard's argument may be brought out through examples. He suggests, for example, that metaphor renders language banal, an argument he illustrates with a fable, wherein the act of reliteralizing a (banal) courtly metaphor has fatal results (Baudrillard, 1990: 121). Similarly, a consistently fatal representation of Blackness can easily become banal in its very predictability — as with the metaphors of blood which now circulate around the Aboriginal. Andrew Lattas writes a piece entitled 'Wiping the blood off Aboriginality' (1992); he opens the article with Frederic Fanon on Black experience:

> I took myself far off from my own presence. . . . What else could it be for me but an amputation, an excision, a haemorrhage that splattered my whole body with Black blood.
>
> (Fanon, quoted in Lattas, 1992: 160)

Fanon's experience of Black identity is expressed in powerful metaphorical images. But in modern Aboriginal experience, and certainly in settler understanding of 'Aboriginality', these images are seen to be no more than figures of speech. They no longer carry the literal charge which adhered to the concept of 'blood' in early Australian history of Aboriginal–settler contact. In the accounts of The Monitor, 'blood' represented the literal fatality which might befall settlers in their interactions with Aborigines. By contrast, in the 1990s, 'blood' is now commonly used in discussions of Aboriginality to stand for a certain idea of genetic inheritance of racial

characteristics (Cowlishaw, 1988; Hollinsworth, 1992). What was initially fatal experience is now metaphor – as banal as Baudrillard argues language can be. To constantly discuss the Aboriginal in these terms is to play with an increasingly familiar set of discourses. The fatal Aboriginal is a banal image in contemporary Australia.

However, just as these insistently fatal representations of 'authentic' Aboriginality constantly risk collapse into banality, it is concomitantly possible that a banal Aboriginal identity – one which is more similar to than different from white identities – could prove to be more fatal to these white identities than any of the exotic 'fatal' (and perhaps safely distanced) representations which have gone before.

That this may be the case is recognized by Veronica Brady. In reviewing Sally Morgan's *My Place*, a successful account of a woman discovering as an adult her Aboriginal identity, Brady comments that it is about 'people more or less like ourselves who have been successful in our terms and by and large accept what we like to think of as our values' (Brady, 1987: 4). She then makes clear the disruptive potency of such representations: 'it is precisely their moderation, their acceptability, which makes their stories so powerfully troubling . . . as a half-caste, [Morgan] represents what white society refuses to accept about itself' (ibid.). To use Johnathon Dollimore's terms, this *perversion* (a difference which claims similarity with dominant cultural forms) may yet prove to be one of the most disruptive forms of cultural expression (Dollimore, 1991: 219–27).

The Cosby Show/Blacks in suits

It is at this point that the differences between American and Australian genealogies of Blackness are most inescapable. The point of this article is that a banal Aboriginality in Australia – an Aboriginal identity which partakes of such elements of 'white' culture as education, wealth and bourgeois 'taste' – is a useful addition to the range of available Black identities. Such celebration would be out of place in writing about contemporary America. For although it is difficult to find examples of middle-class Aboriginality in Australian films and television programmes, it is relatively easy to discover images of middle-class *Blackness* in imported programmes (both American and British). *The Bill, Dangerous Curves, The Cosby Mysteries*, all present such Black identities: they are not rare in these countries. In fact, it may be that the situation in America is close to the opposite of that in Australia. According to the account of Sut Jhally and Justin Lewis, a historical movement of American television (a movement in which *The Cosby Show* has a prominent place), has led to the exchange of one set of archetypal images for another. Performing a contents analysis on American television in the 1970s and in the 1980s, they suggest that there are no more Black characters in modern American television than there were in the past. The changes that *have* occurred are to do with the fact that, whereas in previous decades the vast majority of Black characters were working class, it is now the case that a similarly large percentage are upper/middle class (Jhally and Lewis,

1992: 71). Jhally and Lewis suggest that what is happening in America is less a changing of attitudes towards race than a cementing of attitudes towards class. Middle-class Blacks are now more respected – but their existence leads to the demonizing of working-class Blacks. The latter, as proved by the existence of the former, are obviously lazy – poor only because they do not want to work, lack ambition, and so on. The middle-class Blacks 'prove' that race is no longer a problem in America.

Cultures of poverty

In Australia, the situation is different. Representations of blatantly middle-class Aboriginality are still sufficiently rare to present a useful complement to the culture of poverty and the traditional societies which still provide the most recognizable Australian representations of the Aboriginal. The image of the middle-class Aborigine – or of the rich Aborigine, or of the educated Aborigine – is not one which has yet become familiar enough even to be unproblematically regarded as Aboriginal. There is certainly little danger of its over-dominance becoming a problem. Aboriginality in Australia is still largely reported as connecting directly to poverty: indeed, there is a certain (pseudo) academic turn which legitimates this linkage – the idea of the 'culture of poverty'.

This term was introduced into ethnographic discourse by the anthropologist Oscar Lewis. Initially formulated in relation to South American, Central American and Mexican communities, it suggests simply that certain groups are kept in a state of poverty not by any form of structural racism, nor even by the acts of individual racists: rather, it is aspects of their own culture which ensure they will remain marginalized in capitalistic cultures. Because of their 'orality, weak ego structure, confusion of sexual identification, a lack of impulse control . . . little ability to defer gratification and to plan for the future', they are unable to compete effectively in Western societies (Oscar Lewis, quoted in Langton, 1981: 18).

This idea – that aspects of Aboriginal culture are innately caught up with poverty – has proved to be particularly attractive to reactionary writers in Australia. Marcia Langton traces the vocabulary in academic work, citing such writers as Catherine Berndt in a belief that it is aspects of Aboriginal culture which 'anchor most of them . . . in a relatively low socio-economic category' (Berndt, quoted in Langton, 1981: 17). Ian Anderson finds a similar mobilization of the idea in political arenas, quoting John Hyde (the Executive Director of the Australian Institute of Public Affairs in 1993) in his belief that 'a significant part of the cause [of Aboriginal disadvantage] may be found in Aboriginal culture itself' (quoted in Anderson, 1993: 25). In a review of the film *The Fringe Dwellers*, Patrick McGuinness, a journalist well known for his reactionary politics, suggests that:

the problem facing many Aborigines in Australia is not racism at all . . . but the culture of poverty. . . . Extended families, where relatives have the

right to share the food and shelter of any successful members of the family, are a major barrier to individual upward mobility and escape from the culture of poverty.

(McGuinness, 1986: 51)

The concomitant argument of such assimilationist views is an approving belief that Aborigines who succeed in white terms are no longer linked to Aboriginal culture. In these reactionary arguments such an estrangement is no bad thing; rather, it is (as Jhally and Lewis find in the American context) proof that capitalism can indeed serve everyone equally. This thinking, as much as in the case of romantic notions of the authentic and spiritual outback Aboriginality, believes that success in white society, and 'Aboriginality', are mutually exclusive. This is not the case. As both Gillian Cowlishaw (1993) and Andrew Lattas have pointed out, it is 'naïve' (Lattas, 1993: 241) to think of 'resistance and incorporation as antithetical processes . . . that taking up one [culture] necessarily detracts from the other'. Lattas argues for an Aboriginal identity which functions in many ways within a recognizable white culture, but within which specific acts (in the case of his work, drunkenness) function as resistant Aboriginal practices – guaranteeing an Aboriginal identity.

Similarly, Cowlishaw finds the binarism that sees 'resistance' and 'accommodation' as binary opposites to be simplistic (1993: 184). It is wrong, she argues, to think of a simple choice between selling out to white culture (a banal Aboriginal identity) and maintaining a resistant, fatal Aboriginal identity which refuses even to engage with white culture. To maintain such oppositions denies the possibility that Aboriginal people can engage and negotiate with white culture while remaining in any way 'Aboriginal'.

White/Black: the dangers of binarisms

It is also worth noting the worries of some cultural theorists that simply to invert the categories involved in cultural taxonomies may do little to address problems with the structures themselves – the 'dispute about whether the inversion of binary opposites subverts, or on the contrary, reinforces the order which those binaries uphold' (Dollimore, 1991: 65). The example Dollimore takes is of sexual perversion, employing two approaches to answer this question. The first is a theoretical one which involves the invocation of canonical work; Dollimore suggests that for Derrida, 'a crucial stage in the deconstruction of binaries involves their inversion, an overturning which brings low what was high':

> I strongly and repeatedly insist on the necessity of the phase of reversal, which people have perhaps attempted too swiftly to attempt to discredit. . . . To neglect this phase of reversal is to forget that the structure of the opposition is one of conflict and subordination and thus to pass too swiftly, without gaining any purchase against the former opposition,

to a neutralisation which in practice leaves things in their former state and deprives one of any way of intervening effectively.

(Derrida, quoted in ibid.)

Dollimore also presents a historical account of the potency of perversion: of reconstructing the meanings of dominant binaries without stepping entirely outside them. Although the situation of homosexual men and women, and that of Aboriginal people cannot be equated as identical, Dollimore makes clear that the act of inverting binaries has historically proved to be immensely threatening to dominant orders. Although it cannot be 'proved', it may be that promoting images of banal Aboriginality – an identity that is successful in white terms, but still claims an indigenous identity – may prove disruptive (and 'perverse') enough to have some impact on the ways in which Aboriginality has traditionally been represented.

Dangers of 'Blackness'

This article begins to suggest, then, that Australian and American Blacknesses may in fact be more different from, than similar to, each other. Disparate histories of 'banal' representation make this clear; but the disjunction also becomes visible when other histories are addressed. As is mentioned above, there seem to be remarkably few examples of Australian Aboriginality being represented in the comic mode, even in early cinema history. Such a statement stands in stark contrast to work on the American situation, where, as Jim Pike and Donald Bogle made clear in their early summaries of Black filmic representation, the comic was in fact the dominant mode for putting Blackness on the American cinema screen (Pines, 1975: 40; Bogle, 1988: 1).

This difference between American and Australian Blacknesses should not be a surprising one, for the status of the two identities is quite different. Aborigines are indigenous to Australia and, in their status as indigenes, offer quite different possibilities and problems for settler representation. Black American identities are formed from, and against, quite other histories. It is perhaps logical, then, that the representation of Australian Aborigines might be more aptly compared to that of native Americans. In fact, this has rarely been done. Rather, a set of critical assumptions work to naturalize the equation of Australian and American Blackness.

Catriona Moore and Stephen Muecke, for example, in their article on 'Racism and the representation of Aborigines in film' (1984) (an originary and much cited piece of work which stands at the beginning of academic Australian writing on Aboriginal representation), turn for their primary theoretical model to the work of Robert Stam and Louise Spence. This earlier work deals with the representation of Blackness in America – and the racism of Western reviewers towards the production of countries such as Brazil – but makes no mention of indigenous American representation (Stam and Spence, 1983). Similarly, when Emmanuel S. Nelson comes to address the possibility of an Aboriginal literary aesthetic, the model and the

terminology to which he turns write Aboriginality into a continuum not with native Americans, but with an Afro-Carribean community, as he headlines his piece 'Struggle for a Black Aesthetic' (Nelson, 1992). In it is the very obviousness of this 'Black'ness that much critical writing has lost sight of indigenous identities. Aboriginal people have an identity which can be labelled as 'Black' (although, of course, many Aboriginal people in Australia are not dark-skinned): and such a 'Blackness' is a seductively visible identity, one which is obviously (visibly) shared with Black Americans. Such visibility leads to the invocation of critical models taken from a history of writing on Black American representation, even where it may not, in fact, be entirely appropriate. To write about Aboriginal representation through a history of writing about Black American representation may, in fact, turn out to be quite misleading.

To briefly contrast the propositions of the current article with the situation of native American representation, it seems plausible to suggest that the same insistence on spirituality and meaningfulness which plagues Australia's indigenous groups is evident in American representations of the continent's native inhabitants. In American programmes such as *Dark Justice*, the native American sidekick is friendly but at the same time somewhat implacable (and ultimately unknowable). *Northern Exposure* offers two native American characters, both of whom might be fully included in the wackiness of the programme's community, but when the lead character offends the native American woman by reading her diary, she is still able to call upon her (mysterious, spiritual) heritage to place a curse on him. Similarly, in the nouveau-mysticism of *Star Trek: The Next Generation*, in the episode 'Journey's End', although the native American settlement on a distant planet is technologically advanced, it is also the site of spirituality and rituals which, of course, prove to be efficacious and more powerful than Starfleet's limited technology (respect for the spiritual is a central part of rendering it fatal). Comparisons with the indigenous identities of America, then, might prove to be more enlightening for considerations of Aboriginal Australia than those with Black America, and this article seeks to make clear that this is indeed the case. However, the apparent obviousness of a 'Black' identity leads much critical writing to assume that Australian Aboriginality can best be interpreted in relation to Black American rather than Native American histories of representation.

Conclusion

When Aboriginal contestants on game shows spin wheels covered in glitter, or compete for the chance to guess that a 'Well-known television identity' is in fact 'Rex Hunt', they become part of a 'banal' entertainment in the most immediately recognizable sense of that word. It is not merely the class implications of Ernie Dingo's suit or the capitalistic logic upon which the game show hinges, but the very triviality of the whole enterprise that is so potent in this situation.

There is an implication vaguely scandalous in the appearance of an Aboriginal contestant on such a banal form of television. As the combined weights of literally and metaphorically fatal histories of Aboriginal representation bear down, it seems quite shocking that these spiritual, unknowable creatures are involved in such a trivial enterprise. It is such a sense of unease that produced this article, and which points to the very real possibilities represented by these Aboriginal contestants. Why should they not be allowed to compete on these terms? What is it about Aboriginality that produces such a sense of juxtaposition when an indigenous contestant competes for Monet-patterned tableware? The charge arises from the perceived distance between the fatal and the banal: and game shows in Australia, bringing these two poles suddenly together, represent a fascinating contribution to the history of representations of the country's indigenous inhabitants.

Notes

1 See the work of Andrew Pike and Ross Cooper (1981), who suggest that dozens of early Australian films feature hostile Aboriginal tribes.
2 As well as the proto-horror of *The Last Wave*, less generically ambiguous examples include *The Howling III: the Marsupials, The Dreaming, Kadaicha*, and *Zomie Brigade*.
3 Deirdre Jordan quotes from Colin Tatz. She points out that Senator Neville Bonner, a Queensland Parliamentarian who identifies as Aboriginal, had his identity challenged in Parliament because he was university educated and therefore not really Aboriginal: 'Once an Aboriginal person was educated . . . by definition he could no longer be an Aboriginal' (Jordan, 1985: 32).
4 As with Hollinsworth (1992); Attwood (1992); Lattas (1992); Beckett (1992).

References

Anderson, Ian (1993) 'Black suffering, white wash: Ian Anderson looks at "expert" commentary and the construction of Aboriginality', *Arena*, June–July: 23–5.
Attwood, Bain (1992) 'Comment on Hollinsworth', *Oceania*, 63 (2): 158–9.
Baudrillard, Jean (1990) *Fatal Strategies*, London and New York: Simiotext(e)/Pluto.
Beckett, Jeremy (1992) 'Comment on Hollinsworth', *Oceania*, 63 (2): 165–7.
Bogle, Donald (1988) *Blacks in American Films and TV: An Illustrated Encyclopedia*, New York: Garland Publishing.
Brady, Veronica (1987) 'Something that was shameful – review of *My Place* and *Through my Eyes*', *The Age Monthly Review*, October 1987.
Cowlishaw, Gillian (1988) *Black, White or Brindle: Race in Rural Australia*, Cambridge: Cambridge University Press.
—— (1993) 'Introduction: representing racial issues', *Oceania*, 63 (3): 183–94.
Dollimore, Johnathon (1991) *Sexual Dissidence: Augustine to Wilde, Freud to Foucault*, Oxford: Clarendon Press.
Fiske, John (1987) *Television Culture*, London and New York: Methuen.
Hodge, Robert and Vijay, Mishra (1990) *Dark Side of the Dream*, Sydney: Allen & Unwin.

Hollinsworth, David (1992) 'Discourses on Aboriginality and the politics of identity in urban Australia', *Oceania,* 63 (2): 137–55.

Jhally, Sut and Justin, Lewis (1992) *Enlightened Racism: The Cosby Show, Audiences and the Myth of the American Dream,* Boulder, Col.: Westview Press.

Jordan, Deirdrie (1985) 'Census categories – enumeration of Aboriginal people, or construction of identity', *Australian Aboriginal Studies,*1: 28–36.

Langton, Marcia (1981) 'Urbanising Aborigines: the social scientists' great deception', *Social Alternatives,* 2 (2): 16–22.

Lattas, Andrew (1987) 'Savagery and civilisation: towards a genealogy of racism', *Social Analysis,* 21: 39–58.

—— (1990–1991) 'Review, *Past and Present: The Construction of Aboriginality*', *Oceania,* 61: 282–5.

—— (1992) 'Wiping the blood off Aboriginality: the politics of Aboriginal embodiment in contemporary intellectual debate', *Oceania,* 63 (2): 160–4.

—— (1993) 'Essentialism, memory and resistance: Aboriginality and the politics of authenticity', *Oceania,* 63 (3): 240–66.

McGuinness, P. P. (1986) 'The Fringe Dwellers: an honest look at the culture of poverty', *Financial Review,* 22 May 1986.

McLean, Philip (1991) 'Grant creates history and fights Jana: unknown moves into TV hot seat', *Sydney Telegraph,* 29 December 1991.

Marcus, Julie (1988) 'The journey out to the centre: the cultural appropriation of Ayers Rock', in Anne Rutherford (ed.), *Aboriginal Culture Today,* Special issue, *Kunapipi,* 10 (1 and 2): 254–74.

Moore, Catriona and Muecke, Stephen (1984) 'Racism and the representation of Aborigines in film', *Australian Journal of Cultural Studies,* 2 (1): 36–53.

Morris, Meaghan (1990) 'Banality in cultural studies', in Patricia Mellencamp (ed.), *Logics of Television: Essays in Cultural Criticism,* Bloomington and Indianapolis: Indiana University Press.

Muecke, Stephen (1982) 'Available discourses on Aborigines', in P Botswan (ed.), *Theoretical Strategies,* Sydney: Local Consumption Publications.

Nelson, Emmanuel S. (1992), 'Struggle for a Black aesthetic: critical theory in contemporary Aboriginal literature', *Australian Studies,* 6: 29–37.

Pike, Andrew and Cooper, Ross (1981) *Australian Film 1900–1977,* Melbourne: Oxford University Press.

Pines, Jim (1975) *Blacks in Films,* London: Studio Vista.

Rockett, Will H. (1988) *Devouring Whirlwind: Terror and Transcendance in the Cinema of Cruelty,* New York: Greenwood Press.

Stam, Robert and Spence, Louise (1983) 'Colonialism, racism and representation: an introduction', *Screen,* 24 (2): 2–20.

Wood, Robin (1984) 'An introduction to the American horror film', in Barry Grant (ed.), *Planks of Reason: Essays on the Horror Film,* Metuchen, NJ: Scarecrow Press.

LINE GRENIER AND

JOCELYNE GUILBAULT[1]

CRÉOLITÉ AND FRANCOPHONIE IN MUSIC: SOCIO-MUSICAL REPOSITIONING WHERE IT MATTERS

ABSTRACT

This article deals with the contemporary cultural practices associated with two of the most salient socio-musical articulations of the *créolité* and *francophonie* movements: zouk from the Caribbean and the popular mainstream from Québec, respectively. It aims to examine how socio-musical practices can make a significant contribution to singular political or literary movements such as *créolité* and *francophonie,* and to explore how distinct musics, when viewed as integral parts of complex cultural and political configurations, can be instrumental in providing means for setting into motion new forms of social relations, networks and alliances, thereby creating alternative yet limited fields of possibilities and prescriptions. After analysing the genesis of *créolité* and *francophonie* as both objects and instruments of discourse, we move on to examine the socio-musical terrains where these movements have unfolded. Our discussion then focuses on the narratives of alliances that zouk and the *Québécois* mainstream have helped to establish and the strategies of valorization through which their related products and producers have been positioned on internationally oriented markets. We argue that *créolité* and *francophonie* mediate the repositioning of local musics in ways which tend to indicate that circulation is becoming the most pressing issue as new sets of rules and criteria for defining who, where and what matters politically and culturally within globalizing economies are established and contested.

KEYWORDS

popular music; discourse; culture; local/global; Québec; West Indies

This article focuses on contemporary cultural practices associated with the *créolité* and *francophonie* movements. More precisely, it examines the

practices constitutive of zouk from the Caribbean and the popular mainstream from Québec as two of the most salient socio-musical articulations of *créolité* and *francophonie*, respectively.

The *créolité* and *francophonie* movements are located in distinct times and spaces, have histories of their own, mobilize different population groups, and are analysed and commented upon by contrasted groups of experts traditionally working in self-enclosed millieux. But these disjunctured and, at times, opposed movements also intersect. Typical instances of borrowing, juxtaposition and métissage, they both value creation as the transformation of the given. Moreover, in the context of the increasing anglophonization of the world and the ongoing reproduction of the pervasive Northern–Western canons of purity, *francophonie* and *créolité* as well as their associated socio-musical practices can be viewed as distinct yet related ways of dealing with and experiencing power relations.

The object of our analysis is twofold: to examine how socio-musical practices can make a significant and original contribution to singular political or literary movements such as *créolité* and *francophonie*, which partake and emerge from diffused realities; and to explore how distinctive musics, when viewed not in and by themselves but rather as integral parts of complex cultural and political configurations, can be instrumental in providing means for setting in motion new social relations, networks and alliances, thereby creating alternative yet limited fields of possibilities and prescriptions.

We begin our discussion with a critical review of the respective genesis of these movements and some of the controversies through which they have been articulated, in order to show how *créolité* and *francophonie* have been constructed as both objects and instruments of discourse. We then move on to examine the socio-cultural terrains where the two movements have unfolded as we turn our attention to the musical practices of zouk and *Québécois* mainstream. More precisely, our discussion focuses on the narratives of alliances these musics have helped to establish, and the strategies of valorization through which their related products and producers have been positioned on internationally oriented markets. As we will argue, the *créolité* and *francophonie* movements mediate the repositioning of local musics in ways which tend to indicate that *circulation* is becoming the most pressing issue as new sets of rules and criteria for defining who, where and what matters politically and culturally within globalizing economies are established and contested.

The movements of *créolité* and *francophonie*

CRÉOLITÉ AND FRANCOPHONIE AS OBJECTS OF DISCOURSES

The *créolité* and *francophonie* movements have found support within particular local, national and international scenes. Their respective goals and strategies have been the object of ongoing debates in the cultural and political arenas where these movements have come to occupy prominent positions. We propose to examine their genesis by focusing on some of the

discursive practices through which *créolité* and *francophonie* have been articulated.

More specifically, this section deals with the specific discourses which officialized the inception of the two movements into the public realm: a literary manifesto in the case of *créolité*, and a series of political speeches in the case of *francophonie*. Drawing from the work of Michel Foucault, we view these discourses as events that neither language nor meaning can quite exhaust, as statements which are 'linked to a writing gesture or to the articulation of speech' but also '[open] up to [themselves] a residual existence in the field of a memory, in the materiality of manuscripts, books, and any form of recording' (Foucault, 1972: 28). The particular events under study differ from others insofar as, although each is unique, both have been subject to many repetitions, transformations and reactivations, thereby mediating the incessant redefinition of the boundaries of the discursive space within which *créolité* and *francophonie* have been deployed. Consequently, we are not interested in discussing the 'true' meanings of *créolité* and *francophonie*. Rather, we aim to critically examine the procedures for the production and circulation of statements through which *créolité* and *francophonie* have been created as objects of discourse, and hence what they have come to stand for, for whom and from which position of authority. We therefore use the term *discourses of inscription* to refer to the events which have helped to officialize *créolité* and *francophonie*.

The discourse of inscription which officialized *créolité* is the publication of *Éloge de la créolité*, a book written in 1989 by linguist Jean Bernabé, and novelists Patrick Chamoiseau and Raphaël Confiant. Associated intuitively with the West Indies in general through the Creole language, *créolité* has been formally formulated in Martinique. While it emerged at the end of the 1980s, the genesis of *créolité* dates back to the 1940s. In fact, it is indissociable from two determining intellectual movements which, each in their own way, have helped to cast off the yoke of colonial domination and repression: *négritude* (1940s) which emphasized black identity and took pride in its specificity, and *antillanité* (1970s) which celebrated hybridity as the embodiment of the singular histories and cultures of the West Indies.

Éloge de la créolité was first presented at a conference held in Paris during the *Festival de la Caraïbe* in May 1988. However, it is only after it was published by one of France's most important publishing companies, Gallimard in 1989, that *créolité* has had significant public exposure. In the materiality of a book, the discourse on *créolité* has found an echo first, simultaneously in France and Martinique, and circulated afterwards mainly among the intelligentsia of France's Creole-speaking departments (Guadeloupe, French Guyanna and La Réunion) as well as Mauritius and the Seychelles.

The book takes the form of a manifesto which incorporates a linguistic project designed to promote French-based Creole,[2] a distinctive language rooted in orality viewed as a counter-cultural testimony to local forms of resistance and survival.

True galaxy in formation around the Creole language as its core, *créolité*

still enjoys a favorite formulation, orality. . . . Creole orality, although challenged in its aesthetic expression, encompasses a whole system of counter-values, a counter-culture; it testifies to common genius applied to resistance, devoted to survival.

(*Bernabé et al., 1989: 34)[3]

The manifesto also promotes an aesthetic approach characterized by a particular way of apprehending the diverse, the complex and the heterogeneous; that is, a *rapport au monde* (relation to the world) based on the conscious harmonization of preserved diversities, called *diversalité* after Edouard Glissant's coinage.[4]

And if we recommend our creators such an exploration of our particularities, it is because it brings back the natural of the world, outside the Same and of the One, and because it opposes to Universality the possibility of a defracted yet recomposed world, the conscious harmonization of preserved diversities: la *DIVERSALITÉ*.

(Ibid.: 54–5)

Éloge de la créolité engages also with identity politics articulated around the central issues of cultural *métissage* and of what the authors have called 'an updating of the true memory'; in other words, the recovery of a West Indian history lost in colonial narratives.

Given its constitutive mosaic, *créolité* is an open specificity. . . . To express it means expressing not a synthesis, not merely a metissage, or any other unicity. Rather, it means expressing a kaleidoscopic totality, that is, a non-totalitarian consciousness of a preserved diversity. . . . Our history (or more appropriately our histories) is buried in colonial History. Collective memory is our urgency. What we believe to be Antillean history is only the history of the West Indies' colonization.

(Ibid.: 37)

As denoted by its inscription, *créolité* is defined in reference to a Creole literature, and portrayed in this context as a creative, transformative and performative process. By incorporating various influences, this literature is said to create a new form of expression which combines the oral and written poetics and aesthetics of several languages, local experiences as well as more conventional literary forms of narratives. Although written in French, it is nevertheless considered transformative because it puts forward a *mode d'être* (way of being) which alters France's typical literary text. Moreover, Creole literature is promoted as having a performative character since it creates a decentralized space within which French no longer represents a hegemonic mode of expression, way of perceiving, way of knowing the world imposed on colonial societies. *Créolité* is defined more emphatically through literature which, traditionally, has been viewed by Martinican and Guadeloupean intellectuals as the site *par excellence* where issues of identity are articulated:

To live simultaneously the poetics of all languages, means not only to

enrich each of them, but also to break away from the usual order of these languages, and to reverse their established meanings. It is this break which will allow the audience to expand its literary knowledge of ourselves.

(*Ibid.: 49)

Although the authors of *Éloge de la créolité* focus on political issues as sensitive as identity and the recovery of a history in the colonial context of the West Indies, they claim that *créolité* is not a political movement. Paradoxically, they view the search of identity, conceived first and foremost in terms of 'inner vision' and 'self-acceptance', as an essential prerequisite to political action yet not as a political process in and by itself.[5]

In line with the non-political character of the movement as it has been originally formulated, *créolité* has been produced through discourses stemming almost exclusively from artistic millieux. As will be explained below however, its discursive production has moved beyond the boundaries of the literary field and the movement has also been most visible in musical milieux during the 1980s – the period during which it has had its greatest currency in the French departments and in France. Even though it has always drawn the attention of the political elect, *créolité* cannot be said to have been an integral part of the official political platform, even in Martinique where the movement received its widest yet most controversial exposure.

In contrast, *francophonie* has always been steeped in politics. As a journalist from the French newspaper *Le Monde* and former Member of Parliament during the De Gaulle era once claimed, 'The francophonie will be political or won't be at all' (quoted by *Tétu, 1992: 61–2). The discourse on *francophonie* has been produced mainly, albeit not exclusively, by heads of state, diplomats and administrators from various governmental and para-governmental agencies. It has also been one of the key sites where the political agenda of the polylateral organization, known today by English-speakers as the Francophony, has been discussed.[6] While the discourses which officialized *francophonie* have surfaced some eighty years after the term was coined by geographer Onésime Réclus in 1880, their genesis is inseparable from the movements of decolonization and national identity assertion which emerged in Africa after the Second World War.

There is, however, no one material recording which, as in the case of *créolité*, launched the official entry of *francophonie* in the public domain, but rather a combination of written and predominantly oral statements. The most significant discursive events are, on the one hand, public speeches delivered by African intellectuals and political leaders in both Africa and Québec between 1962 and 1969 – namely, Léopold Sédar Senghor, the first president of the Senegal Republic who stayed in power from 1961 to 1981; Habib Bourghiba, president of Tunisia from 1956 (when the country became independent) to 1987; and Hamani Diori, president of the Republic of Niger from 1960 to 1974, and also the chair of the *Organisation commune africaine et malgache* (OCAM), a multilateral organization

created to promote cooperation among independent African countries. Another important event has been, on the other hand, the 1962 special issue of France's influential journal *Esprit* devoted to French as a modern language, which featured articles by well-known linguists and cultural theorists from France as well as poets and cultural activists from Africa, including the aforementioned reputed spokesperson of *francophonie*, Senghor, also a reknowned writer and poet.

Within these discourses, *francophonie* has been articulated in four distinct but related ways. First, defined in linguistic terms, the notion refers to the diffusion of French as one of the world's oldest and most widely spread modern languages. Second, it is constructed as a geographical entity: *francophonie* denotes the whole territory occupied by individuals who speak French, albeit in different contexts of use. This territory is said to have a changing geometry, but also, to use Xavier Deniau's expression, a pretty stable 'gravitation triangle' (*Deniau, 1992) comprised of Europe (France, Switzerland, Belgium and Luxemburg especially), Eastern North America (particularly Québec), as well as Northern and Central Africa (from Senegal to Zaïre). Third, *francophonie* stands for a language and culture-based pluralistic community described by the editors of the 1962 issue of *Esprit* as 'a site of métissage and hybridization', an experience of solidarity, fraternity and fellowship. In a speech delivered at Niger's capital, Niamey, in 1969, Diori claimed that the notion captures the feeling of belonging to a spiritual community which an increasing number of people have come to share despite their differences; that is, geographical distances, diversity of races, beliefs and standards of living, and various relationships to other groups or communities. In his influential contribution to *Esprit*, Senghor wrote:

> *Francophonie* is this integral humanism which is woven around the world: this symbiosis of 'stagnant energies' from all continents and races which are revitalised by the heat of their complementarity.
>
> (Quoted in *Tétu, 1992: 68)

A few years later, at Université Laval in Québec city, during a ceremony where he was presented with a *honoris causa* doctoral diploma, Senghor insisted that, although this community is founded on shared values and culture through language, it can only survive with the respect of the different singular identities rooted in specific regions, nations, continents, locales and histories which give *francophonie* its specific character.

Within the discourses of inscription of *francophonie*, the promotion of the French language is therefore not viewed as a goal in and by itself, but rather as a means to both further consolidate this community and facilitate communication among its members. Exchange and communication have therefore been established as the underlying rationale of this community which, however, has been said to lack the means, channels and instruments to establish and maintain relationships among its members. Accordingly, in its fourth articulation, *francophonie* has taken on an institutional face as it is used to describe the various public and private associations and organizations which aim at promoting and facilitating multilateral cooperation in

various sectors of activity (including culture, trade, technology, science and education) among peoples and nations who share the usage of French. The most salient and influential organization is the Francophony, which regroups the heads of state and leaders of government of forty-seven countries, nations and regions sharing the use of French.[7]

The *francophonie* movement thus has an official governmental body which was created in the 1980s, but whose genesis is indissociable from the project of a structured yet flexible vertical international organization originally formulated in the 1960s by Senghor and further developed by Bourguiba. Considered its godfathers, these two African leaders have been committed to the creation of the Francophony, an institution designed primarily to create and promote cultural as well as economic multilateral relations, networks and agreements among French-speaking population groups. They viewed this institutional project as a strategic way to consolidate *francophonie* as a community of both language and history concerned with issues of spiritual solidarity and economic development. Their efforts are said to have rallied hitherto sceptical African leaders, many of whom were not enthusiastic about resuming a relationship with French language and culture seen as the very embodiments of a still recent colonial past. Bourguiba expressed the view that, far from impinging on the national independence of African countries, the notion of *francophonie* helps to think beyond it. He argued, given that 'colonization is not an exclusively negative phenomenon' (quoted in *Tétu, 1992: 72), Africans had to learn how to build from this experience. In 1967, in front of an audience of African intellectuals and political leaders, he urged all Africans to participate in the project since, in his view, 'Not to defend our shared past would mean to repudiate a part of who we are' (ibid.).

Since its discursive inscription, *francophonie* has been constructed as a complex movement which is defined at once as a linguistic group, a geographical territory, a solidarity-based cultural community, and an institution of polylateral cooperation. It has promotors not only within the political realm, but also in artistic and cultural milieux. The discourse on *francophonie* is especially prominent in the field of music considered by many as its cultural flagship *par excellence*. Over the past few years, many organizations have been created with a view to promoting Francophone artists and repertoires, and the production, distribution and marketing of the numerous and extremely different musical products from what is called the Francophone space.[8]

Créolité and *francophonie* as discursive operators

We have examined so far how *créolité* and *francophonie* have been constructed as objects of discourse by focusing on their respective moments of inscription. As we have already indicated, these discursive events have been subject to numerous repetitions, transformations and reactivations. Through this iterative process, the specific realities that these events have discursively produced have been named: *créolité* designates a linguistic project, an

aesthetic process and an updating of a lost memory, and *francophonie* a linguistic grouping, a geographical territory, a community, as well as an organization. This 'naming' process does not, however, exhaust the phenomena under study. Far from being reducible to the discursively objectified reality to which they refer, *francophonie* and *créolité* also appear to act as devices which are used, within the discursive spaces where the notions are deployed, to produce statements through which other objects are constructed, and hence, other sets of issues addressed. Consequently, we argue that *créolité* and *francophonie* can be viewed as *discursive operators*. We borrow this concept from Jean-Michel Berthelot who created it to describe discrete discursive units whose 'referent . . . no longer works as an object of knowledge but rather, through the mediation of a linguistic sign, functions as an instrument for the construction of a discourse' (*Berthelot, 1992: 17). Berthelot adds that these operators, as manifestations and effects of discourses, are equally informative and normative: 'under the auspices of a shared referential evidence, to talk simultaneously about something else means, more often than not, not only to talk but to plead' (ibid.: 11–12). In other words, they describe as much as they prescribe. In fact, he further claims that, while the operators are not essential in and by themselves, the meaning and efficiency of the statements made through them are; for this reason, these discursive operators ought to be viewed in semantic as well as pragmatic terms.

We intend to demonstrate that, indeed, to talk about *créolité* and *francophonie* means to talk about much more than *créolité* and *francophonie*; that in many cases it means to vindicate; furthermore, that the statements made through these discursive operators produce particular sets of meanings and situated ritualized actions. We will do so by concentrating on the terrains where the controversies raised, albeit differently, by *créolité* and *francophonie* intersect: language, place and subjectivity. By focusing on these terrains, we will identify the specific sets of issues constructed in the discourses which they contribute to produce, and the particular pleas or vindications through which these issues are articulated. As we will show, on the terrain of language, controversial issues dealing with the respective status of French and Creole are addressed, and identity claims are being played out. On the terrain of place, issues related to forms and instances of solidarity are debated within discourses which vindicate the importance of locality. On the terrain of subjectivity, the role of France within different networks of exchange is at the centre of heated debates through which participants claim their right to be subjects rather than objects of their respective history. As we will argue in a later section, although these issues and vindications have been formulated through literature and politics, they have found resonance in other fields of practice; namely, music.

CONTROVERSIES OVER LANGUAGE

Francophonie and *créolité* have been articulated in linguistic terms. While the centrality of the French and Creole language respectively is taken for

granted, the status, role and uses of these two languages seen as means of expression, and hence means of control, have raised questions.

All the above mentioned definitions of *francophonie* involve the sharing of the French language. The ways in which Francophones relate to French, however, are profoundly different depending on whether it represents a mother tongue, an official and/or vernacular language, or a language used in education, commercial trading and everyday life. For some people, these differences constitute both an asset of and a driving force behind the development of *francophonie* viewed as a unified yet plural linguistic grouping based on the 'coexistence and conviviality of the many languages that accompany French' (*Haut Conseil de la Francophonie*, 1993: 496) within the Francophone space. Others have argued that this idea, referred to as 'Francopolyphony', is utopian: since the promotion of French is often done at the expense of local languages which are no less important for particular communities' indigenous economy, politics and cultures, it thereby threatens their very survival. Ali Moindjie from the Comores has claimed that 'French is an instrument of power which is used by an elite to push aside a population, which destroys particularities and creates a certain uniformity' (quoted in *Tétu, 1992: 216). Many African Francophony members strongly believe that, as long as French remains the predominant language, a colonial influence is bound to be felt and resented by large sections of local populations. But as a writer from Congo, Thchikaya U'Tsami, has pointed out in reference to various appropriations of French in African literatures, the colonial influence experienced through language need not be unidirectional: 'The French language colonizes me, but in turn, I colonize it' (quoted in *Tétu, 1992: 224).

Debates concerning whether or not French is killing local languages are also accompanied by arguments over the kind of French promoted within the Francophone space. Some consider that *francophonie* is not about French but rather about the diversity of French, that is, both the concurrent forms of French and cultural *métissage* which results from their ongoing transformation. Others believe, on the contrary, that an imperialist view of France's French as the ultimate, purest and most sophisticated form, prevails and leads to the canonization of the forms of writing and speech associated only with the Hexagone. This ethnocentric attitude is said to lead to the rejection of other forms of French thereby seen as mere idiosyncracies, regionalisms or colloquialisms. Many Francophones from outside of the Hexagone feel that they are the only ones who are asked to adapt, despite the fact that they outnumber by far the Francophones from France. This opinion is also shared by some of France's intellectuals. In an issue of the magazine *Le Point* devoted to the ways in which France is perceived from abroad, editors have argued that there exists 'an incredible contradiction between the influence that [France] hopes to exercise or claims it has, and its real impact on the world' (Michel Colomès quoted in *Hugues, 1995: 43).

In the case of *créolité*, similar questions pertaining to whose Creole should prevail are also being asked. These questions are highly mediated by

the particular position occupied by the Creole language in the French West Indies: even though Creole constitutes the vernacular language of the majority of the population, French remains the only official language. Despite great efforts made by independent politicians and intellectuals in the 1970s to promote the language as a key symbol of Antillean identity, Creole has been denied any official institutional recognition. Combined with the notion that French is the language of prestige and power, this has traditionally led French West Indians who strove for respectability and social mobility to even prohibit the use of Creole in their own households. In the 1980s, new attempts at promoting Creole as the written language of a specifically Creole literature, while receiving wide support from some intellectuals and writers, have not challenged its otherwise marginal status.

Controversies surrounding language with regard to the *créolité* movement need to be examined in this context. The fact that the debates surrounding this movement have largely taken place in books and journals published in French from the outset has thus provoked the scorn and outrage of many. As Annie Lebrun (1994) has ironically indicated, so did the fact that the second edition of *Éloge de la créolité* was not published in French and Creole, but rather in both French and English. Moreover, the various ways in which Creole has been used in some of the most prominent literary works associated with *créolité* have been the subject of many debates. For example, Lebrun has questioned the criteria used by some critics to evaluate the level of purity of Creole they deem unsatisfactory in the works of writers such as Patrick Chamoiseau. She claims that those who believe they have the authority to decide which Creole is better, hence legitimate, are all 'witch hunters', be they 'Whites, Blacks, or Metis' (*Lebrun, 1994: 20).

In both cases, through controversial statements concerning language, protagonists do not only talk about French or Creole. They also plead to have their distinct situated identities acknowledged and protected, an essential condition for their being either Francophones or Creoles – hence for taking part, respectively, in the *francophonie* and *créole* movements.

CONTROVERSIES OVER PLACE

As indicated previously, *créolité* and *francophonie* are also defined in reference to specific geographic territories. The 'places' they designate, however, are determined by and through different forms of solidarity. From this perspective, questions have been raised as to which individuals and groups are or can be included in or excluded from these places. We will show that, through these controversies, issues pertaining to the boundaries of the respective spaces of *créolité* and *francophonie*, as constructed from within these movements, are in fact being addressed.

Bernabé *et al.* have argued in *Éloge de la créolité* that

> We, Antillean Creoles, bear a twofold solidarity. An Antillean solidarity
> with all the people of our archipelago regardless of our cultural

differences: our *antillanité*. A Creole solidarity with all African, *Mascarins*, Asian, and Polynesian peoples who show the same anthropological affinities: our *créolité*.

(*Bernabé *et al.*, 1989: 32–3)

Within this discourse of inscription, *créolité* is thus said to imply not only a geopolitical solidarity, but also an anthropological (cultural) one. Accordingly, the spaces of *créolité* could be said to extend beyond its situated place (West Indies). This very argument, however, has been challenged on the grounds that, despite the authors' claim, their approach to *créolité* typically reflects a Martinican experience. As Haitian writer René Depestre has argued, *créolité* remains first and foremost a Martinican business: created by and for a Martinican intelligentsia, it does not speak to other Creole-speaking West Indians in the same way. Depestre is one of those people who puts into question the notion that *créolité* describes a generic Antillean reality. In his view, there exists distinct *états de créolité* (states of *créolité*) characteristic of the different Caribbean societies which cannot be fused and confused as though they were interchangeable experiences and realities (Depestre, 1994: 160).

The so-called anthropological solidarity constitutive of *créolité* is also the object of harsh controversies. As Martinican Fred Réno has noted, the definition of creolization (a term used interchangeably by the authors of *Éloge de la créolité*)[9] prevailing throughout the French Caribbean greatly contrasts with that which exists in the English Caribbean. Their main difference, he has claimed, lies in the centrality of Africa as the key to the authentic identity of the Caribbean region. In the French Caribbean literature on *créolité*, the African contribution is acknowledged but is not considered to be the determining factor – while it is in its English counterpart.[10]

In the case of *francophonie*, the criteria for exclusion and inclusion are the cause of harsh disputes, especially insofar as the institutional Francophony is concerned. To this day, the governmental body comprises forty-seven members who, however, do not all enjoy the same status. France and Canada are among the so-called full members, a status which Cambodia, Bulgaria and Romania have received only recently after having long been mere observers; Moldavia, in turn, is still an observing member; non-governmental organizations such as the *Assemblée internationale des parlementaires de langue française* (AIPLF) are, in contrast, among the associated members. The 'membership' policy of the Francophony has been the subject of much criticism, to the extent that participants at the 1993 Summit felt the need to question how the organization could further open up its membership. Reporting on this discussion, CPF's chair, Shirin Aumeeruddy-Cziffra, has claimed that the Francophony has never been more open, and that while such a democratic trend is highly positive, it raises important questions: 'In which direction are we heading? Should the Francophony be a private club? . . . Will we be able to find an appropriate balance between a defensive attitude and our eagerness to openness?' (*Aumeeruddy-Cziffra, 1994: 18).

Similar controversies have been raging over the boundaries of the Francophone community. There have been deep concerns with the current practice of linguists and geography experts who, in their assessment of Francophone populations, tend to differentiate between full-time and occasional Francophones (Fahy, 1991: 14), between Francophones and Francophiles (Lalanne-Berdouticq, 1993), and thus between 'real' and 'fake' Francophones. Do such distinctions mean that there are different orders of *francophonie*? Are there criteria which could be used to measure an individual's or group's degree of solidarity with French-language or Francophone cultures, and hence of belonging to the Francophone community? Furthermore, critics have expressed the view that there might be an insurmountable gap between, on the one hand, the ideological rationale of solidarity among equals which informs the notion of a pluralistic community and, on the other hand, the sheer reality of *francophonie* as the terrain *par excellence* where economic and political inequalities between North and South are reproduced. In an interview published in *Antilla* magazine, African writer Bernard Doza vehemently attacks the idea of *francophonie* for its severe implications on the economies of most Francophone African countries. Developed in detail in his book, *Liberté confisquée* (Confiscated Freedom) – which, he claims, has been boycotted by the French media – his central argument is that so-called multilateral cooperation translates into a systematic exploitation by industrialized countries (especially France) of African countries whose leaders, Doza says, are often in their pay (Doza, 1992).

By and large, what is at stake here is in whose interest *créolité* and *francophonie* exist. These controversies, we argue, point to the centrality of locality in the debates surrounding the respective spaces of *francophonie* and *créolité*. The particular instances of solidarity by and through which these spaces are produced tend to be articulated in ways which emphasize the 'local' in relation to the 'non-local'. Whether it means district, region or country, locality is not conceived in oppositional but rather in relational terms. It represents a territorialized way of existing within a broader space as much as a distinct way of experiencing a deterritorialized community – be it Francophone or Creole.

CONTROVERSIES OVER SUBJECTIVITY

The third and last set of controversies we want to examine concerns subjectivity. More precisely, we wish to explore some of the subject positions which are articulated through the debates over the networks of exchange through which *francophonie* and *créolité* are discursively produced.

The two movements are defined at the intersection of a plurality of networks which are maintained through varying combinations of strong and weak ties. Some networks function exclusively within the respective confines of *créolité* and *francophonie*: it is the case of the *Carrefour des opérateurs culturels de la Caraïbe* and of the *Organisation commune africaine et malgache*, respectively. Others operate across the boundaries of *créolité* and

francophonie, thereby connecting them with other political and economic networks (constitutive, for example, of the United Nations and European Economic Community) and also with cultural networks (such as those formed by and around the broadcast Eurovision Song Contest and the Francofolies music festivals held annually in different cities – including La Rochelle, Spa and Montreal).

Given these various networks, to be both Creole and Francophone is neither impossible nor contradictory. As Raymond Relouzat has explained, the promotion of Creole does not offend *francophonie*, rather it 'reinforces it and gives it a privileged meaning which authorizes us to reserve the Caribbean *francophonie* a special and promising place within the Francophone concert' (*Relouzat, 1994: 191).

While the necessity of these networks and their potential advantages for individual participants and for each of the movements as a whole is not put into question, the role and status of France within these various networks is open to passionate debates. Given that France is an important member of the institutional Francophony and that the French West Indies are French departments, France's political representatives and various cultural and economic organizations are part of most of the networks of exchange through which *créolité* and *francophonie* are defined. The presence of France is almost inevitable, but many individuals and groups involved in either movements share the view that France represents an unequal partner with whom they experience a typical love/hate relationship. The motivations and rationale underlying this view vary greatly, and appear to be relative to the political positions occupied by the actors within the networks.

There are indeed important differences between the ways in which France is perceived by those who occupy a position of relative dependence and those who enjoy a greater independence with regard to *francophonie* or *créolité*. In the former case, controversial issues are raised as France is often accused of adopting a typically colonial attitude towards its overseas departments in the West Indies. That is, of maintaining the Creole-speaking populations under its full control while, when deemed relevant, taking advantage of the fact that they are not 'from the continent'. While some consider the political sovereignty of the French Caribbean nations as the only solution to such problematic and often downgrading relations, others are prompt to argue that the reason these populations benefit from a fairly high standard of living is precisely because they are French departments. From a different perspective, in the Canadian province of Québec, France is in and by itself a subject of controversies. Some *Québécois* see themselves as France's related cousins from the other side of the ocean and cherish the fact that they can claim common ancestors, historical and cultural heritage, rich language, and values of equality, sister/brotherhood and justice; they are also proud of the traditional political and cultural support that France has given to Québec. Others argue that, although more than two centuries have passed since Québec was a colony – lost to England in the late eighteenth century – France still treats it as a poor relative, and thus maintains

an imperialist attitude. It is this attitude, they claim, which explains why, especially in cultural domains, France has traditionally acted as though Québec was just an extension of its domestic market and at times, has also adopted protectionist measures *vis-à-vis Québécois* products. France is indeed accused of systematically refusing reciprocity, of being paternalistic (for instance, by adding subtitles to French-language films and dubbing Francophone television series made in Québec) and therefore of negating the specificity of Québec's distinct yet full-fledged Francophone cultures.

In the case of individuals or organizations from Europe and Africa who occupy positions of relative independence within the *créolité* and *francophonie* networks, controversies over France's role and status take a slightly different turn. On the one hand, they widely acknowledge that France takes too much room, so to speak, tends to interfere in everybody's business, often lacks respect, and has a tendency to act in a protectionist way – in short, that it adopts a typical neocolonialist attitude. On the other hand, on the positive side of the relationship, they see France as a crucial ally in the common fight against both the anglophonization of the world and uniformizing threats also posed by the increasingly powerful Islamic and Japanese blocks.

By and large, it can be said that France is considered to be the least committed Francophone member of the Francophony, and to support the cause of Creole only when it suits its needs. The fact that France is constructed as an unfair partner within both *créolité* and *francophonie* is probably imputable to the central role this nation state has played, albeit differently, in the development of the various groups and societies involved in these networks in its capacity as a colonial, neocolonial or postcolonial power. In this context, to talk about *créolité* and *francophonie* is, no doubt, to talk about the respective histories of the individuals, groups and organizations engaged in these networks but in less conventional terms; that is, by refusing to sanction France as the sole underlying driving force behind their respective development, or in many cases, underdevelopment. In other words, to talk about *créolité* and *francophonie* means to claim a discursive position from which some people can produce their own histories as situated subjects, not merely as more or less passive objects.

The musical practices of zouk and the *Québécois* mainstream

FROM PRESCRIPTIVE DISCOURSES TO SOCIO-MUSICAL PRACTICES

Based on our examination of *créolité* and *francophonie* considered as objects of discourse and discursive operators, we argue that the discourses through which they are produced (and reproduced) constitute prescriptive discourses on identity, locality and history; that is, discourses which lay claim to multiple and open identities, to deterritorialized and territorialized localities, and to subject-driven situated recovered histories. They represent specific ways in which power relations are articulated, albeit differently;

more precisely, strategies which could be instrumental in transforming the power relations in which individuals and population groups involved in *créolité* and *francophonie*, are engaged. Our assumption is that music can play a role in this transformation process since socio-musical practices are among the situated ritualized interactions by which the distinct statements made through *créolité* and *francophonie* find their effectivity. As Sara Cohen (1994) has demonstrated, music can exercise localizing power insofar as it gives people a sense of place and, we would add, a sense of 'space'. In a similar way, we argue that music can be said to exercise belonging power by providing people with a sense of their singularized identities and their 'desires to belong' (Probyn, 1994: 63). Furthermore, since music engages people as historically situated subjects whose distinct ways of being in and to the world matter, music can also be said to exercise subjectifying power.

In the next section, our discussion focuses on how socio-musical practices, namely zouk and *Québécois* mainstream, considered to be situated articulations of *créolité* (Guilbault, 1994) and *francophonie* (Grenier and Morrison, 1995), exercise such powers.[11] It examines, on the one hand, the ways in which zouk and *Québécois* mainstream operate as oriented/prescriptive musical narratives of alliance. On the other hand, it also explores how these narratives inform distinct strategies of valorization of zouk and *Québécois* mainstream on a variety of markets – which they contribute to configure and through which they are, in turn, reconfigured. Our main argument is that zouk and the *Québécois* mainstream are instrumental in transforming the power relations involved in the production and positioning of these musics on so-called international-oriented markets.

ZOUK AND THE *QUÉBÉCOIS* MAINSTREAM AS NARRATIVES OF ALLIANCE

The narratives of zouk

Zouk emerged in the early 1980s from Guadeloupe and Martinique, but draws on many local, regional and international musical genres. These include primarily three main popular music forms from the Creole-speaking islands (biguine, compas direct and cadence-lypso), but also forms from some Francophone African countries (soukous) and Spanish Caribbean islands (salsa), as well as from the Anglo-Saxon world, especially the United States (rock, soul and other 'funk' music forms). Zouk is the first Creole music to have achieved an unprecedented commercial success not only in the Creole-speaking Islands and the Caribbean as a whole, but also in Europe and Francophone African countries (Guilbault, 1993a).

Zouk is a genre which asserts and promotes Antillean-Creole identity. It does so by relying exclusively on Creole for lyrics and on *métissage* for instrumental composition. It is thus by means of a particular language and a distinctive aesthetic process that zouk derives its assertive character and projects a sense of identity. In keeping with the notion of *diversalité* used in

the *Éloge de la créolité*, zouk is produced through a qualified *métissage*; that is, a creative process centred on the appropriation, manipulation and reordering of heterogeneous elements. This process is experienced in zouk not only in composition practices, but also in the creation and performance of staged choreographies, dress codes and lyrics.

Métissage, it should be noted, is nothing new, especially in the Caribbean, where borrowing, mixing and reordering have been of necessity an integral part of music-making. What is original about zouk, however, is that it has given *métissage* a new political meaning which has altered the criteria used in defining so-called 'authentic' Antillean-Creole music. Prior to zouk, hybridity has long been associated with the 'unpure', the degenerated and the inferior. Leading zouk voices have taken issue with this view inherited from the colonial regime. They have promoted *métissage* as a positive and enriching process and, by so doing, rendered it legitimate.

There are many ways in which zouk has allowed the recovery of Martinican and Guadeloupean specific histories. In contrast with most traditions of Creole-language popular music forms, its lyrics typically have dealt with the everyday life of/on the islands, especially in its most common, 'banal' and least sensationalist forms. Through the media, zouk has been known to articulate the notion of *antillanité*. For instance, a zouk singer once explained that the aim of this music is to make the Antilles known as a series of distinct yet related populations, cultures and histories rather than as two dots on the map, the mere combination of sun, sand and sea (Jocelyne Bérouard, quoted in *Aumis, 1987: 15). At yet another level, zouk has involved a multiracial discourse which aims at counteracting the exclusion and marginalization of those who, throughout colonial history, were defined as 'the Other'. In this regard, the group Kassav, zouk's chief exponent, has made a highly publicized statement by featuring a heterogeneous musical formation which includes Blacks and Whites, Martinicans and Guadeloupeans, Antilleans and Africans, Creole-, French- and Arab-speakers.

Musical practices constitutive of zouk have thus helped to establish affinities at several levels; namely, linguistic, sonic, historical and racial. It is precisely through such affinities, we argue, that zouk has produced a narrative of alliance among population groups from different Creole-speaking islands, other minority groups faced with a growing xenophobia within the Hexagone, as well as other musical communities with whom zouk shares some of its most salient characteristics, such as rhythmic patterns, instrumentation, lyrics, structure and promotion strategies.

The narratives of the Québécois mainstream

Francophonie can refer to an indefinite variety of musics relative to a wide range of genres and traditions which are sung in various languages, use different instrumentations, and are produced by artists from at least four continents.[12] There are thus contrasting socio-musical articulations of

francophonie: what Francophone music stands for or how it is experienced by musicians from Burkina Faso most likely differs from what it means or how it is lived by musicians from Switzerland.

The socio-musical appropriations of *francophonie* in Québec will be our sole concern here. In our view, however, neither the plurality of contemporary musical patterns involved, nor the full implications of their construction as Francophone can be adequately grasped in terms of musical genres. Rather, these phenomena can be best accounted for in terms of patterns of relationship between musical practices (Straw, 1991) unfolding within Québec as a historically situated space (Grenier and Morrison, 1995). More precisely, we will examine the particular relationships between heterogeneous local products enjoying great commercial success and forming a diffused yet recognizable whole. These relationships link a number of songs which get both the widest exposure and broadest diffusion and which stand, within the confines of Québec, for the ever-changing familiar, popular, common and 'middle-of-the-road' in music. The *Québécois* mainstream, which designates this complex set of economic, social and cultural relationships, mediates a form of musical communication which revolves around songs considered to be discrete, relatively homogeneous (3–5 minute format), and independent meaningful units which constitute the raw material out of which albums, concerts, videos, radio and television programmes are fashioned.

The emergence of the *Québécois* mainstream (Grenier, 1993a) has been the result of and a key driving force behind the development of the indigenous music industry over the last fifteen years or so. Since the mid-1970s this young industry has experienced a significant growth, thanks in part to the political and ideological consolidation of a corporate milieu formerly divided in two opposite factions associated respectively with the France-derived *chanson* and the United States-derived pop-rock genres. The opposition between *chanson* and pop-rock has been characterized by the conflation of politics, musical genres and performing styles. While this conflation has made other sites of differentiation, such as age, gender, ethnicity and region secondary, if not irrelevant, it has furthermore been instrumental in the construction of *chanson* as the sole embodiment of 'true' *Québécois* music. It is beyond the scope of this article to examine in detail the various forces which led to the attenuation of this iterative opposition. Let us only say that, as of the early 1980s, the *chanson* versus pop-rock opposition has lost its centrality, and the criteria for defining authentic *Québécois* music have become objects of controversies. Formerly viewed as cultural symbol *par excellence* of *Québécois*-ness, *chanson* has been attributed a new status as it has become a generic label applied to Québec's musical terrain as a whole.

The *Québécois* mainstream has been characterized by an unprecedented blurring of genres (for example, *chanson française*, pop, rock, blues), a combination of different types of musical formations (from piano solo to a six-piece combo), and the use of distinct musical forms (such as verse-refrain, strophic, call-and-response). It has also involved a significant

transformation of the status of French, hitherto the sole linguistic, and hence identity trademark of any true *Québécois* popular music. While French remains by far the most common language of lyrics, it is no longer the exclusive one. For example, some popular artists are pursuing a singing career in French as well as in English, albeit to varying degrees of success, and one successful local duo has even recorded several albums exclusively in their native Innu language: their respective music can be said to be *Québécois* insofar as it is created by Francophone artists; that is, individuals who share the usage of French, whether or not it is their mother tongue. This phenomenon is indicative of how, within the *Québécois* mainstream, issues of identity in music are no longer addressed strictly in linguistic terms, but more and more in ethnic and cultural terms.

Insofar as it actualizes and, in turn, reconfigures the specific Francophone heritage of Québec, the mainstream can be said to articulate a twofold notion of Francophone community. On the one hand, it derives its sense of purpose from the affective links it establishes between current musical practices and the musical traditions which render these practices appropriate to the context of contemporary Québec. Songs associated with the mainstream have appropriated and mixed various local traditions prominent during the mid- to late-1960s (including *chansonnier*, yé-yé and cabaret music) or during the 1970s (rock, *musique de variété*, folksong à *l'américaine*). By so doing, they have contributed to the ongoing exploration of genres and styles deemed central to the geographically rooted socio-musical history of Québec as both a people of French descent and French-speaking population group in North America. The *Québécois* mainstream articulates a notion of community, whose boundaries correspond to the province's geographical limits, which allows its members to develop a territorialized sense of place. On the other hand, the mainstream's sense of purpose is also articulated through the affective linking of musical practices from Québec and from other Francophone musical cultures. These affinities are instrumental in the construction of practices and products of Québec's artists as integral parts of a larger international music scene, a space within which they occupy a position viewed as similar to that of artists from other Francophone areas. It is also through such 'affective alliances' (Grossberg, 1992) that songs created by some Canadian Francophone artists from outside the province find a niche within the *Québécois* mainstream.[13] From this perspective, the *Québécois* mainstream can thus be said to produce yet another notion of community, one whose boundaries are not confined by Québec's territory but rather coincides, more or less, with those of *francophonie* as a pluralistic yet unified entity. Insofar as it articulates this 'imagined' community, the mainstream can also be said to give musical audiences a sense of space founded not exclusively on territory but on culture and history as well.

In addition to articulating affective alliances, the mainstream has also involved economic alliances experienced through a series of organizations which contribute to its configuration. In keeping with the process of institutionalization which culminated in the founding of the Francophony, some

of the most important organizations established in Québec to further develop and promote the Francophone musical space have become key components of the socio-economic and communication networks and infrastructures constitutive of the *Québécois* mainstream. This is the case, for instance, of the *Francofolies de Montréal*, which is perhaps the most famous and influential privately funded institution involved in this process.[14] Its 1994 edition included over 160 free outdoor and paying indoor concerts, featuring more than 1000 artists and musicians from about twelve countries whose diverse genres and styles 'represent various facets of the Francophone musical space' (*Simard, 1994: 6). The audience has been evaluated at half a billion people, and the festival's revenue is said to have reached close to fifty billion Canadian dollars. While the festival may aim at promoting Francophone musical cultures, it is in no way a philanthropist enterprise. As organizers have pointed out in several press conferences, in contrast with public-funded organizations, the festival is held in Montreal because it is a good means to 'make business . . . to make cultural business' (*Lemieux, 1993: C-8). Responding to journalists who criticized the festival's 1993 programming for its lack of new or unknown acts, its president has argued that the *Francofolies* were not a mere artistic fantasy, but rather part of a strategic industrial process:

> It is a deliberate choice of the *Francofolies de Montreal* to create an industrial impact with the artists we include in our programming. Even when we attempt to promote a new artist, we make sure that his/her participation has some economic impact. . . . We work hand in hand with our corporate partners from the record and live entertainment industries, we encourage synergy among the various sectors of showbusiness.
>
> (*Brunet, 1993: E-12)

The festival, it could be argued, represents an increasingly important forum where artists, record producers, agents and concert promoters from different regions, especially of the Francophone world, can meet, exchange and discuss, as well as, hopefully, sign business deals. Some of the contacts established through this network have resulted, for instance, in the participation of some *Québécois* artists in music festivals and tours in Europe, and the signing of distribution contracts with influential European artists by Québec-owned firms. Moreover, in keeping with the festival's comprehensive coverage by local as well as foreign print and electronic media, some musical formations from Québec have extended their audience at home, while some groups from outside Québec (including, interestingly, Antillean Zouk Machine) have made new fans in yet another locale.

STRATEGIES OF VALORIZATION OF ZOUK AND THE *QUÉBÉCOIS* MAINSTREAM

As we have attempted to show, zouk and the *Québécois* mainstream can be viewed as singular articulations of *créolité* and *francophonie* respectively, and from this perspective can be said to produce distinct yet related

narratives of alliance. These narratives are articulated on a variety of planes, from the aesthetics of music composition and performance to the poetics of lyrics, by means of affect, politics, history and economy, and therefore put forward contrasting alliances which vary in form as much as in rationale and intensity. What we want to examine in these final sections is how these narratives of alliance mediate the strategies of valorization of zouk and the *Québécois* mainstream, and hence their positioning on various markets.

On targeting singular situated audiences

The qualified cultural *métissage* in zouk and the unprecedented blurring of genre distinctions in the *Québécois* mainstream represent two distinct instances of musical alliance which both have some bearing on the audiences constructed by and through these sets of practices. By mixing and multiplying cultural, linguistic and musical traditions in which they partake, zouk and the mainstream have broadened their potential audiences while diversifying them. One can be a biguine fan and still like zouk, or be a devoted folk lover and find at least part of the *Québécois* mainstream appealing.

Through the respective affective links they articulate, both socio-musical phenomena are constructed in strict relational terms, in keeping with musics from 'elsewhere' with which they are affiliated without ever being confused with them. Although it borrows from and is affiliated with compas direct, zouk cannot be mistaken for this Haitian musical genre; and while many draw at least partially from United States' folk pieces, no one song relative to the *Québécois* mainstream is ever going to perfectly qualify as an American folk-song. While both sets of practices put an emphasis on linguistic issues through lyrics, they none the less encourage a more comprehensive approach to music which also includes stage choreography, sound materials and organization techniques. The multiracial composition of zouk musical groups is as important as the groups' depiction of everyday life in Creole lyrics; similarly, the smallest and most important common denominator of the songs constitutive of the mainstream is not the language or even the meaning of their lyrics, but rather the fact that most of them cannot be readily associated with an exclusive musical genre or style. In light of these alliances, we suggest that the strategies of valorization of zouk and the mainstream target diversified yet specifically situated audiences, strengthen relations with newly discovered 'relatives' from 'elsewhere' and promote music as a global multifaceted experience.

The narratives of alliance articulated through zouk and the *Québécois* mainstream have not only oriented their socio-cultural valorization but also their institutional valorization. In this respect, the increasing number of local and internationally oriented festivals and competitions featuring zouk or Francophone music cannot be overlooked. While the respective roles of such organizations have yet to be fully assessed, it seems reasonable to infer that they have significantly helped artists, genres, songs and records to gain

an official recognition by music-related industries at home and abroad; furthermore, they have contributed in the establishment of the measures designed to evaluate success and define popularity within the industrialized confines of the musical domain. If this were the case, it could be argued that they have been instrumental in constructing the place occupied therein by the practices whose recognition and popularity they have helped to consolidate.

Local musics on 'international' markets

The processes of valorization we have briefly described also inform how musical commodities related to zouk and the *Québécois* mainstream have been promoted and distributed. More precisely, they can be viewed as integral parts of the specific marketing strategies involved in positioning these commodities in highly competitive markets. Drawing from the multiple forms of alliances articulated through zouk and the mainstream, these strategies have involved the construction of various target markets which, we want to emphasize, do not necessarily form a fixed hierarchically organized series, but rather heterogeneous groupings of different orders of markets. There is indeed no unique, readily accessible and taken-for-granted market for zouk or *Québécois* mainstream musical commodities. Furthermore, record sales, radio airplay and other indicators of the scale of diffusion of these commodities are not necessarily the only criteria used for configuring and defining their respective markets, as linguistic affinities, shared histories, socio-economic and geographic proximities, as well as converging political agendas, also appear to play a significant role.

We argue that the practices of zouk and the *Québécois* mainstream have contributed to the production, transformation and consolidation of a wide range of so-called international markets. This does not mean that the widely acclaimed Michel Rotin zouk artist has found or will ever find a niche in Seattle, Washington in the United States, nor that the latest release of *Québécois* superstar Richard Séguin is known or will ever be known in Amsterdam in the Netherlands. What it means is that the popularity of zouk and *Québécois* mainstream artists such as Rotin and Séguin has developed way beyond the confines of their respective country or region of origin in ways which, we argue, would qualify them as international artists. We are fully aware that this last statement defies the usual definition of what has been so far called 'international market'. But our point is precisely to question this very definition in order to attempt to account more adequately for the strategies of valorization articulated by music such as zouk and the *Québécois* mainstream.

Our approach rests upon three key assumptions which challenge the ways in which the 'international' has been largely defined. First, the boundaries of the so-called international market do not correspond to those of the so-called advanced industrialized world. Northern Western capitalist countries have not necessarily been the sole bearers of all economically and culturally meaningful markets. Countries or regions usually discriminated

against on the sole basis of their supposedly less viable economies have also been involved, albeit to varying degrees, in both the economic and cultural development of various musical practices and commodities. Second, different singular articulations of the 'international' coexist. As polylateral exchanges among countries or regions from the Southern hemisphere suggest (Guilbault, 1994), 'international' patterns and forms of exchange need not involve individual and corporate partners from the 'overdeveloped world' (Gilroy, 1990). Third, the 'international' constitutes the meeting place of groups or entities which need not be defined in strict political terms. An international market may involve exchanges among nation states, but bilateral or multilateral exchanges among localities/communities can also assume a no less important role in its mapping.

In light of these assumptions, we deem it more appropriate to speak of 'international markets'. By using the plural form we want to emphasize the co-presence of various habits and patterns of exchange constitutive of distinct markets. Some of the articulations of the 'international' elaborated within these markets can be usefully referred to as 'inter-national' to mean exchanges among groups whose collective identity is posited as nation – whether or not its political realization takes the form of the nation state; and 'inter-local' to mean exchanges among communities whose members' sense of belonging can be imagined in linguistic, religious, racial, gendered, as much as ideological and aesthetic terms.

What are the implications of framing international markets the way we have suggested for zouk and the *Québécois* mainstream? It is our contention that the alliances constitutive of these musical practices have allowed their valorization within the specific inter-national and inter-local markets they have helped to produce or expand.

To acknowledge the importance and specificity of inter-national markets means to better understand the role zouk has played in further developing cultural and commercial relations among various national groups of the Southern hemisphere. For example, at the Music Festival of Cartagena where zouk has been given a place of pride, artists from Martinique and Guadeloupe as well as from Columbia and Venezuela – among others – have been able to meet annually, perform for increasingly diversified audiences, and sell records to a wider range of music buyers. While the *Québécois* mainstream has not yet played any significant part in South/South inter-national markets (as has some American jazz in some circumstances), many other socio-musical articulations of *francophonie* have. It is the case of popular music from Zaïre, Madagascar and the Cameroons whose artistic and corporate producers have had increasing opportunities to meet through specialized forums such as the MASA, where they also come in contact with their Southern as well as Western counterparts.

The musical practices under study have also been central in the reconfiguration of already inter-national markets. For instance, the popularity of zouk has been instrumental in redefining musical relationships between Martinique and Guadeloupe on one side, and Haiti on the other. The fact that Martinican and Guadeloupean zouk has become popular in Haiti has

counterbalanced the predominance which Haitian compas music has had in the French departments during 1960 to 1980. Similar reconfigurations have occurred within inter-national markets in which France has been involved. Although the popularity of zouk has not revolutionized the relationships between France and its departments in the West Indies, it has given the musical cultures of Martinique and Guadeloupe a much brighter place under the sun of the Hexagone. This phenomenon can be observed at various levels: French artists have recorded zouk songs, Caribbean artists have been designated to represent France in inter-national song contests, and Caribbean music has been getting more airplay on France's radios and greater visibility on television. In a similar way, the advance of the *Québécois* mainstream can be said to have participated in modifying France–Québec relations, hitherto a one-way cultural street where Québec has been confined to the receiving end. New phenomena such as the increasing number of versions of *Québécois* songs recorded by French artists and the implementation in France of the French-language vocal music radio broadcasting requirement which has made corporate music lobby groups from Québec famous (Grenier, 1993b) signal that *Québécois* musical cultures as well as industrial and political expertise have gained more prominence in France.

Moreover, the socio-musical articulations of *francophonie* and *créolité* under discussion have contributed to the configuration of emerging inter-local markets. It has been the case of some of the markets of the *Québécois* mainstream which have been constructed through new exchange programmes between the *Québécois* and Walloon French-speaking communities. It has also been the case of already existing markets shared by the French Antillean and African artistic communities in Paris which have been further strengthened as zouk has acquired greater commercial and cultural value worldwide.

Towards new regimes of circulation

In this article we have drafted a sketch of zouk and *Québécois* mainstream practices as specific socio-musical articulations of *créolité* and *francophonie* with a view to analysing how singular configurations of particular so-called local music is produced, and to better understand the power relations at play. Our analysis has shed some light on the ways in which zouk and the mainstream are negotiated and articulated at the interplay of complex economic, linguistic, racial, political and aesthetic forces foregrounded by the discourses through which the *créolité* and *francophonie* movements have been officialized. It has also shown that these particular musical practices and distinct cultural/political/economic movements have contributed to the continuous legitimation of the separated yet related spaces which they helped to create and within which they have unfolded. These discursive spaces, we have indicated, allow for the emergence and consolidation of new alliances and strategies of valorization which could be said to respond to the imperatives of the contemporary global cultural economy as

a 'complex, overlapping, disjunctured order' (Appadurai, 1990: 296). The ordering of the various flows of capital, commodities, politics and policies, ideologies, technologies and expertises which these new alliances render possible are the object of our final remarks.

We argue that the most pressing issues within increasingly globalized musical terrains do not concern production, distribution, promotion and marketing strategies as much as circulation. More precisely, what appears to be at stake is the emergence of new 'regimes of circulation'; that is, particular systems of power/knowledge (Foucault, 1991) viewed as conjunctural linkages of institutions and discourses which allow the regulation of what, who and how circulates where and why. We use this notion to emphasize the fact that the affinities, alliances and affiliations articulated by and through zouk and *Québécois* mainstream as singular expressions of *créolité* and *francophonie* in music are conjunctural, historically contingent; and the strategies of valorization through which these musics are produced and marketed are monitored, controlled. While we suspect these socio-musical practices to have become 'dangerous crossroads', that is, intersections 'between the undeniable saturation of commercial culture in every area of human endeavor and the emergence of a new public sphere that uses circuits of commodity production and circulation to envision and activate new social relations' (Lipsitz, 1994: 12), we are convinced that such crossroads are policed.

How are crossroads policed? How is circulation limited? What are the situated political, economic, cultural and musical agencies at play? We have no comprehensive answer to offer, only a few analytical guidelines to suggest in view of initiating a critical study of emergent regimes of circulation we deem pressing.

Regimes of circulation, we propose, may be analysed in terms of the discursive and non-discursive practices which regulate, sanction and legitimize the configuration of movements, trajectories and rituals of passage. First, circulation implies movement insofar as it refers to the process of changing position or place. Regulating circulation therefore means limiting the positions a given music can occupy, the 'places' between which it can move back and forth – given that 'places' can designate not only geographical territories or landscapes, but also ethnoscapes, mediascapes, technoscapes, finanscapes and ideoscapes (Appadurai, 1990). It also means sanctioning the material forms through which music moves (commodities, experiences, individuals, know-how and policies, for instance) and the types of exchange entailed in this process (sale retailing, loan, home taping, reselling, barter, conversation, instrument making, to name a few). Second, given that circulation implies movement within a circumscribed space, it could be argued that the more or less formalized circuits through which musical spaces are institutionally and discursively produced are also regulated. We call trajectories the ordered circuits at play in the circulation of music, and differentiate between 'extensive' and 'intensive' trajectories depending on whether circulation mobilizes a variety of circuits or is confined to the systematic exploitation of a limited number of circuits. Third, to circulate music can

also evoke how music gets spread among and used by various people. For lack of a better term, 'rituals of passage' is the expression we use to denote the conventional ways in which music is 'passed along'. More precisely, we mean to refer, on the one hand, to the legitimation of certain patterns of reproduction/dissemination of music; and, on the other hand, to the regulation of practices through which traditions are invented (Hobsbawn and Ranger, 1983), memories created and activated, and given traces left behind by 'moving' music retained and reactivated therein.

While these propositions remain to be further developed, they are in keeping with a critical examination of zouk and *Québécois* mainstream music which made us realize that their current and future development depend not only on whether or not they will sell and how much, but perhaps, more importantly, on whether they will circulate, where, how and for how long.

Acknowledgements

The authors would like to thank organizers and participants of the Border Crossing: Future Directions in Music Studies conference held in Ottawa in March 1995, where a preliminary version of this article was presented. They would also like to acknowledge the financial assistance they have received from the Social Sciences and Humanities Research Council of Canada. Line Grenier extends her gratitude to the Fonds FCAR of Québec.

Notes

1 While conventions demand that authors' names appear one after the other, in this case the order is in no way indicative of their respective investment of time and effort. This article is entirely the result of a collaboration. In fact, the authors have argued over every word and every comma!

2 In the Caribbean context, the expression 'French-based Creole' refers to the language spoken in Martinique, Guadeloupe, French-Guyanna, St Lucia, Dominica and Haiti. Unlike other Creoles of the English Caribbean, its vocabulary has been deeply influenced by French, whereas its structure has been mostly associated with African languages. For further references on this subject, see Bernabé (1983), Carrington (1988) and Prudent (1989a). While acknowledging the existence of various Creoles spoken in the Caribbean region, for the purpose of this discussion we will refer to French-based Creole as 'Creole'.

3 * means that the quotation has been translated from French.

4 A famous writer from Guadeloupe, Edouard Glissant, has written *L'Antillanité* (1979) – a most influential book from which the authors of *Éloge de la créolité* have borrowed heavily.

5 This paradox can best be understood in relation to Martinican politics which, as of the mid-1980s, was seen by some as putting the question of identity, and not that of national independence, at the forefront. Among the various impetus for this shift were, on the one hand, the strategic decentralization policies set in motion by France's recently elected President of the Republic, François Mitterand, and on the other hand, the moratorium on independence presented by

the *Parti Progressiste Martiniquais* (PPM) and orchestrated by Aimé Césaire, poet and leader of the party.

6 Throughout this article, the English form Francophony is used to refer to the international political organization, whereas the French form, *francophonie*, is used to refer to the cultural, social and economic movement as a whole.

7 Its members meet every two years during what has become known as the *Sommet Francophone* (the fifth and most recent one was held in Mauritius in 1993); they establish orientations and formulate policies which are carried out by two organizations known as the key operators of the institutional francophony, the *Conseil Permanent de la Francophonie* (CPF) and the *Agence de coopération culturelle et technique* (ACCT).

8 Two of the most important musical organizations which participate in the institutional Francophony are the *Conseil Francophone de la Chanson* (CFC), which has been founded in 1986, and whose goals are to encourage international exchange and cooperation among the creators and producers of popular music, and the *Marché des arts du spectacle africain* (MASA), which was created in 1993 in order to provide a forum where the current and future state of development of African cultural industries can be discussed and contacts established between African artists and producers as well as tour organizers from different parts of the world.

9 As argued by Réno (1994), among others, and confirmed by many during interviews conducted by Jocelyne Guilbault in Martinique between May and August 1994, one of the critiques made by opponents to the *créolité* movement has been to point out the significant difference between *créolité* and creolization, terms which they claim refer to a state and a process respectively. In their view, by conflating the two terms, the promoters of *créolité* are proposing an ambiguous if not contradictory project which combines both a static and dynamic approach to Antillean identity.

10 This argument is at the bottom of the conflict which opposes intellectuals associated with the *négritude* and *créolité* movements. Whereas in *négritude* African ancestry is seen as central to the construction of Caribbean identity, in *créolité* it constitutes only one aspect of its genesis since, for instance, the East Indian experience is also recognized as playing a key role in this process. For further discussion on this issue, see Guilbault (1994).

11 These practices do not thoroughly exhaust how these movements are musically articulated. They are, however, strategic sites from which to observe how the complexities of *créolité* and *francophonie* are played out by those directly involved in events or organizations related explicitly to either movements.

12 It can thus evoke, for example, the respective repertoires of Ray Lema from Zaire, Céline Dion from Québec, Youssou N'Dour from Sénégal, Zap Mama from Belgium, Ismaël Lo from Sénégal, Francis Cabrel from France, and Édith Butler from Eastern Canada.

13 It is typically the case of Daniel Lavoie from Manitoba and Roch Voisine from New Brunswick whose respective music, associated with the 1980s–1990s musical 'middle-of-the-road', are both labelled *Québécois*.

14 Created in 1989 by the chief executives of the Spectra Scène group (also producers of the acclaimed Montreal International Jazz Festival), this annual week-long festival has been modelled on France's *Francofolies de Larochelle* which interestingly, according to his founder, were inspired by two Québec-made organizations: the 1974 *Superfrancofête*, a festival aimed at promoting cultural exchanges among young Francophones from around the world and

sponsored in part by the ACCT; and the *Festival d'été de Québec* created in 1967, which took over the Francophone mandate of the *Superfrancofête* during the mid-1970s and became the eldest major annual festival to be devoted exclusively to Francophone music from the province and abroad.

Bibliography

Appadurai, Arjun (1990) 'Disjuncture and difference in the global cultural economy', in Mike Featherstone (ed.), *Global Culture. Nationalism, Globalization and Modernity*, London: Sage: 295–310.

Aumeeruddy-Cziffra, Shirin (1994) 'Le sommet francophone de Maurice', *L'Année francophone internationale* (3), Québec: 11–20.

Aumis, Alain (1987) 'Special Kassav', *France-Antilles* (Martinique), 30 May: 16–18.

Bernabé, Jean (1983) *Fondal-Natal*, Paris: L'Harmattan.

Bernabé, Jean, Chaimoiseau, Patrick and Confiant, Raphaël (1989) *Éloge de la créolité*, Paris: Gallimard.

Berthelot, Jean-Michel (1992) 'Le corps comme opérateur discursif', *Sociologie et Sociétés*, 24(1): 11–19.

Brunet, Alain (1993) 'Les Francofolies. Du 26 novembre au 4 décembre, une dizaine de spectacles par jour, dont cinq événements spéciaux', *La Presse*, Montreal, 20 October: E-12.

Carrington, Lawrence D. (1988) *Creole Discourse and Social Development*, Manuscript Report no. 212e, Ottawa: International Development Research Centre.

Cohen, Sara (1994) 'Identity, place and the "Liverpool" sound', in Martin Stokes (ed.), *Ethnicity, Identity and Music. The Musical Construction of Place*, Oxford/Providence: Berg Publishers: 117–34.

Deniau, Xavier (1992) *La francophonie*, Paris: P.U.F. Que Sais-je?

Depestre, René (1994) 'Les aventures de la *créolité*', in Ralph Ludwig (ed.), *Écrire la 'parole la nuit': la nouvelle littérature antillaise*, Paris: Gallimard: 159–70.

Doza, Bernard (1992) 'Une interview the Bernard Doza, auteur du livre "Liberté confisquée",' *Antilla*, 502: 22–4.

Fahy, Paul (ed.) (1991) *Dialogues*, Dossier 'La Francophonie', Paris: Mission Laïque Française, October, 34: 9–30.

Foucault, Michel (1972) *The Archaeology of Knowledge and the Discourse on Language*, New York: Pantheon.

—— (1991) 'Politics and the study of discourse', in G. Burchell, C. Gordon and P. Miller (eds), *The Foucault Effect. Studies in Governmentality*, Chicago: The University of Chicago Press: 53–72.

Gilroy, Paul (1990) 'One nation under a groove: the cultural politics of "race" and racism in Britain', in D. T. Goldberg (ed.), *Anatomy of Racism*, Minneapolis: The University of Minnesota Press: 263–82.

Glissant, Edouard (1981) *Le discours antillais*, Paris: Seuil.

Grenier, Line (1993a) 'The aftermath of a crisis: Québec music industries in the 1980s', *Popular Music*, 12(3): 209–28.

—— (1993b) 'Policing French-language music on Canadian radio: the twilight of the popular record era?', in T. Bennett, S. Frith, L. Grossberg, J. Shepherd and G. Turner (eds), *Rock and Popular Music. Politics, Policies, and Institutions*, London: Routledge: 119–41.

Grenier, Line and Morrison, Val (1995) 'Le terrain socio-musical populaire au

Québec. "Et dire qu'on ne comprend pas toujours les paroles!" ', *Études littéraires* 'Poétiques de la chanson', 27(3): 75–98.

Grossberg, Lawrence (1992) *We Gotta Get Out of this Place*, London: Routledge.

Guilbault, Jocelyne (1993a) *Zouk: World Music in the West Indies*, Chicago: Chicago University Press.

—— (1993b) 'On redefining the "local" through world music', *The World of Music*, 35(2): 33–47.

—— (1994) 'Créolité and the new politics of difference in popular music in the French West Indies', *Black Music Research Journal*, 14(2): 161–78.

Haut Conseil de la Francophonie (1993) *État de la francophonie dans le monde*, Paris: La Documentation Française.

Hobsbawm, E. J. and Ranger, M. (eds) (1983) *The Invention of Tradition*, Cambridge: Cambridge University Press.

Hugues, Pascale (1995) 'Point de vue allemand. Le poison des arrière-pensées', *Le Point, Spécial France*, 1167: 43–4.

Lalanne-Berdouticq, Philippe (1993) *Pourquoi parler français?*, Paris: Fleurus Essais.

Lebrun, Annie (1994) *Pour Aimé Césaire*, Paris: Jean-Michel Place.

Lemieux, Louise (1993) 'Contrairement au Festival d'été, les Francofolies de Montréal misent plus sur les gros noms', *Le Soleil*, Québec, 2 December: C-8.

Lipsitz, George (1984) *Dangerous Crossroads. Popular Music, Postmodernism and the Poetics of Place*, New York: Verso.

Probyn, Elspeth (1994) *'Love in a Cold Climate'. Queer Belongings in Québec*, Montreal: GRECC, Concordia University and Université de Montréal.

Prudent, Lambert Félix (1989a) 'Écrire le créole à la Martinique: norme et conflit socio-linguistique', in Ralph Ludwig (ed.), *Les créoles français entre l'oral et l'écrit*, Tübingen: Gunter Narr: 65–80.

—— (1989b) 'La Pub, le zouk et l'album', *Autrement*, 41: 209–21.

Relouzat, Raymond (1994) 'Caraïbe, Martinique, Guadeloupe, Guyanne', *L'Année francophone internationale*, Québec: 185–93.

Réno, Fred (1994) 'Introduction', in F. Réno and R. Burton (eds), *Les Antilles-Guyanne au Rendez-vous de l'Europe*, Paris: Economica: 5–17.

Simard, Alain (ed.) (1994) *Programme officiel. Les Francofolies de Montreal*, Montreal: Les Francofolies de Montréal, 71 pages.

Straw, Will (1991) 'Systems of articulation, logics of change: communities and scenes in popular music', *Cultural Studies*, 5(3): 369–88.

Tétu, Michel (1992) *La Francophonie*, Montreal: Guérin Universitaire.

KEVIN FOSTER

TO SERVE AND PROTECT: TEXTUALIZING THE FALKLANDS CONFLICT

ABSTRACT

This article examines the roles and functions of narratives in the conduct and prosecution of the Falklands War. It looks at how, and with what degree of success the Falklands conflict was emplotted into potent definitions of national identity; how it was constructed as the embodiment of certain cherished ideals of nationhood, and thus slotted into what Patrick Wright calls the 'mythical Histories' of Britain and Argentina. It considers how the languages of diplomacy and sport were articulated within a discourse of war. It examines how participants in the conflict, journalists and combatants, made use of narratives cognate with the tradition of the romance quest in an effort to make sense of the conflict, promote its aims and provide themselves with reassurance at times of uncertainty, if not naked terror. It also considers how opposition to the war, dissenting opinions about the legitimacy of its aims and prosecution, and a more critical view of its costs, was most often and most effectively articulated in narratives which contested and deconstructed the discursive norms of the romance quest, or which challenged the coherence of the narrative or the narrative subject itself.

KEYWORDS

War; Falkland Islands 1982; mythical 'History'; narrative and nationhood

When, on 1 April 1982, Argentine forces 'recovered' *las Islas Malvinas*, Britain lost far more than an obscure and inhospitable colony in the South Atlantic. Its political and military humiliation by 'a nation associated mainly with Corned Beef . . . and Grand Prix drivers' was seen in some quarters as dramatic testimony of how far Britain had fallen from its imperial grandeur of a century earlier (Brown, 1987: 18).

The Conservative government had come to power in 1979 dedicated to halting Britain's decline, rekindling the nation's pride and restoring it to its rightful (ruling) destiny. According to Seabrook and Blackwell, Margaret Thatcher's electoral success stemmed from her ability to inscribe this policy

agenda within an ennobling narrative framework, 'to offer an epic account of where we are now and an heroic vision of how our situation may be transformed' (1982: 7). The basis of this heroic transformation lay in a return to Victorian values which, it was claimed, had been the cause of and not merely the context for Britain's nineteenth-century pre-eminence. The reinstitution of self-help, self-improvement, thrift and rigid hierarchies of race, class and gender as the basis of both public policy and private conduct would, it was asserted, engender political, economic and moral renewal, thereby stimulating national regeneration. The Prime Minister held up the task force and its defeat of Argentina as clear evidence of a direct, causative relationship between Victorian values and national greatness. At a Conservative Party rally only days after the Argentine surrender, she identified the primary cause of Britain's victory in the South Atlantic with the same rigid hierarchies of rank, class, race and gender that had provided the functional and ideological focus for empire. The same virtues of leadership, duty and sacrifice that had served the nation so well in subduing large tracts of Africa, India and the Caribbean had ensured victory over Argentina, and could now be turned to the reconquest of Britain itself. The task force, she claimed, provided a model of the organization and conduct required for moral and political renewal at home, where those who were unwilling to conform with its example, to follow orders, obey their superiors and subordinate their own needs to the good of the country, the enemies within, were obstructing Britain's return to the Promised Land of recovery and renewed greatness. The task force had shown the way ahead – they had confirmed that the nation's future lay in a return to the past.

> When we started out, there were the waverers and the fainthearts. The people who thought that Britain could no longer seize the initiative for herself . . . that Britain was no longer the nation that had built an Empire and ruled a quarter of the world.
> Well they were wrong. The lesson of the Falklands is that Britain has not changed and that this nation still has those sterling qualities which shine through our history. This generation can match their fathers and grandfathers in ability, in courage and in resolution. We have not changed. . . . Just look at the Task Force as an object lesson. Every man had his own task to do and did it superbly. Officers and men, senior NCO and newest recruit every one realized that his contribution was essential for the success of the whole. All were equally valuable – each was differently qualified. By working together – each was able to do more than his best. As a team they raised the average to the level of the best and by each doing his utmost together they achieved the impossible. That's an accurate picture of Britain at war – not yet of Britain at peace. But the spirit has stirred and the nation has begun to assert itself. Things are not going to be the same again.
>
> (Barnett, 1982: 150–1)

Those who would not accept their allotted roles in the new order would be compelled to do so by radical economic and social policies which would

extend hostilities from the peat bogs of the Falklands to the picket lines and dole queues of the domestic front. Reduced public spending, welfare cutbacks and employment legislation would do for 'socialist' councils, welfare recipients and trade unions what Botany Bay and the gallows had done for the political dissidents of the eighteenth century, and what hand grenades and howitzers did for the Argentinians.

The government could only hope to win public support for the radical policy agenda framing its return to Victorian values by ensuring a broad consensus about the causes, aims and conduct of the war. It did so by sanctioning and promoting a range of 'official' accounts dedicated to capturing differing, often competing, constituencies and thereby forging a consensus. A moral concord about the aims and causes of the conflict, for example, was produced by divorcing the fighting from its immediate geographical and operational contexts, and constructing it as a moral and metaphysical – as much as a military – confrontation. The Prime Minister actively encouraged and solicited the formation of a moral consensus in her description of Argentina's invasion of the Falklands as 'one of those insidious tests which throughout history evil has used to undermine the resolve of the good. . . . The world wondered the would good and true respond? And the good and true did' (*Guardian*, 17 May 1982: 2). The establishment of a cultural and political consensus on the conflict conversely relied on the identification in it of immediate physical details which established the invasion and 'our' response to it as a genuinely national cause. The weatherboard cottages of Stanley and the undulating expanses of the surrounding 'camp' (countryside), both prominent in file footage from the early days of the campaign, were just such potent cultural symbols, appealing to what Anthony Barnett has called 'a country cottage fetish and allotment consciousness', a deep-seated attachment to the countryside and its idealized village communities which cuts across the traditional divisions or race, class and gender (1982: 102). Later news footage from the islands of ransacked cottages, helicopters on the greensward, gun-toting troops camped behind white picket fences and Morris Minors forced to drive in the right-hand lane did more than register the details of Argentine occupation, they symbolized an assault on the country's spiritual heartland, the desecration of its most cherished symbols of nationhood – hence Fred Halliday's claim that the invasion of the islands was as if 'the Nazis had taken over the Archers' (quoted in Barnett, 1982: 101). Like the regulars from *The Archers* (an everyday story of country folk inhabiting the fictitious village of Ambridge, broadcast daily on BBC Radio 4 since 1951), the Falkland Islanders were identifiably, if not ideally our kith and kin. 'Their evident British accents and rural gait made a deep impression' (Barnett, 1982: 101). Not least on Sir Bernard Braine who told the House of Commons that 'the very thought that our people, 1800 people of British blood and bone could be left in the hands of such criminals was enough to make any normal Englishman's blood – and the blood of Scotsmen and Welshmen boil too' (Morgan, 1982: 16). In dispatching the task force, it was implied that the nation was fighting for far more than

1800 British subjects and their innumerable sheep: it was defending an idealized image of itself and its people – a model of the very consensus which the narrative was intended to sponsor.

The care with which a consensus on the Falklands War was cultivated can, I believe, be largely attributed to the central role played by the conflict in the production of a 'mythical History' of contemporary Britain, intended to secure for the government a retrospective endorsement of its proposed programme of radical economic and social reforms. 'Mythical History' is distinct from other historical forms, according to Patrick Wright, in its tendency 'to flow *backwards* rather than forward in time':

> mythical 'History' flows backwards because it works in a way opposite to those teleological and future orientated conceptions in which History moves forwards through time towards its goal . . . the mythical conception of 'History' establishes a national essence which is then postulated as an immutable if not always ancient past. In this chronically and sometimes violently mournful perspective the essential stuff of history remains identical through time – even though it is unfortunately all concentrated at an earlier point in the passage of time. Hence the passage of years becomes entropic, opening up an ever widening gulf between 'us' in the present and what remains 'our' rightful and necessary identity in an increasingly distant past.
>
> (Wright, 1985: 176)

Mythical 'Histories' of Britain from Arthurian legend to accounts of Dunkirk and the Blitz have been articulated and augmented by a narrative structure which, according to Wright, 'comes up again and again in various and diverse fables of nationalism' (ibid.: 179). It is characterized by a trinity of interrelated themes, 'the postulated purity of an essential identity' threatened with 'violation', 'public indifference' or 'the stumbling incompetence of bigoted and arrogant professionals' when confronted with its 'erosion', and 'struggle and victory for the forces of good', by which 'the essence is redeemed' and 'the threat of violation laid low as the essential order of things is restored' (ibid.: 179–80). This article will analyse the processes by which narratives from the Falklands War were inscribed palimpsestically over this and other fables of moral and national renewal, it will consider the construction of the conflict as a symbol of the loss, struggle for and redemption of the nation's 'rightful and necessary identity', and it will examine its role in the promotion and subversion of partial, party political 'Histories' of Britain and Argentina.

When news broke in London, late on 1 April 1982, that Argentine forces had taken and occupied the Falkland Islands, the overriding emotions at Westminster were despair that nothing immediate could be done to counter the intervention, and anger that it had apparently been unforeseen. The Franks Report, commissioned less than a month after the cessation of hostilities 'To review the way in which the responsibilities of government in relation to the Falkland Islands and their dependencies were discharged' reveals that the possibility of an invasion had, in fact, been taken into

account and that contingency plans were in preparation (1983: para. 1, p. 1). It records that on 8 March, twenty-three days prior to the invasion, the Prime Minister had asked her Minister for Defence, John Nott, 'how quickly Royal Naval ships could be deployed to the Falkland Islands if required'. His reply, that 'passage time for a frigate deployed to the Falklands . . . would be in the order of twenty days' was received by the Prime Minister's office four days later on 12 March: twenty days before the Falklands' governor, Rex Hunt, and the eighty-five Royal Marines and other naval personnel defending him were taken prisoner by members of the Argentine Navy's Amphibious Commando Company (Franks, 1983: para. 153, p. 45).

Stanley, the Falkland Islands' capital, is slightly more distant from London than Vladivostock, and significantly less accessible. This expansive distance and the time needed to cover it, which caused the government such distress at the time of the invasion, played a vital role in the campaign's eventual political and military success. The twenty-six days between the departure of the capital ships and the first naval bombardment of Argentine positions around Stanley gave the government ample time to prepare, introduce, explore and ultimately reject a range of diplomatic proposals, thereby preparing the political and discursive ground for the initiation of hostilities and the promotion of their intended results.

The whole diplomatic process was, in fact, little more than an elaborate charade: far from offering a credible alternative to military confrontation, it was merely an obligatory preface to the fighting which it was supposed to avert. It is an unwritten and now widely accepted condition of public support for the use of force, recently reaffirmed in the Gulf War, that a government must be seen to have explored every means of achieving a peaceful settlement before the populace can be expected to sanction the military option. The discourse in which the implementation and progress of diplomacy was described, however, denied the conditions for its effective exercise if not its existence. The diplomatic initiative was represented as a global poker game in which Argentine possession of the Malvinas was General Galtieri's 'powerful negotiating card' (*Guardian*, 14 April 1982: 13). For Mrs Thatcher every move in the South Atlantic was 'a gamble', and having successfully recaptured South Georgia it was suggested by one defence correspondent 'that it will surely pay to settle now because if she plays again, the odds will be much worse' (*Guardian*, 17 April 1982: 1). Yet it was the vocabulary of war itself which was most commonly plundered to furnish descriptions for the progress of diplomacy. Negotiating chambers came to bear anominous resemblance to the polarized battlefields of the Great War: conciliation conducted from entrenched, diametrically opposed positions across a no-man's land of mutual mistrust. Attack and counter-attack gave place to 'proposal' and 'counter proposal' after which the antagonists returned to their respective trenches, no closer to any kind of settlement. As the task force neared the islands, the diplomats donned khaki and formed search parties on the prowl for peace: 'The formula for which three mediators were again out on separate reconnaissance at first light' continued to elude them, the *Guardian* reported, as all

around 'the diplomatic battle' raged (7 May 1982: 14; 8 May 1982: 1). The final, most telling interpenetration of the diplomatic by the military register came on the day before the British re-invasion of the islands, when the UN Secretary-General, Javier Perez de Cuellar 'called in the Argentine and British representatives' and 'told them he had already established a "task force" which had explored various ways in which the UN might be useful' (*Guardian*, 20 May 1982: 2). Twenty-four hours later, having talked their way to the gates of war in the language of peace, the British government scuttled the UN's conciliatory task force by using its own to launch the re-invasion of the islands.

The use of military and sporting idioms subverted the diplomatic process by encouraging the public to evaluate the negotiations as it would judge a military campaign. What hope for conciliation, compromise and trade-offs when the language used to describe them associated every concession with capitulation and constructed every bargain as a back-down? Clearly, this was a false diplomacy: the very discourse which purportedly offered an alternative to bloodletting locked the antagonists into an unavoidable and bloody confrontation. Reversing Von Clausewitz's famous dictum on war and policy, the discursive construction of Falklands diplomacy was an extension of hostilities by other means.

For both British and Argentine governments, armed confrontation in the South Atlantic was the key to political success – but no guarantee of it. A military victory was of only limited use without a corresponding triumph over public indifference or dissent. This could best be achieved, as I have noted, by establishing the conflict as a symbol of national consensus. The nature and duration of the journey south offered a vital interregnum in which the British could make narrative preparations to this end. While the troops aboard the task force ships prepared their bodies and weapons for the test ahead, the public were subjected to a parallel process of discursive drill for their role in supporting the coming combat, trained to respond to specific textual interpellations with a series of stock, patriotic reflexes. The construction of the journey south as a romance quest or crusade established the conflict within a hallowed moral, military and cultural tradition, whose discursive norms implicitly affirmed the justice of 'our' cause and the virtue and heroism of those fighting for it – to which the public were accustomed and could be expected to respond positively. Paul Fussell, drawing on Erich Auerbach's work, outlined the characteristic features of the romance quest:

The protagonist, first of all, moves forward through successive stages involving 'miracles and dangers' towards a crucial test. Magical numbers are important and so is ritual. The landscape is 'enchanted', full of 'secret murmurings and whispers'. The setting in which 'perilous encounters' and testing take place is 'fixed and isolated', distinct from the settings of the normal world. . . . Training is all-important: when not engaged in confrontations with the enemy . . . the hero devotes himself to 'constant and tireless practise and proving'.

(Fussell, 1975: 135)

Sailing south through hazardous seas into unknown dangers, training daily for the perilous encounters to come, the accounts of those who made the journey to the Falklands wrote themselves, with varying degrees of self-consciousness, into the descriptive patterns and idiomatic traditions of the crusading narrative. Some inscribed their own and the task force's experiences over the discursive norms of the romance quest in a conscious gesture of solidarity with the government, propounding the justice and virtue of its espoused aims in the South Atlantic. Others, notwithstanding their disdain for the venture, adhered faithfully to the narrative's structural and idiomatic forms. For example, Robert Fox of the BBC could barely contain his derision when he first embarked on SS *Canberra* for the journey south. The whole situation was pure '*opera buffa*', 'a bizarre postscript in the chronicle of empire in which the Marx brothers appeared to have a hand' (1982: 2). This cynicism extended to the preparations undertaken by the men for the perilous encounters to come, and was expressed in his disparagement of the NCOs and other ranks. Their interest in physical fitness was an irrational 'fetish', and when not running around the upper deck with great logs across their shoulders they were swinging 'like monkeys from available bulkhead and beam' (Fox, 1982: 8). Yet as the mid-Atlantic resupply base at Ascension Island and the certainties of peacetime disappeared over the horizon, the enchantment of the landscape, full of secret whisperings and murmurs, began to exert its influence. Patrick Bishop recalls that soon after a brief stop in Freetown, Sierra Leone:

the ship was hit by a strange outbreak of superstition. Four days earlier we had hit a whale, killing it and staining the sea with blood, which some of the men took as a bad portent. A series of worrying coincidences followed. A story went around that a French clairvoyant had predicted that a great white whale would be sent to the bottom of the sea, plunging the world into a final war. The ship's nickname was the Great White Whale. Then it was noted that the postal number given to the Canberra by the British Forces Post Office was 666, which as every soldier knew from the horror movie *Omen* showing on board, was the mark of The Beast of Revelations. The story produced near panic in some quarters.
(Bishop and Witherow, 1982: 62)

Cooped up on board ship, the troops were divorced from all external sources of news, commonly with less information than the British public about the progress of the conflict. As Marc Bloch noted of combatants in the Great War, these conditions reduced personnel 'to the means of information and the mental state of olden times before journals, before news sheets, before books'. They were driven back on to more traditional methods of disseminating and gathering information which in turn occasioned 'a prodigious renewal of oral tradition, the ancient mother of myths and legends' (1954: 107). Fears, mediated through myths and legends like the above, led the combatants to seek reassurance and comfort in familiar structures. Foremost among these were the daily routines of the ship which assumed a ritualistic quality, providing an antidote to superstition and fear.

The lectures which Fox had earlier disdained assumed a new significance, and his attendance at them took on the form of a moral and psychological obligation, reflected in his description of later addresses in explicitly worshipful terms, 'litany', 'invocation' and 'homilies' (Fox, 1982: 59, 76). There is not hint of the supernatural in this. It represents a perfectly explicable psychological response to fear. Richard Holmes has noted just such a reverence for ritual among soldiers: 'On the battlefield ritual, often in the form of the drills rammed home in peacetime training, is a raft of familiarity in an uncertain environment. . . . Individuals fall back on ritual, to which they sometimes attribute magical properties, as a means of defending the ego against anxiety' (1987: 237–8). Fox, who came to mock, remained to pray. He found reassurance not only in the comforting rituals of the ship, but also in the familiar, narrative patterns of the romance quest, whose discursive assurance of the hero's well-being established the precedent and carried the implicit promise of personal survival – attainable, evidently, at the cost of his moral and political disinterest.

The journey south had a more obvious textual counterpart in the voyage of Coleridge's ancient mariner. Anyone aware of the similar course of the two voyages would, however, be keen to avoid too close an identification between them, and some went to extraordinary lengths to preclude such a possibility: 'One afternoon', recalls Robert Fox, '[Colonel] Tom Seccombe [Military Force Commander aboard *Canberra*] felt sure that a para[chute regiment] company at firing practice on the *Canberra*'s stern was about to bring down an albatross, and, quite clearly having had enough of the Navy already on the expedition, did not want to condemn himself to a life sentence as Ancient Mariner. He ordered that all live firing should be curtailed for the afternoon.' Yet from the immediately succeeding description of 'all manner of living thing, glinting, gliding and slithering' in the sea, it seemed that the colonel's caution was to no avail (1982: 70). This closely resembles Coleridge's description of the sea *after* the ancient mariner had shot the albatross. 'The very deep did rot: O Christ!/ That ever this should be!/ Yea, slimy things did crawl with legs/ Upon the slimy sea' (1987: 232). The albatross, and the curse brought about by its killing, only fell from the mariner's neck when he blessed the beauty and majesty of all God's creatures, and accepted his subjection to a power greater than his own, which his shooting of the bird had denied:

Within the shadow of the ship
I watched their rich attire:
Blue, glossy green, and velvet black,
They coiled and swam, and every track
Was a flash of golden fire.

O happy living things! no tongue
Their beauty might declare:
A spring of love gushed from my heart,
And I blessed them unaware:

Sure my kind saint took pity on me,
And I blessed them unaware.

The self same moment I could pray;
And from my neck so free
The albatross fell off, and sank
Like lead into the sea.

<div align="right">(1987: 236)</div>

Fox clearly knew his Coleridge. The second half of his description of the ocean balances the earlier, ill-omened account of 'glinting, gliding and slithering' things with a powerful evocation of the strange beauty of the sea and its creatures: 'occasionally the sea would boil with dancing dolphins. . . . Despite the onset of winter skies and squalls as the ship ploughed steadily south, the flying fish continued to attempt ever longer and more daring leaps . . . I saw one flying fish skim above the waves for over three hundred metres' (Fox, 1982: 70). Fox's apparently objective seascape, like the Colonel's curtailment of firing practice, gain added significance when they are seen in the context of *The Rime of the Ancient Mariner*. As much as they are responses to or depictions of the immediate situation, both also serve as talismanic gestures intended to appease a greater and potentially malign power, to preserve the individual from psychological if not physical distress. They are inscribed over and offered as an antidote to the fate of the ancient mariner. The course of Fox's journey to war is plotted not only through the pitching seas of the South Atlantic but also through a discursive landscape. His narratives, as such, in the process of ensuring him of his personal redemption, unwittingly, perhaps unwillingly, endorse the campaign's ideological aims.

Opposition to the conflict and the political agenda which its official, consensual accounts have been made to serve has been most commonly and most effectively articulated in narratives which have contested the discursive norms of the romance quest. One such account is by Robert Lawrence. Lawrence, a lieutenant in the Scots Guards, was shot in the head during the battle for Tumbledown Mountain on the outskirts of Stanley. Left partially hemiplegic, he was discarded by his regiment and suffered the full blast of the bureaucracy's indifference during his lengthy rehabilitation. Disillusioned with his treatment he migrated to Australia in 1987. His story has been told twice: once in his own words, and once in Charles Wood's screenplay for the BBC film of his war and its aftermath, *Tumbledown* (1987), directed by Richard Eyre. What unites these narratives is their debunking of the romance hero. In *Tumbledown*, Eyre dramatizes this subversive structure by juxtaposing brief black-and-white shots of an archetypal warrior figure, 'Bergen Man', with longer scenes lingering on the static Lawrence: one journeying heroically into battle on the prow of the southbound ship, the other learning to walk again, battling incontinence or bellowing at the 'cripples' around him. The written equivalent of these dramatic, deflating cross cuts is articulated in the subversion of discursive norms, and in unexpected, unsettling changes of idiom. In the autobiographical account of his

war experience Lawrence claimed, 'I saw my time in the Army as an opportunity to have a bit of a *Boy's Own* existence' (1988: 9). But from the moment that the Guards set foot on the Falklands his portrayal of succeeding events systematically deflates the archetypes of military heroism. His account of his actions immediately before he is shot closely adheres to, and then just as painstakingly subverts the discursive norms of a *Boy's Own* adventure. On the very brink of reaching the summit of Tumbledown, Lawrence was held up by some stubborn resistance. He recalled:

> I felt I had to keep the momentum going. I grabbed two or three people including Corporal Rennie and Sergeant McDermott, and went round the other end of the rock, and we started skirmishing down – one guy moving on while the other covered him. Again, I remember thinking that this was just like the movies. . . . Men from the different platoons behind me were dealing with the wounded and prisoners, but I was aware, as I moved along, of other people coming up behind me taking various routes. Ian Bryden, our company second-in-command was dashing along the top of the mountain doing all sorts of heroics. Sergeant Jackson handed his rifle and webbing to a Guardsman and went off on his own, with two grenades, to take some Argentinians out. It was all incredible stuff. I remember seeing the lights of Stanley below us and thinking how strange that it hadn't been blacked out. This was supposed to be a war. I turned to Guardsman McEntaggart as we went along and for some inexplicable reason, suddenly cried out, 'Isn't this fun?' Seconds later, it happened. I felt a blast in the back of my head that felt more as if I'd been hit by a train than by a bullet. It was a high-velocity bullet, in fact, travelling at a speed of around 3800 feet per second, and the air turbulence and shock wave travelling with it was what caused so much damage. I found this out later. At the time, all I knew was that my knees had gone and I collapsed, totally paralysed, on the ground.
>
> (Lawrence and Lawrence, 1988: 313)

The transition from heroic discourse to ballistic analysis, from Rambo to helpless cripple in one easy stumble contests the romance quest's implicit promise of heroic inviolability. The familiar lineaments of the *Boy's Own* narrative dissolve. Lawrence's predictable progress through the successive stations of heroic preparation is halted – becoming an unwanted journey into pain through a landscape of loss and despair from which he can never fully emerge. Less than a page earlier in the narrative Lawrence had bayoneted a man to death, stabbing him in his fear and frenzy all over the upper body, the chest, arms, and horrifyingly the face. Within hours the roles were reversed: with the surgeon probing his head wound, extracting the fragments of beret embedded in his brain, it is Lawrence who is on the receiving end, *his* body and *his* dreams of macho valour that are violated. In the romance quest, the hero's success is the ultimate ideological endorsement of the cause and the means of its prosecution. By subverting the discursive norms of the heroic narrative, Lawrence not only challenges the romance

quest's misrepresentation of the experience of war, his maiming and his subsequent maltreatment at the hands of his own people implicitly contest both the justice of the cause and the society on whose behalf it has been prosecuted.

Summer Soldier (1990) is Philip Williams's account of his experiences in the Falklands. Williams, like Lawrence, of the Scots Guards, suffered acute battle reaction after he was caught in the blast of a bomb while searching for the wounded on the slopes of Mount Tumbledown. He stumbled off the mountain, dazed and disorientated, and was lost. Unaccounted for after the battle, his unit reported him missing presumed dead. His family were notified and, in the absence of his body, held a memorial service in their local church – an apposite response, as it transpired, though he was not (entirely) dead. For the next six weeks when he wasn't sheltering in a crofter's cottage, shared with a decomposing Argentine soldier – dubiously nicknamed 'Pete' – he wandered in search of food, drifting in and out of consciousness and sanity. He finally found his way to the cottage of Diane and Kevin Kilmartin, and after a few days in Stanley Hospital was returned to Britain and the glare of publicity. Yet the 'soldier who came back from the dead' found that his problems really began only *after* he got home. The newspapers and friends who had lauded his heroism when it was thought he had died in the service of his country now hinted darkly at 'desertion'. On his return to his unit after leave, Williams was subjected to a series of savage beatings by his fellow Scots Guardsmen who were convinced of his cowardice. He absconded from the regiment and found escape from his present difficulties and memories of his recent suffering in LSD, barbiturates and heroin. When he was eventually recaptured, he spent six months in the psychiatric ward of a military hospital before he was released and discharged from the military. Unable to settle down back in 'civvy street', Williams drifted from squat to squat, and after a period of heroin addiction spent several weeks in jail on an assault charge. The final stages of the book detail the rootless, wandering life he now pursues, and his total rejection of mainstream society and its values.

Jeffrey Walsh has dismissed *Summer Soldier* as 'an angry crude book' (Walsh, 1992: 42). Yet its crudeness is no stylistic solecism, it is a vital structuring device. The book's constant invective, and the self-consciously 'artless', quasi-oral form in which it addresses its readers deconstructs the discursive norms of the journey motif which was central to the conflict's production as a romance quest, and those involved in it as heroes engaged in a sacred rite of personal and social purification. Williams refuses the hero's mantle of destiny, portraying himself instead as a bemused and terrified wanderer, without directional or discursive purpose: 'I simply couldn't understand what all this hero crap was about. I just got lost, that was all. I'd been cold and hungry and shit scared. I couldn't see anything very heroic in all that' (Williams, 1990: 99). Williams's narrative emulates his experience. A kaleidoscope of impressionistic, discontinuous paragraphs, it articulates and embodies his directionless wandering in a fearful and unfamiliar landscape, stumbling from the well-trodden paths of the

journey motif into a discursive no-man's land. He describes one particularly vivid hallucination during his time in the crofter's cottage:

> I was woken by soft bangings and scrapings coming from downstairs. Jesus, that frightened me . . . after a bit, the noises stopped, so I clambered down from the loft into the bathroom. I stood in the doorway facing the kitchen, wondering whether to check the other rooms or get the hell out of there.
>
> Suddenly there was a shuffling sound coming from the bedrooms, and voices speaking in Spanish. . . .
>
> I don't honestly know how long I stood there, it seemed like about ten minutes, but it could have been a few seconds or an hour, but the next thing I saw was this dirty-looking bloke in helmet and combat clothing coming into the kitchen followed by a woman and two children. Even now, today, this minute, I can see them. The two kids wore corduroy dungarees over thick sweaters. . . . The man wore an overcoat and wellies. The woman was in jeans and a jumper. They looked scared too. Oh, and a couple of other soldiers followed them into the kitchen, and they had rifles with fixed bayonets.
>
> All the adults seemed to be talking but their lips weren't moving. The soldier leading the group walked up to within two feet of me, looked at me, turned and ordered everyone out of the croft. They trooped past me, and went out into the snow.
>
> I was pretty shattered I can tell you. I went to one of the little windows and looked out. They'd gone. I ran out and peered about for a sign of them. Nothing. There was a hillock to the left and I presumed they'd gone round behind that. It was then I noticed that the only footprints in the snow were my own.
>
> (1988: 45–6)

Haunted by mirages, persistently unsure of where, even who he is, the stable self, the romance quest's discursive and ideological standard bearer, fragments. The collapse of the subject thus precludes any progress towards either individual self-discovery or cultural self-justification.

It is no coincidence that Williams spends forty hungry days after his baptism of fire wandering through a wilderness blighted by war, littered with mines, discarded arms and the decomposing carcasses of man and beast. After *his* baptism in the River Jordan, Christ spent forty days fasting in the wilderness, where Satan offered 'all the kingdoms of the world in all their greatness' if he would only worship him (Matthew, 1976: 4: 8). Christ resisted and was augmented by his victory over temptation: anointed with 'the power of the Holy Spirit' he went forth to preach his Father's word (Luke, 1976: 4: 14). Williams too emerges from the wilderness a changed man, yet he is destroyed by his experiences there.

The Philip Williams who returned from the islands is not the carefree boy who had embarked for the South Atlantic; he is 'dead', and Williams has a sheaf of documents from the army, his MP, even the Mayor of Lancaster to prove it. As his mother remarks, with some comic prescience, on his return

to Britain: 'I can't look at you without thinking your dead Phil' (Williams, 1990: 94). Christ suffered and died that others might live in the hope of salvation; Williams 'died' and continues to suffer, with little hope of his own or others' redemption. Unlike Christ who was resurrected that he might ascend to his father's right hand in heaven, Williams, reborn, and rebaptised in a hot bath at Stanley Hospital, is trapped and tormented in a sensory and psychological hell, condemned to relive the horrors of the wilderness: 'Doors banging sounded like bombardments. Footsteps in the corridor outside like rifle fire. The rattle of metal dishes on a trolley like tanks rumbling. . . . And the smell of the hospital was weird after all the fresh air. For some reason the antiseptic cleanliness stank like putridness in my nose' (Williams, 1990: 59). Christ rose from the dead to remind the disciples of their duty to 'Go throughout the whole world and preach the gospel to all mankind. Whoever believes and is baptized will be saved: whoever does not believe will be condemned' (Mark, 1976: 16: 15–16). Williams cannot help but preach his gospel wherever he goes, the horrors of war are inscribed all over his body in the signatures of depression, disorientation and dementia, and like Christ, he is condemned for it by the military and the media.

If Lawrence found conformity with the heroic ideal a tall order, Williams faces an impossible task. He is a walking refutation of the official line on this and all wars. Ritually interred and discursively enshrined as a fallen hero, his return from the dead is a kind of blasphemy, a radical deconstruction of military and civilian society's most hallowed narratives. This, perhaps, explains why his experiences invert the Bible's discursive norms. In reversing the traditional forms of Resurrection, Enlightenment and Salvation, Williams rejects the society that can offer him neither sanctuary nor redemption.

The most significant determinant of Argentine narratives on the conflict is the place occupied by the Malvinas in the nation's cultural mythology. The Malvinas are held to be an integral part of the Argentine state. Ceded to the United Provinces of the Rio de la Plata when it won its independence from Spain in 1816, the emergent nation of Argentina sent its first governor to the Malvinas in 1823. His subsequent expulsion and the seizure of the islands by the British ten years later united political and religious divisions across the nation – and continued to do so for the following 149 years. The Catholic Church in Argentina preached that the return of the islands to Argentine jurisdiction was a moral, Christian duty. In the early 1980s the crumbling popularity of the military Junta also made it a political imperative. The fatal union between political and religious interest was consummated in the sacramental discourse which portrayed the military's last grasp at power as a latter-day crusade and a sure means to national regeneration. When Rear Admiral Carlos Busser, Commander of the Argentine force which captured the islands, agreed at the last minute to change the codename of the invasion from *Operacion Azul* to *Operacion Rosario* this did not reflect a dramatic loss of confidence in his chances of success. It re-emphasized how central was the crusading theme in official Argentine narratives of the journey to war through its direct reference to the Virgin of Rosario, whose feast day was established by Pope Gregory XIII in 1573 to

commemorate Don John of Austria's victory over the Turkish forces. As Jimmy Burns, formerly *The Financial Times'* correspondent in Argentina noted, 'Busser had no doubt that the infidel, personified by the kelpers [the islands' native residents] and the seventy-odd British marines, was about to suffer an equally Virgin-sent defeat' (1987: 68).

If changing the operation's codename had not made sufficiently clear the conscripts' role in *Las Islas Malvinas* as new conquistadores, then Father Jorge Pincinalli's homily to the occupying forces, delivered in the Town Hall at Stanley on 25 April 1982, spelt out the discursive norms of the crusading narrative and the allotted duties of its protagonists in their renewal of the nation and its faith.

> *Nuestro pueblo Argentino que es católico, porque es hispánico, porque es romano, hoy ha prorrumpido en la gesta de la reconquista de un territorio para la Nación. Nación que tiene como origen el cristianismo. Entonces nosotros, todo lo que estamos acá, tenemos que sentirnos santamente orgullosos de pisar estas tierras; y quizá no seamos dignos de ésto. Es un gran honor, un incomesurable honor estar aquí. Tenemos que ver ésto como la gesta de la defensa de la Nación para Jesucristo. Tenemos que tomar en nuestros manos el Santo Rosario y confiar en la Santísima Virgen que siempre va a estar con nosotros. Porque esta patria ha sido consagrada a la Virgen de Luján. Y la Virgen de Luján y la Virgen del Rosario nos van a proteger, tenemos que estar seguros. Y ese rosario que hoy ustedes tienen en sus cuellos y también toman en sus manos, sepan que es el gran instrumento. Es la gran defensa porque es la defensa del espíritu sobre la materia. Sabemos que el espíritu es absolutamente superior a toda materia. Por eso tenemos que confiar plenamente en Dios, plenamente en Cristo, plenamente en la Santísima Virgen, reina y señora de estas tierras de las Malvinas, que ya es tierra de la Argentina.*
>
> (Kasanzew, 1982: 160–1)

[Today, our Argentine people who are Catholic, Hispanic, Roman, have succeeded in the reconquest of a territory for the Nation. A Nation which has Christianity as its origins. So all of us who are here have to feel miraculously proud to stand upon these lands; and perhaps we are unworthy of this honour. It is a great honour, an immeasurable honour to be here. We have to see this as an act in defence of the Nation for Jesus Christ. We must take the holy rosary in our hands and trust that the holy Virgin will always be with us. Because the fatherland has been consecrated to the Virgin of Lujan. And the Virgin of Lujan and the Virgin of Rosario are going to protect us, we must be certain of that. And you must know that that rosary which you have around your throats and in your hands today is a great instrument. It is the great defence because it is the defence of the spirit above the material. We know that the spirit is absolutely superior to all matter. Therefore we have to trust completely in God, completely in Christ, completely in the holy Virgin, queen and patroness of these lands of the Malvinas, which is now Argentine land.

(My translation)

This confidence in the power of spirit over matter is conspicuous by its absence in the firsthand accounts of the conscripts who had to confirm its validity in the face of British gunfire and artillery. While the narratives describing the conscripts' passage to, through and from the islands are framed by the same narratives of national and spiritual regeneration which shaped the official accounts of events, the specific palimpsests over which the conscripts inscribe their memoirs suggest that their experiences on the islands owed more to *la crucifixion* than to *una cruzada*.

For Argentinian troops, the journey to the Malvinas from the mainland was much shorter than that endured by their British counterparts, little more than a couple of hours' flight from the air force bases at Rio Gallegos and Comodoro Rivadavia. For many of *Los chicos de la guerra* from Entre Rios or Corrientes, the trip was, quite literally, a terrifying journey into the unknown, as Guillermo remembers: 'On the night of the fifteenth [of April], we took a plane to the Malvinas . . . many of the people with me on that trip and on the journey to Rio Gallegos had never been on a plane before in their lives. They were terrified: at that moment they were more frightened of the plane than of the war. Besides, many of them weren't really aware we were going to war' (Kon, 1983: 15). Many of the conscripts spent their entire time on the islands in ignorance of where they were. Only when he was transported back to Argentina aboard the *SS Canberra* did Guillermo learn that he had spent the previous eight weeks dug into a hillside in front of the former Royal Marine barracks at Moody Brook:

at the time I hadn't the slightest idea what that area was called, I didn't know where I was. When I was a prisoner aboard the *Canberra*, I talked to some of the English and they showed me a very small pocket map with coloured dots marking even our positions. And those guys I talked to weren't officers, they were ordinary troops; but as soon as they had landed they had had an idea of where they were, they knew which hill was which. I, on the other hand, had no idea.

(Kon, 1983: 16–17)

Adding to the conscripts' anxiety by shrouding their departure for the islands in secrecy not only confused their geographical bearings; it also deprived them of the opportunity to locate themselves and their cause within a specific discursive framework. The connection between ignorance of one's geographical and narrative places is a vital one here. Without maps, the conscripts were, both literally and discursively, lost, lacking the sense of place and role central to their functions as both soldiers of an occupying army, and catholic conquistadores in the unification and renewal of the nation. Consequently, their accounts of their experiences in the islands tend to subvert the generic norms of the evangelizing narrative, denying its depiction of war as a means to individual and national purification, an elevating proof of the superiority of spirit over matter. Instead, they write from the one place they all knew too well: from the mud, blood and gore of the battlefield. Their accounts of war focus on the physical degradation and social regression which its conditions imposed upon them: it was above all an

experience emphasizing the primacy of the material over the spiritual, the purgatorial rather than the paradisal.

From their first hours on the islands – having been received at the airport with a comforting 'Welcome to the Malvinas, here's your rosary' (Kon, 1983: 132) – the conscripts set about constructing their defences against the expected British onslaught. Some, as Guillermo recalls, 'built caves' (ibid.: 17). These were stone sangars, protection against strafing and artillery. Having constructed 'caves' it was not long before many front line troops were reduced to living like their neolithic forebears. The failure of supply lines meant that some positions went without food for days. The occupants were forced to make raids on the supply depots in Stanley, or to shoot, skin and butcher the ubiquitous Falklands sheep. Let down by their officers and seemingly abandoned by the high command, the conscripts forged new alliances, alternatives to the military hierarchy based on the barter system and the supply and demand of vital food and fuel. As Guillermo remembers, 'Clans started forming. Each clan was always tucked away inside its cave . . . we were like cavemen. We made fires with odd bits of wood, we cooked in empty tin cans, we always went around with our faces and hands black from the smoke. We were tramps, we must have been a sorry sight, we looked awful' (ibid.: 23).

Many of the conscripts' accounts implied a more fundamental process of personal degeneration. Fabian recalled that the night of the final British assault on his position, which he spent huddled on the floor of his trench with his two companions, was like being 'buried alive' (Kon, 1983: 165). Often this was all too literally the case, as many of the conscripts were buried in the trenches they had dug in the sodden peat. Yet Fabian's description of how he and his friends surrendered to the British early next morning counterbalances the humiliation of defeat and downplays the finality of death by drawing upon the stock imagery of light and darkness to stress the triumph of personal survival: 'We went out with our hands up . . . I saw the light again; it was a sunny day' (ibid.: 155). For Ariel's family, his unexpected return from the Malvinas with rheumatic fever represented a kind of resurrection. When they first visited him in a Buenos Aires hospital their reactions to him were much like Thomas's response to the resurrected Christ. As Ariel recalls: 'The moment of reunion was incredible; everyone touched me, as if they wanted to prove to themselves it was really me. One of them kissed my face, another hugged my back, someone else pressed my hands. It was very beautiful' (ibid.: 58).

The ultimate resurrection craved by the majority of the disillusioned combatants interviewed soon after their repatriation was that of the Argentine national spirit, as Guillermo noted: 'I'd like to help keep the Argentine people united. Over there we felt that unity, and now I'm back I feel that although we lost the islands, I don't know, we could do something, we could win Argentina' (Kon, 1983: 35). They did so by democratizing the definition of national identity and decentring power over its determination. The bungling and brutality in the South Atlantic had made it clear that the military no longer served or represented the nation. The removal of the junta

and a return to democratic, civilian rule ensured that it would never again have the authority to delimit and define an orthodox, Argentine nationhood, to identify its own as the national interest, and to destroy or 'disappear' those 'subversives' who failed to conform with it. Though they lost the islands, the Argentine people thus achieved a far greater victory: they won back the right to rule and define themselves.

Britain's victory in the Falkland Islands, on the other hand, resulted in the monopolization by a single political party of the right to determine and define authentic nationhood. Those who questioned its right to prescribe the national identity, or who resisted the resultant orthodoxy by opposing the political and economic reforms which it was intended to endorse, were, culturally, 'disappeared'. Labelled as 'traitors', or 'the enemy within', they were refused any part in the determination of their own and the nation's identity beyond the oppositional role issued to them by the government: culturally disenfranchised, they were symbolically stripped of their citizenship. Britain may have won the battle for the Falkland Islands, but its people are losing the war for cultural sovereignty over themselves and their own country: denied the right to meaningful self-definition, they are locked in a present impelled towards an ideal and unreachable image of the past.

References

Barnett, Anthony (1982) *Iron Britannia*, London: Allison and Busby.

Bishop, Patrick and Witherow, John (1982) *The Winter War: The Falklands*, London: Quartet.

Bloch, Marc (1954) *The Historian's Craft*, trans. Peter Putnam, Manchester: Manchester University Press.

Brown, David (1987) *The Royal Navy and the Falklands War*, London: Leo Cooper.

Burns, Jimmy (1987) *The Land That Lost Its Heroes: Argentina, the Falklands and Alfonsín*, London: Bloomsbury.

Coleridge, Samuel Taylor (1987) *The Rime of the Ancient Mariner*, in John Leonard (ed.), *Seven Centuries of Poetry in English*, Melbourne: Oxford University Press.

Fox, Robert (1982) *Eyewitness Falklands. A Personal Account of the Falklands Campaign*, London: Methuen.

Franks, Lord *et al.* (1983) *Falkland Islands Review: Report of a Committee of Privy Counsellors*, London: HMSO.

Fussell, Paul (1975) *The Great War and Modern Memory*, Oxford: Oxford University Press.

Holmes, Richard (1987) *Firing Line*, London: Penguin.

Kasanzew, Nicolas (1982) *Malvinas: A Sangre y Fuego*, Buenos Aires: Editorial Abril.

Kon, Daniel (1983) *Los Chicos de la Guerra*. Sevenoaks, Kent: New English Library.

Lawrence, John and Lawrence, Robert, MC, with Price, Carol (1988) *When The Fighting Is Over: A Personal Story of the Battle for Tumbledown Mountain and Its Aftermath*, London: Bloomsbury.

Luke, Mark, Matthew (1976) Gospels, in *The Good News Bible*, New York: American Bible Society.

Morgan, K. S. (1982) *The Falklands Campaign – A Digest of Debates in the House of Commons 2 April to 15 June*, London: HMSO.

Seabrook, Jeremy and Blackwell, Trevor (1982) 'Suffering Thatcher for the sake of her visions', *Guardian*, 3 May 1982.

Walsh, Jeffrey (1992) ' " There'll always be an England": the Falklands conflict on film', in James Aulich (ed.), *Framing the Falklands War: Nationhood, Culture and Identity*, Milton Keynes: Open University Press: 33–49.

Williams, Philip, with Power, M. S. (1990) *Summer Soldier*, London: Bloomsbury.

Wood, Charles (1987) *Tumbledown: A Screenplay*, London: Penguin.

Wright, Patrick (1985) *On Living in an Old Country: The National Past in Contemporary Britain*, London: Verso.

MEGAN BOLER

THE RISKS OF EMPATHY: INTERROGATING MULTICULTURALISM'S GAZE

ABSTRACT

Empathy is widely embraced as a means of educating the social imagination; from John Dewey to Martha Nussbaum, Cornel West to bell hooks, we find empathy advocated as the foundation for democracy and social change. In this article I examine how students' readings of Art Spiegelman's *MAUS*, a comic-book genre depiction of his father's survival of Nazi Germany, produces the Aristotelian version of empathy advocated by Nussbaum. This 'passive empathy', I argue, falls far short of assuring any basis for social change, and reinscribes a 'consumptive' mode of identification with the other. I invoke a 'semiotics of empathy', which emphasizes the power and social hierarchies which complicate the relationship between reader/listener and text/speaker. I argue that educators need to encourage what I shall define as 'testimonial reading' which requires the reader's responsibility.

KEYWORDS

empathy; emotion; testimony; *MAUS*; reading; power

How old is the habit of denial? We keep secrets from ourselves that all along we know. The public was told that Dresden was bombed to destroy strategic railway lines. There were no railway lines in that part of the city. . . .
 I do not see my life as separate from history. In my mind my family secrets mingle with the secrets of statesmen and bombers. Nor is my life divided from the lives of others. . . . If I tell all the secrets I know, public and private, perhaps I will begin to see the way the old sometimes see, Monet, recording light and spirit in his paintings, or the way those see who have been trapped by circumstances – a death, a loss, a cataclysm of history.
 (Susan Griffin, *A Chorus of Stones*)

Social imagination and its discontents

Upon an ivory hill in central California another fall evening's garish red-hues announced my fourth year of teaching *MAUS*, the comic-book representation of author Art Spiegelman's father, Vladek, narrating his

experience of surviving the Holocaust of the Second World War. Three hundred 18-year-olds – forty-seven of them charged to me – have been assigned this text, preceded by *The Joy Luck Club* by Amy Tan and quickly followed with *Zoot Suit* by Luis Valdez – the epitome of an introductory multicultural curriculum in the arts and humanities.

To all appearances, I should sleep well as a participant in this introduction to multiculturalism through the arts and literature; I should laud myself for taking up the liberatory potential outlined by forerunners John Dewey and Louise Rosenblatt. At the onset of the Second World War, the same moment that Vladek Spiegelman's story begins, progressive educational philosophers John Dewey and Louise Rosenblatt wrote optimistically of their faith in the 'social imagination', developed in part through literature which allows the reader the possibility of identifying with the 'other' and thereby developing modes of moral understanding thought to build democracy. In 1938 Louise Rosenblatt wrote, '[i]t has been said that if our imaginations functioned actively, nowhere in the world would there be a child who was starving. Our vicarious suffering would force us to do something to alleviate it' (1938: 185). She describes the experience of reading a newspaper in a state of numbness, that all too familiar strategy for absorbing information without feeling it. 'This habit of mind,' she writes, 'has its immediate value, of course, as a form of self-protection. . . . Because of the reluctance of the average mind to make this translation into human terms, the teacher must at times take the responsibility for stimulating it' (ibid.). Social imagination protects us, in this view, from Susan Griffin's above condemnation of the 'habit of denial' that enables an occurrence like the bombing of Dresden. Thus faith is maintained today, for example, by Aristotelian philosopher Martha Nussbaum, who advocates 'poetic justice' in which the student as 'literary judge' comprehends the other through sympathy and fancy as well as rationality as the foundation for dignity, freedom and democracy (1995: 120–1).

Educators, philosophers of emotion and politicians have not abandoned this project of cultivating democracy through particular emotions, of which empathy is the most popular. Across the political and disciplinary spectrum, conservatives and liberals alike advocate variations of empathy as a solution to society's 'ills'. At a recent public lecture, Cornel West insisted that empathy is requisite to social justice.[1] Empathy is taught in legal and medical education under the rubric of 'narrative ethics'; there is now a journal entitled *Literature and Medicine*. Cognitive scientists claim empathy as a genetic attribute, and speculate on a neurological map of ethics (May *et al.*, 1996). Empathy has been popularized recently through the bestselling book *Emotional Intelligence*, further publicized through *Oprah Winfrey*, *Time Magazine* and National Public Radio. Empathy, a primary component of 'emotional intelligence quotient', is a product of genetic inheritance combined with self-control, Aristotelian fashion. This emotional literacy, essentially a behavioural modification programme, is now taught in hundreds of public schools throughout the United States.[2] Finally, in the last fifteen years of Western 'multiculturalism', empathy is

promoted as a bridge between differences, the affective reason for engaging in democratic dialogue with the other.[3]

But who and what, I wonder, benefits from the production of empathy? What kinds of fantasy spaces do students come to occupy through the construction of particular types of emotions produced by certain readings?[4] In what ways does empathy risk decontextualizing particular moral problems?[5] In short, what is gained by the social imagination and empathy, and is this model possibly doing our social vision more harm than good?

While empathy may inspire action in particular lived contexts – it is largely empathy that motivates us to run to aid a woman screaming next door – I am not convinced that empathy leads to anything close to justice, to any shift in existing power relations. In fact, through modes of easy identification and flattened historical sensibility, the 'passive empathy' represented by Nussbaum's faith in 'poetic justice' may simply translate to reading practices that do not radically challenge the reader's world view.

I see education as a means to challenge rigid patterns of thinking that perpetuate injustice and instead encourage flexible analytic skills, which include the ability to self-reflectively evaluate the complex relations of power and emotion. As an educator I understand my role to be not merely to teach critical thinking, but to teach a critical thinking that seeks to transform consciousness in such a way that a Holocaust could never happen again. Ideally, multiculturalism widens what counts as theory, history, knowledge and value, rather than enabling modes of empathy that permit the reader's exoneration from privilege and complicities through the 'ahhah' experience.

Nussbaum admits that no matter how powerful a vision of social justice is gained by the empathetic reader, our habituated numbness is likely to prevent any action. 'People are often too weak and confused and isolated,' she says, 'to carry out radical political changes' (1996:57). One can only hope then that empathy is not the only viable route to inspiring change. As another colleague succinctly stated, these 'others' whose lives we imagine don't want empathy, they want justice.[6]

The untheorized gap between empathy and acting on another's behalf highlight my discomfort with the use of MAUS in an introductory 'multicultural' curriculum. My students' readings of MAUS enabled them to enter 'imaginatively into the lives of distant others and to have emotions related to that participation', Nussbaum's prescription for an 'ethics of an impartial respect for human dignity' (1995: xvi). But passive empathy satisfies only the most benign multicultural agenda. MAUS could be taught, I recognize, within a curriculum in such a way as to avoid some of the risks of empathy.[7] Yet introductory multicultural curricula cannot be all things, and most often do not provide detailed histories as backdrop to the literature read. What are the risks of reading a text like MAUS in the absence of more complete historical accounts?[8] What kinds of histories are presented in the name of multiculturalism, and what kind of historical sensibility is associated with these democratic ideals?

In question is not the text itself, but what reading practices are taught,

and how such texts function within educational objectives. I hope to complicate the concept of empathy as a 'basic social emotion' produced through novel-reading. I invoke a 'semiotics of empathy', which emphasizes the power and social hierarchies which complicate the relationship between reader/listener and text/speaker. I argue that educators need to encourage what I shall define as 'testimonial reading'. Testimonial reading involves empathy, but requires the reader's responsibility. Shoshana Felman asks, 'Is the art of *reading* literary texts itself inherently related to the act of *facing horror*? If literature is the alignment between witnesses, what would this alignment mean?' (Felman and Laub, 1992: 2). Such readings are possible potentially not only with testimony, or with novels, but across genres. Ideally, testimonial reading inspires an empathetic response that motivates action: a 'historicized ethics' engaged across genres, that radically shifts our self-reflective understanding of power relations.

The risks of passive empathy

Philosophers do not agree on empathy's role in moral evaluation. Kant, for example, views emotions as far too unreliable a basis for moral action, and held that only a unified and rational moral principle could be the basis of right action. David Hume, on the other hand, saw emotions as central to our moral behaviour. Nussbaum states in passing that her Aristotelian views could be 'accommodated by a Kantianism modified so as to give emotions a . . . cognitive role' (1995: xvi). In a pivotal treatise on altruism (Blum, 1980), a central unresolved question is the extent to which altruistic emotions must include being disposed to take action to improve the other's condition.

Empathy belongs to a class of 'altruistic emotions' which go by different names. Nussbaum draws on Aristotle's 'pity', but switches to 'compassion' to avoid the contemporary connotations of pity that Aristotle doesn't intend. In our common usage, 'pity' indicates a sense of concern, but more negatively a sense that the other is possibly inferiorized by virtue of their 'pitiful' status. Sympathy commonly refers to a sense of concern based not on identical experiences but experiences sufficiently similar to evoke the feeling of 'there but for the grace of God go I'. Empathy is distinct from sympathy on the common sense that I can empathize only if I too have experienced what you are suffering.

Throughout the discussion that follows, a key question remains: what role does *identification with the other* play in definitions of altruistic emotions? Can we know the other's experience? Briefly I suggest that in the definitions above, pity does not require identification; sympathy employs a generalized identification as in 'that could be me' or 'I have experienced something that bears a family resemblance to your suffering'; and empathy implies a full identification. In the cases of sympathy and empathy, the identification between self and other also contains an irreducible difference – a recognition that I am not you, and that empathy is possible only by virtue of this distinction.

I elect to use the term 'empathy' because it is the term most frequently used across the different literatures I detailed in the introduction. However, what I call empathy and Nussbaum calls compassion is probably best understood as our common-sense usage of 'sympathy'. I further distinguish 'passive empathy' to refer to those instances where our concern is directed to a fairly distant other, whom we cannot directly help. Some philosophers have it that in such cases the sufficient expression of concern is to wish the other well. I shall argue that passive empathy is not a sufficient educational practice. At stake is not only the ability to empathize with the very distant other, but to recognize oneself as implicated in the social forces that create the climate of obstacles the other must confront.

In her latest work, *Poetic Justice* (1995) and in 'Compassion: the basic social emotion', recently published in *Social Philosophy and Policy* (1996), Nussbaum advocates a humanist, democratic vision in which educators successfully enable students to imagine others' lives through novel-reading. The 'others' in her examples are the homosexual man, the African-American man and the working-class man. She summarizes Aristotle's definition of 'pity', which Nussbaum calls 'compassion' and I call 'passive empathy':[9]

> [Pity posits] (1) the belief that the suffering is serious rather than trivial; (2) the belief that the suffering was not caused primarily by the person's own culpable actions; and (3) the belief that the pitier's own possibilities are similar to those of the sufferer.
>
> (1996: 31)

The central strategy of Aristotelian pity is a faith in the value of 'putting oneself in the other person's shoes'. By imagining my own similar vulnerabilities I claim 'I know what you are feeling because I fear that could happen to me'. The agent of empathy, then, is a fear for oneself. This signals the first risk of empathy: Aristotle's pity is more a story and projection of myself than an understanding of you. I can hear the defensive cries: But how can we ever really know the other save through a projection of the self? While I share this question, our inability to answer it adequately is not a defence of passive pity. More to the point is to ask, What is gained and/or lost by advocating as a cure for social injustice an empathetic identification that is more about me than you?

Pity centrally posits the 'other' as the secondary object of concern, known only because of the reader's fears about her own vulnerabilities. Pity's first and second defining aspects are supporting corollaries to this positioning of self/other: the reader is positioned as judge, evaluating the other's experience as 'serious or trivial', and as 'your fault/not your fault'. The other's serious suffering is 'rewarded' by the reader's pity, if not blamed on the sufferer's own actions.

The identification that occurs through compassion, Nussbaum claims, allows us also to judge what others need in order to flourish. Nussbaum emphasizes that 'pity takes up the onlooker's point of view, informed by *the best judgment* the onlooker can make *about what is really happening to the person* being observed ... implicit in pity itself is *a conception of human*

flourishing, the best one the pitier is able to form' (1996: 32–3; my emphasis).

Nussbaum indicates that we can 'know the other' through compassion. I have significantly less faith in our capacity to judge what is 'really happening' to others. To judge what 'others need in order to flourish' is an exceptionally complicated proposition not easily assumed in our cultures of difference. Feminist and post-colonial writers, from Fanon and W.E.B. DuBois, to Irigaray and Levinas, have critiqued the self/other relationship assumed in Western and psychoanalytic models of identification. While there is much more to this question than can be pursued here, I wish to point out that the uninterrogated identification assumed by the faith in empathy is founded on a binary of self/other that situates the self/reader unproblematically as judge. This self is not required to identify with the oppressor, and not required to identify her complicity in structures of power relations mirrored by the text. Rather, to the extent that identification occurs in Nussbaum's model, this self feeds on a consumption of the other. To clarify: in popular and philosophical conceptions, empathy requires identification. I take up your perspective, and claim that I can know your experience through mine. By definition, empathy also recognizes our difference – not profoundly, but enough to distinguish that I am not in fact the one suffering at this moment. What is ignored is what has been called the 'psychosis of our time': empathetic identification requires the other's difference in order to consume it as sameness. The irony of identification is that the built-in consumption annihilates the other who is simultaneously required for our very existence. In sum, the social imagination reading model is a binary power relationship of self/other that threatens to consume and annihilate the very differences that permit empathy. Popular and scholarly (particularly in the analytic traditions of philosophy) definitions of empathy seem unwittingly founded on this ironic 'psychosis' of consumptive objectification.[10]

The troublesome terrain of identification poses questions about empathy that must be pursued elsewhere. How do critiques of identification complicate Western models of empathy? What might empathy look like, and produce, when it doesn't require identification? What about more difficult cases in which the reader is required to empathize with the oppressor, or with more complicated protagonists? (Here I think of Marleen Gorris's film *A Question of Silence*; and of performances like Anna Deveare Smith's *Fires in the Mirror*, a representation of the Crown Heights conflicts in Brooklyn which permits the viewer to empathize with multiple points of view. Deveare Smith's performance exemplifies the potential for a disturbingly relativized ethics, while highlighting the vast historical and cultural ignorances which cause such moral conflicts.) Finally, the readers Nussbaum speaks of represent a largely homogenous group in terms of class and ethnicity. What would it mean to empathize across other differences; when and why, for example, should inner-city youths read Virginia Woolf or *Wuthering Heights*?[11]

For the time being I can confirm that the Aristotelian definition of pity can indeed be produced through reading literature, as it was when students

read *MAUS*. Passive empathy produces no action towards justice but situates the powerful Western eye/I as the judging subject, never called upon to cast her gaze at her own reflection.

The risks of reading *MAUS*

Art Spiegelman's *MAUS* engages the social imagination precisely as progressive educators advocate: the reader easily identifies with the other, and easily occupies an emotional space that feels the other's experience. *MAUS* represents an additional effect of empathetic identification. While some students do read *MAUS* as a portrait of father/son dynamics rather than a story centrally about the Second World War, many come to the particularly dangerous conclusion that they have gained new insight into 'history'. The effect of this book on its audiences can be remarkable, literally beyond words: few readers put the book down, once begun; students attest again and again how profoundly the reading affects them; and they state that for the first time they are able to 'identify' with the experience of the Jewish people during the Second World War. The story takes the form of two narratives: Vladek's story of survival during the war, interrupted by present-moment interactions of Vladek, and the author, Art Spiegelman, living out their father–son relationship as Art interviews his father. Spiegelman enables a mixture of detachment and identification through his use of animal caricatures of Nazis, Jews and Polish people. Spiegelman stated in an interview that, in writing this comic-book he had no intention of the work representing history. Rather, this comic – his unique artistic genre, first published as a comic-book series in *RAW* – was his way of coming to terms with his relationship with his father and his mother's suicide.[12]

MAUS is an appropriate representation of the incommensurability of histories and empathy: to read *MAUS* is to walk the border of mesmerizing pleasure, the apotheosis of the pleasure of the text, alongside absolute horror. Empathetic identification is not necessarily with the Holocaust survivor. Pleasure is enabled by the easy identification with Art, the son, through whom we witness the father's story of the Holocaust. One can read through Art's veiled 'survivor's guilt' ('we too were excepted from this fate'), a consequence of the fact that his brother, his parents' first child, was taken by the Nazis. Second, the depiction of characters through animal metaphor allows for pleasurable detachment. Finally, there is no doubt that reading pleasure stems from the unimaginable horror of the Holocaust being well-contained in the genre of comic-book 'frames'.

This year one student commented that the device of representing people as animals – Spiegelman's technique of detachment, dehumanization and understatement – made the story all the more horrific; while another disagreed, saying that these devices are effective because the reader can learn about the Holocaust without guilt.

In a telling description of passive empathy, another student writes:

A person unaccustomed to reading the kind of material presented in novels recounting the Holocaust might be more comfortable reading the

easier flow of the comic-book-style used by Spiegelman. Spiegelman can ensnare readers into his book *MAUS* by sheer curiosity, and once they have begun it would be difficult to stop reading.

... By not pulling any punches, he addresses the horrors that occurred without making the reader feel as though she or he has been bombarded by feelings of rage and guilt. Often, the story of the Holocaust is told from a standpoint of such emotional turmoil that factual information is lost. Although *MAUS* is filled with strong images and disturbing occurrences, the reader does not feel that blame and pity is being forced onto himself or herself, but rather that Spiegelman is just 'telling his story'.

This student's primary concern is for the reader's comfort: Spiegelman doesn't 'pull any punches'; his representation does not 'bombard' the reader with 'feelings of rage and guilt'. By 'just telling his story' and through the 'easier flow of the comic-book style', *MAUS* permits the reader not to feel attacked; the 'reader does not feel that blame and pity is being forced onto herself.' This 'comfort' appears to rest in part on her classification of *MAUS* as an 'unemotional' genre. Her account juxtaposes 'just telling [a] story' and 'factual information' on the one hand, with the emotionality of blame, pity, rage and guilt on the other. *MAUS* works effectively because unlike other genres it 'just tells a story', she says, while 'novels recounting the Holocaust' and 'the story of the Holocaust' she classifies as too emotional and cause the reader discomfort. But this brings us directly to a risk of empathy: If this text allows the reader this sense of gripping and relatively 'easy' reading, are we not faced precisely with an abdication of responsibility? The reader does not have to identify with the oppressors. Rather, one identifies with the son who was not present, and with the dehumanized animal metaphors. What does it mean to experience a pleasurable read and be spared the emotions of rage, blame and guilt? In what ways is passive empathy related to the dehumanization strategies used to justify and represent war?

Quite in line with Aristotle's ideal definition of empathy and with the ego's consuming desire for the distinctive other, the use of animal metaphor permitted students to feel relatively undisturbed, while simultaneously permitting them to easily 'imagine the other' – too easily, with little self-reflective engagement. In a twist of Aristotle's shared vulnerabilities model, 'being in the other's shoes' was possible not through identification with power relations, but through a floating animal metaphor that allows heightened detachment rather than intimacy as the basis for empathy. The identification with Art's witnessing of his father functioned both through reversibility ('I could be in your shoes'), and through a mode of passive empathy that not only frees the reader from blame, but in this case allows the voyeuristic pleasure of listening and judging the other from a position of power/safe distance. While in some cases the pleasurable reading of this text may inspire students to pursue study of Jewish history and culture, I am not at all convinced that this potential benefit outweighs the risk of readings that abdicate responsibility.

The readers' desire to occupy a particular space of empathic identification

was challenged in a lecture on *MAUS* delivered to all 300 students that semester.[13] The philosophy professor stated that the reader is utterly deceived if s/he feels they can imagine the Holocaust from reading *MAUS*. He argued that to learn successfully about the Holocaust required reading stories and statistics until it becomes, precisely, *un*imaginable. Since the primary response of students is a variation of 'after reading *MAUS*, I feel for the first time that I understand the experience of those who survived', his challenge was appropriate. In our discussion some days later, the students expressed an almost unilateral offence at his statement that we could not imagine the Holocaust: they deeply wanted to believe that their identification was sufficient – a version of Rawls' (1972) commitment to 'reversibility' as the abstracted universalization of moral situations.[14]

Students' reading of *MAUS* exonerated and redeemed them from the usual sense of guilt and numbing horror that they associate with histories of the Holocaust. Passive empathy does not engage an identification with the deeper implications of being a Holocaust survivor or child of a survivor; or of being excepted by virtue of WASP status; or of identifying with the contemporary climate of anti-Semitism. In some ways the relationship between reader and text is a shifting confessional: passive empathy absolves the reader through the denial of power relations. The confessional relationship relies on a suffering that is not referred beyond the individual to the social.

To summarize my queries, I can entirely agree with Nussbaum's description that literature promotes 'identification and emotional reaction' which 'cut through those self-protective stratagems, requiring us to see...things that may be very difficult to confront – and they make this process palatable by giving us pleasure in the very act of confrontation' (1995: 6). This palatable permission of pleasure motivates no consequent reflection or action, either about the production of meaning, or about one's complicit responsibility within historical and social conditions. Let off the hook, we are free to move on to the next consumption.

TOWARDS A SEMIOTICS OF EMPATHY

Although used to give the illusion of universalized experience, empathy cannot produce one kind of universal relation between reader and text. Empathy is produced within networks of power relations represented by reader and text, mediated by language, narratives, genres and metaphors. The missing paradigm in theories of emotion across disciplines is an account that shifts emotions from being seen as the property or idiosyncrasy of the individual, towards a collectivist account.[15] Who benefits from the production of empathy in what circumstances? Who should feel empathy for whom? If no change can be measured as a result of the production of empathy, what has been gained other than a 'good brotherly feeling' on the part on the universal reader? As one small contribution to this project I propose 'testimonial reading' as an alternative to passive empathy.

The primary difference between passive empathy and testimonial reading is the responsibility borne by the reader. Instead of a consumptive focus on

the other, the reader accepts a commitment to rethink her own assumptions, and to confront the internal obstacles encountered as one's views are challenged. Shoshana Felman indicates that the 'imperative of bearing witness ... is itself somehow a philosophical and ethical correlative of a situation with no cure, and of a radical human condition of exposure and vulnerability' (Felman and Laub, 1992: 5). To share this burden, testimonial reading recognizes the correlative task of reading as a similar exposed vulnerability. Rather than seeing reading as isolated acts of individual response to distant others, testimonial reading emphasizes a collective educational responsibility.

As we hear about and witness horrors, what calls for recognition is not 'me' and the possibility of my misfortune, but a recognition of power relations that defines the interaction between reader and text and the conflicts represented within a text. Listening plays a central role in this semiotic understanding of any emotion. For example, in a discussion of the collaborative process through which an emotion like 'bitterness' is named and takes shape, feminist philosopher Sue Cambell (1994) articulates how the 'failure to listen' works alongside the recounting of injury to construct the accusation and thus experience of bitterness. In *The Drowned and the Saved* (1989), Primo Levi's discussion of shame exemplifies a structure of feeling that traces a listening to the residue of history.[16] Levi's question 'Are you ashamed because you are alive in place of another?' demands an account of biography and history. In a similar vein, Roger Simon (1994) asks that we learn to 'listen differently', through an integration of history and biography to establish what he calls 'living memory' which depends in part on structures of feeling 'that determine our relations to that history'.

Minnie Bruce Pratt (1988) argues for such an alternative as she analyses her work integrating her biography with her history as a white Southern woman. 'Sometimes we don't pretend to be the other, but we take something made by the other and use it for our own.' She describes her identification experience listening to Black folk singing, and reflects her major turning point when she realized that

> I was using Black people to weep for me, to express my sorrow at my responsibility, and that of my people, for their oppression: and I was mourning because I felt they had something I didn't, a closeness, a hope, that I and my folks had lost because we tried to shut other people out of our hearts and lives.
>
> Finally I understood that I could feel sorrow ... yet not confuse their sorrow with mine, or use their resistance for mine. ... I could hear their songs like a trumpet to me: a startling ... a challenge: but not take them as a replacement for my own work.
>
> (1988: 41)

The challenge to undertake 'our own work' accepts a responsibility founded on the discrepancy of our experiences. There is no need to consume through empathetic identification, or to recognize the words from the

speaker's perspective. Second, there is no need to 'rank oppressions' in such a way that we are pitted against one another to produce guilt rather than empathy. Empathy offers a connection and communication we don't want to lose. It's possible to identify the sense in which we've all been hurt, but to do so without a reductive denial of specificities.

How might we read, not through the ethics of universal reversibility? What would a reading practice look like, if not founded on the consumptive binary self/other which threatens annihilation of the other's difference?

Testimonial reading

What is at stake is not only the ability to empathize with the very distant other, but to recognize oneself as implicated in the social forces that create the climate of obstacles the other must confront. What, then, distinguishes empathetic from testimonial reading? What might it mean for the reader to 'take action'? I suggest that unlike passive empathy, testimonial reading requires a self-reflective participation: an awareness first of myself as reader, positioned in a relative position of power by virtue of the safe distance of reading. Second, I recognize that reading potentially involves a task. This task is at minimum an active reading practice that involves challenging my own assumptions and world views.

In *Testimony: Crises of Witnessing in Literature, Psychoanalysis, and History*, Shoshana Felman analyses the role of testimony in relation to pedagogy to illustrate the crises of meaning and histories that mark education. Co-author Dori Laub outlines the obstacles encountered by testimony's audience. Their analyses suggest the preliminary characteristics of testimonial reading. I draw on two key areas to characterize testimonial reading: our political climate of *crisis*, which requires new representations of 'truth' which are not static and fixed, but allow us to communicate trauma's 'excess'. Second, in response to crisis the reader accepts *responsibility* as a co-producer of 'truth'. This responsibility requires a committed interrogation of the reader's response as she faces the other's experience. To turn away, to refuse to engage, to deny complicity – each of these responses correlates with a passive empathy and risks annihilating the other.

THE CRISIS OF TRUTH

Felman characterizes our historical moment as marked by a 'crisis of truth'. The crisis is material and representational: the historical and social traumas which define our everyday and historical lives, and the crisis of representing these traumas. Testimony responds to the crisis of truth by 'exceeding the facts'. In the legal context, testimony is called for 'when the facts upon which justice must pronounce its verdict are not clear, when historical accuracy is in doubt and when both the truth and its supporting elements of evidence are called into question' (Felman and Laub, 1992: 5-6). By definition, testimony challenges legal and historical claims to truth: specifically, testimony challenges the call for 'just the facts, ma'am'.

What the testimony does not offer is . . . a completed statement, a total-izable account of those events. In the testimony, language is in process and in trial, it does not possess itself as a conclusion, as the constation of a verdict or the self-transparency of knowledge. Testimony is, in other words, a discursive *practice*, as opposed to a pure *theory*. To testify – to *vow to tell*, to *promise* and *produce* one's own speech as material evidence for truth – is to accomplish a *speech act*, rather than to simply formulate a statement. As a performative speech act, testimony in effect addresses what in history is *action* that exceeds any substantialized significance, and what in happenings is *impact* that dynamically explodes any conceptual reifications and any constative delimitations.

(1992: 5)

Testimony in this definition does not claim a static 'truth' or fixed 'certainty'. As a dynamic practice and promise (Felman details the sense in which s/he who testifies carries their own unique obligation to speak), testimony contains the energy and life force that cannot be captured as content or conclusion. Testimony's own medium 'is in process', and has no self-transparency.

Testimony is trauma's genre: the excess and the unimaginable attempts its own representation through testimony. As an artistic and literary genre, testimony portrays 'our relation to the traumas of contemporary history . . . composed of bits and pieces of a memory that has been overwhelmed by occurrences that have not settled into understanding or remembrance, acts that cannot be constructed as knowledge nor assimilated into full cognition, events in excess of our frame of reference' (1992: 5). To listen to testimony is no simple process of identification. Rather, trauma as excess raises the question: what are the forces that brought about this crisis of truth? How have the speaker and her memories come to represent the 'other'? To excavate the forces that constructed the unspeakable is a painful process for the speaker as well as for the listener, because those forces are about oppression.

How do we shift from an understanding of testimony as face-to-face relation, to understanding testimonial reading as a relationship between text and reader? Felman's extension of testimony to describe the process of teaching helps to define my concept of testimonial reading. Teaching, she ventures,

takes place precisely only through a crisis: if teaching does not . . . encounter either the vulnerability or the explosiveness of a...critical and unpredictable dimension, it has perhaps *not truly taught*: it has perhaps passed on some facts . . . with which the students . . . can for instance do what people during the occurrence of the Holocaust precisely did with information that kept coming forth but that no one could *recognize*, and that no one could therefore truly *learn, read*, or *put to use*.

(1992: 53)

Testimony can describe, then, not only the face-to-face relation but a genre of communication that requires the reader to 'encounter vulnerability' and the explosiveness of a 'critical and unpredictable dimension'. Our

responsibility in testimonial reading lies in our response to the crises of truth: how to recognize and put to use the information offered by the text.

THE RESPONSIBILITY OF LISTENING

Most significant to a critique of passive empathy, testimony calls for the listener's – and analogously the reader's – responsibility, invoked and engaged by virtue of testimony being an 'action' and 'promise', rather than a report, description or chronicle. In Dori Laub's analysis of the relationship between the Holocaust survivor who testifies and the listener, the listener's work is crucial: the absence of a listener, or a listener who turns away or who doubts, can shatter testimony's potential as a courageous act in truth's moment of crisis. As Laub warns, 'the absence of an empathic listener, or more radically the absence of an addressable other, an other who can hear the anguish...and thus affirm and recognize their realness, annihilates the story' (1992: 68). The listener plays a tremendous role in the production of truth, and relations of power are thus foregrounded.

Laub describes empathetic identification when she writes that the 'listener to trauma comes to be a participant and co-owner of the traumatic event . . . comes to feel the bewilderment, injury, confusion, dread, and conflicts.' Laub's description so far fits with empathy as a form of identification, of recognition that one is as vulnerable as the speaker – and that the listener 'is also a separate human being and will experience hazards and struggles of his own' (1992: 58). Here again we see the irony of empathy: that it is only our separation – I/not I – that permits empathy. But Laub projects this separation as a place of connection as well: '[the listener] nonetheless does not become the victim – he preserves his own separate place, position, and perspective; a battleground for forces raging in himself, to which he has to pay attention if he is to properly carry out his task' (ibid.).

We arrive finally at the key distinction between passive empathy and testimonial reading: in testimonial reading, the reader recognizes herself as a 'battleground for forces raging . . . to which [she]must pay attention . . . to properly carry out [her] task' (1992: 58). '[T]o properly carry out her task', the testimonial reader must attend to herself as much as to the other – not in terms of 'fears for one's own vulnerabilities', but rather in terms of the affective obstacles that prevent the reader's acute attention to the power relations guiding her response and judgements. For example, to experience a surge of irritation at the text allows the reader to examine potential analyses: does she dismiss the text or protagonist on some count, or examine her own safeguarded investment that desires to dismiss the text out of irritation? Might irritation, for example, indicate the reader's desire to avoid confronting the articulated pain?

Expanding this point of responsibility, Laub identifies the 'listening defenses that may interfere with carrying out the task of bearing witness'. These include a 'paralysis' from 'fear of merger with the atrocities being recounted'; 'anger unwittingly directed at the narrator'; 'a sense of total withdrawal and numbness'; and an 'obsession with fact-finding' that shuts

off the human dynamic (1992: 72-3). By allowing these affective obstacles to interfere with testimonial reading, the reader risks 'annihilating the story' (ibid.: 68). The ultimate risk of passive empathy may be the annihilation of the text into an object of easy consumption.

Testimony resonates with poststructuralist crises of truth: testimony denies the reader's desires for certainty; the emphasis on language as practice, as action, replaces coherence and resolution with vulnerability and ambiguity. One of Felman's pedagogical objectives in using testimony was to

> make the class feel . . . how the texts that testify do not simply report facts but, in different ways, encounter – and make us encounter – strangeness; how the concept of testimony . . . is in fact quite unfamiliar and estranging, and how, the more we look closely at texts, the more they show us that, unwittingly, we do not even know what testimony is and that, in any case, it is not simply what we thought we knew it was.
>
> (1992: 7)

The notion of testimony as an attempt to represent, as Felman says, 'events in excess of our frame of reference' refers back to the idea that such histories as the Holocaust must retain an unimaginable status. This abiding definition of testimony as a discursive process in defiance of closure underscored my discomfort with the risks of reading *MAUS* in isolation from a fuller historicization of surrounding events. My students' readings of *MAUS* seemed to defy the definition of testimony at each turn. Passive empathy did not engage them in an encounter with strangeness, with the uncanny; did not throw into question what they felt they knew. The readers experienced an untroubled identification that did not create estrangement or unfamiliarity. Rather, passive empathy allowed them familiarity, 'insight' and 'clear imagination' of historical occurrences – and finally, a cathartic, innocent, and I would argue voyeuristic sense of closure.

A minimum testimonial reading will call on us to analyse the historical genealogy of emotional consciousness as part of the structure that forms and accounts for the other's testimony. Testimonial reading leaves for the reader 'no hiding place intact. As one comes to know the survivor, one really comes to know oneself' (Felman and Laub, 1992: 72). Testimony calls for empathy as necessary to the comprehension of trauma, and necessary to extend cognition to its limits through historical consciousness. Through testimonial reading, then, one may recognize that I may imagine/feel the speaker's anguish (as my own). However, I also recognize that I cannot know the other (by virtue of historical difference, and/or through recognition that one speaker cannot embody and represent the six million unquantifiable traumas of this historical epoch). Testimonial reading recognizes its own limits, obstacles, ignorances and zones of numbness, and in so doing offers an ally to truth's representational crisis.

To experience rage and shame on Bigger Thomas's behalf is not sufficient; nor is it sufficient to see racism as a 'stain' and 'infection' that prevents a common humanity (Nussbaum, 1995: 96). Recognizing my position as 'judge' granted through the reading privilege, I must learn to question the

genealogy of any particular emotional response: my scorn, my evaluation of others' behaviour as good or bad, my irritation – each provides a site for interrogation of how the text challenges my investments in familiar cultural values. As I examine the history of a particular emotion, I can identify the taken-for-granted social values and structures of my own historical moment which mirror those encountered by the protagonist. Testimonial reading pushes us to recognize that a novel or biography reflects not merely a distant other, but analogous social relations in our own environment, in which our economic and social positions are implicated.

Nussbaum focuses solely on the novel; Felman addresses literature, and Laub addresses the actual testimony of Holocaust survivors. I intend testimonial reading to be applicable across genres.[17] Empathy, argues Nussbaum, is a product of the 'disturbing power' of 'good' novels, an effect less common with histories or social sciences (1995: 5). This may reflect a symptom of our cultural numbness more than a genre distinction. Nussbaum's quick distinctions between genres reflects traditional disciplinary axioms: 'history simply records what in fact occurred, whether or not it represents a general possibility for human lives. Literature focuses on the possible, inviting its readers to wonder about themselves' (1995: 5). In fact, historiographers have long debated history's ability to help us compare who we were and who we want to be.

As the nearly quintessential postmodern genre – comic-book, literature, history, testimonial, biography – MAUS represents an excellent example of the empathies produced not only through novels but through increasingly cross-disciplinary genres. It is beyond the scope of this article to analyse what testimonial reading will look like across different genres. But since texts are historically situated in power relationships, all texts can potentially be read testimonially. To enquire about these reading tasks, we might ask, what crisis of truth does this text speak to, and what mass of contradictions and struggles do I become as a result?

While 'face-to-face' testimony and listening might seem another order from reading, in our fragmented, globalized and technological culture communication becomes increasingly indirect in terms of face-to-face interaction. Schooling itself continues to take form as 'distance' education. Intimate relations are begun and borne out through electronic communications. We may come to redefine 'face-to-face', as we also redefine the genres and forms of testimony. To reconceptualize the task of reading, as text replaces human speech, provides an ethical groundwork for postmodern interaction.

The promises of testimonial reading

Let me conclude with a hopeful example in which a student seemed to move from a decontextualized, empathetic reading of MAUS to a testimonial reading. Her first essay expresses a classic example of social imagination at work:

Spiegelman uses mice and cats to assign Jews and Germans specific charac-

teristics that we usually attribute to these animals. . . . For example, if we imagine a town of mice, running everywhere with nowhere to go, always cautious and afraid, scampering to hide, it gives us a clear picture of what it must have been like for the Jews to be attacked by the Germans.

We had a lengthy and careful discussion about this troubling reading of *MAUS* – a conversation in which I took risks, and pushed her to think deeply about her relationship to the text, to her own audience, and to her experience. In the following excerpt of her revised essay she seems not only to locate herself, but to consider this text in the broadest sense of history and responsibility. 'I used to look at history with a sense of guilt,' she begins, and lists Native American and African-American history and white supremacy, 'and I hated to think that I might be distantly related to some of these [oppressors].

'This way of thinking led me to reject some aspects of history. I felt that I should not dwell on the past I rid myself of any sense of responsibility for what these people had done to other races. . . . ' She then recounts a turning point in high school after viewing *Farewell to Manzanar*, a documentary about the internment of Japanese Americans during the Second World War. The issue was not guilt, she realizes: 'it was more a question of discovering how things like concentration camps were started, and how it was that people came to think along these lines. It was a matter of examining their mistakes and our own mistakes so that we could move on. . . . [Spiegelman]. . . . wants us to find an alternative to guilt.' Strikingly different from her earlier notion that by imagining the Holocaust as a cat-and-mouse chase we understand history, one of her revised conclusions states: 'The collective guilt that overpowers many of us should not be the reason for examining the Holocaust. We need to explore the origin of the cruelty of it.'

'To explore the origins of this cruelty' requires not only multifaceted historical studies, but testimonial reading. Neither empathy nor historical knowledge alone suffices to shoulder the responsibility of this task. To excavate the structures of feeling that mediate testimonial reading is, in a sense, a labour of love. This work represents the obligation of witnessing truth's crisis, and accepting a responsibility to carry out the ethical relations implicit in languages that exceed the facts. In a sense, the reader is called upon to meet the text with her own testimony, rather than using the other as a catalyst or a substitute for oneself.

The call for testimonial reading is situated within a greater need for new conceptions of the relation of emotions and power. As we develop alternatives to privatized and naturalized models of emotion, I offer two concepts of the analysis of emotion and power relations: 'economies of mind', which refers to emotion and affect as models of currency in social relations; and as an alternative to theories of depth unconscious, I suggest we consider emotions as 'inscribed habits of inattention'.

In a historical epoch of saturated communications, there is every temptation to turn our backs, to maintain the habit of denial, and to keep secrets from ourselves through the numb consumption of another's suffering,

grateful for distances that seem to confirm our safety. Yet, at best, this illusion of safety and distance in which most live is precarious. Audre Lorde reminds us that our silence shall not protect us, nor does passive empathy protect the other from the forces of catclysmic history that are made of each of our actions and choices. Aristotle also claimed that virtue is a matter of habit: we choose our ignorances, just as we choose our challenges.

Acknowledgements

I am grateful to many people whose readings have refined this article: Stephen Appel, Betsan Martin, Karen Jones, Mary Leach, Jennifer Mc-Knight, Frank Margonis, Audrey Thomas, Roger Simon, Hayden White, and members of the Philosophy Education Society.

Notes

1 Dr West, author of *Race Matters* (Beacon Press, Boston, 1993), delivered this inaugural W.E.B. DuBois Lecture and Film Series sponsored by the Ebony Museum in Oakland, 14 January 1994.
2 In 'Emotional quotient: the taming of the alien', I argue that contemporary constructions of empathy, and the new curricula of 'emotional literacy', represent metaphorical and ideological shifts which may reflect capitalism's changed conceptions for human resource capital within globalization. (Conference paper delivered at Narrative and Metaphor Across the Disciplines, University of Auckland, New Zealand, 10 July 1995.)
3 The social relations and democractic ideals embedded in articulations of 'multiculturalism' are by no means uniform, given its diverse appropriations. For historical treatments, see McCarthy (1990); McCarthy and Crichlow (1993). For a valuable collection of essays examining the radical practices of education (from W.E.B. DuBois, to John Dewey, to bell hooks), see Perry and Fraser (1993); also Gloria Hull *et al.* (1982). Toni Morrison (1992) offers a stunning analysis of racialized identities mapped through the literary imagination.
4 From a conversation with Karen Jones in 1992.
5 From a conversation with Michael Katz in 1993.
6 A comment made by Ron Glass at the California Association of Philosophers of Education, Stanford University, May 1993.
7 In response to this article's critique of the risks of empathy with *MAUS*, Roger Simon offered an important counterexample regarding the use of *MAUS* in a course he teaches, in which he states 'at least half my class' undertook 'the refusal of the possibility of an empathetic reading. This was generated as a self-conscious moral response by the reader/viewers and was a stance taken in regards to *MAUS*, the film version of *Schindler's List*, Morrison's *Beloved*, and a visit to the Toronto AIDS memorial ... this is a big improvement on any simple assumption of an empathetic identification and this refusal did lead to interesting discussions of the problematics of voyeurism and the possibilities and obligations of "ethical tourism" (helped along I might add by students reading the original version of your paper)' {correspondence, 28 July 1994). In defence of the course which I taught, each year our reading of *MAUS* was supplemented by speakers – one year Art Spiegelman himself, which strongly contextualized the work as 'art' and 'his own story' rather than as a history;

another year, a Holocaust survivor testified; at other times, scholars of Holocaust literature and/or history addressed the students.

8 I am grateful for comments from Hayden White in reponse to this article about what would count as the 'histories' that complicated a reading of *MAUS*. See also, for example, Barzun (1950); White (1978).

9 Aristotle's philosophical portrait represents, of course, one among several; his model is frequently referenced in addition by feminist philosophers, and in popular texts. My rationale for selecting Aristotle is that the risks I see present in his definition represent what are in fact real risks we encounter in political solidarity work and learning to think about differences.

10 In a chapter entitled 'Ethnology, affect, and intensities: the prediscursive zone of infant feeling', of my forthcoming book (1997), I explore contemporary psychoanalytic theorizing of affect and social relations. As Theresa Brennan describes in *History After Lacan*, 'the ego can only make the world over in its own image by reducing the lively heterogeneity of living nature and diverse cultural orders to a gray mirror of sameness' (1993: 4). (See also Fuss (1995) who details the illusions built into the processes of identification; Robert Young (1990) who details the political violence wrought through imperialism as a kind of consumption through reduction of differences.) For further refigurings of the ethical relation, see, for example, Emmanuel Levinas (1989), and Irigaray (1977) in the continental. On Irigaray and education see Martin (1997); on Deleuze and education, see Leach and Boler (1997).

11 See, for example, 'Tim Rollins and the Kids of Survival' in Paley (1995), a different interpretation of classic literature used by a project in the South Bronx which might be called 'transgressive' and reappropriative readings.

12 For example, in contrast to Vladek's understated narrative of the war, the centrefold of *MAUS* is an inlaid cartoon depicting Art Spiegelman's highly emotional experience of his mother's suicide, his guilt, and the tension between Art and his father and the father's regulation of Art's emotional response, all of which puts into relief the deep structures of shame that accompany surviving a suicide or genocide. The presence of history and erasure is evidenced throughout the father/son relationship. The book ends, for example, with Art calling his father a 'murderer', because Vladek confesses that he burned all the journals Art's mother had kept before, during and following her survival of the concentration camps. For further reading on comic-books in relation to history, and commentary on *MAUS*, see Hirsch (1992–3), and Witsek (1987). See also Simon (1994); Zuckerman (1988), and Appelfeld (1993).

13 A lecture to the Porter Core Course students delivered by Professor Robert Goff, November 1993, University of California, Santa Cruz.

14 I have reviewed related questions of ethics, community` and imagination in relation to reading and political communities in Boler (1995).

15 My larger project, *Feeling Power: The Fate of Emotions in Education* (forthcoming), traces the disciplinary discourses of emotion as a map of power relations. Feminist analyses of emotion provide the most consistent political analyses of emotion (as opposed to what I call the three dominant paradigms of emotion). The other three dominant discourses of emotion I have identified as the rational, pathological and romantic). See Sandra Bartky's invaluable political study of shame (1990). On anger, see especially Peter Lyman (1981); Scheman (1977/1983), and Spelman (1989). For a pioneering critique of emotions conceived in relation to the individual, see Scheman (1996). In philosophy, two essays on bitterness suggest promising routes towards a politicized philosophical

theory of emotions: McFall (1991) and Campbell (1994); on trust, see Jones (1996). For interdisciplinary feminist and media studies, two issues of *Discourse* (1990–1) and (1992–3); and especially the work of Woodward in both issues. See also Grossberg (1992) for discussions of affect and agency within cultural studies. In feminist ethnography, see Lutz and Abu-Lughod (1990). Martin (1997) details Levinas's influence on Irigaray, with particular attention to the ethical face-to-face relation which outlines an alternative to the objectification of the other. She quotes John Wild, who suggests that revolutionary potential of Levinas's 'face-to-face' ethical relation is that it is a ' " third" way between individualism and collectivism' (p. 30).

16 Raymond Williams (1961, 1977) introduced the term 'structures of feeling' to describe the least understood aspect of cultural transmission of ideology. In a paper, 'Affecting assemblages', presented at Deleuze: A Symposium (6 December 1996), The University of Western Australia, Perth, I suggest the model 'Economies of mind', to refer to emotion and affect as modes of currency in social relations; and I challenge psychoanalytic models to consider emotions inscribed 'habits of inattention' as an alternative to theories of depth unconscious. On gossip and flight as chizomatic pedagogies, see Leach and Boler (1997).

17 For an interesting discussion of 'bearing witness' in relation to popular culture, in this case an *Oprah* episode on incest survivors called 'Scared Silent', see Champagne (1994–5).

References

Appelfeld, Aharon (1993) *Unto the Soul*, New York: Random House.

Bartky, Sandra (1990) *Femininity and Domination*, New York: Routledge.

Barzun, Jacques (1950) 'History – popular and unpopular', in J. Strayer (ed.), *Interpretation in History*, New York: Peter Smith.

Blum, Lawrence (1980) *Friendship, Altruism, and Morality*, London: Routledge.

Boler, Megan (1995) 'Review essay of Benhabib's *Situating the Self* and Bogdan's *Re-Educating the Imagination*', *Hypatia: A Journal of Women and Philosophy*, 10 (4):130–42.

—— (1997) 'License to feel: teaching in the context of war(s)', in A. Cvetovich and D. Kellner, *Articulating the Global and the Local*, Boulder, Col.: Westview Press.

Brennan, Teresa (1993) *History After Lacan*, New York: Routledge.

Campbell, Sue (1994) 'Being dismissed: the politics of emotional expression', *Hypatia Journal of Women and Philosophy*, 9 (3):46–65.

Champagne, Rosaria (1994–5) 'Oprah Winfrey's scared silent and the spectatorship of incest', *Discourse: Theoretical Studies in Media and Culture*, 17 (2): 123–38.

Felman, S. and Laub, D. (1992) *Testimony: Crises of Witnessing in Literature, Psychoanalysis, and History*, New York: Routledge.

Fuss, Diana (1995) *Identification Papers*, New York: Routledge.

Goleman, Daniel (1995) *Emotional Intelligence*, New York: Bantam.

Grossberg, Lawrence (1992) *We Gotta Get Out of This Place*, New York: Routledge.

Hirsch, Marianne (1992–3) 'Family pictures: MAUS, mourning, and post-memory', *Discourse: Theoretical Studies in Media and Culture*, 15 (2): 3–29.

Hull, Gloria, Scott, P. B. and Smith, B. (1982) *But Some of Us Are Brave: Black Women's Studies*, New York: The Feminist Press.

Irigaray, Luce (1977/1985) *This Sex Which is Not One*, Ithaca: Cornell University Press.

Jones, Karen (1996) 'Trust as an affective attitude', *Ethics*, 107 (October): 4–25.
Leach, Mary and Boler, Megan (1997) 'Giles Deleuze: practising education through flight and gossip', in M. Peters (ed.), *Naming the Multiple: Poststructuralism and Education*, New York: Bergin and Garvey.
Levi, Primo (1989)*The Drowned and the Saved*, New York: Vintage Books.
Levinas, Emmanuel (1989) *The Levinas Reader*, Cambridge: Basil Blackwell.
Lutz, Catherine and Abu-Lughod, L. (eds) (1990) *Language and the Politics of Emotions*, Cambridge: Cambridge University Press.
Lyman, Peter (1981) 'The politics of anger: on silence, ressentiment, and political speech', *Socialist Review*, 11(3): 55–74.
McCarthy, Cameron (1990) *Race and Curriculum*, Philadelphia: Falmer Press.
McCarthy, Cameron and Crichlow, Warren (eds) (1993) *Race, Identity, and Representation in Education*, New York: Routledge.
McFall, Lynne (1991) 'What's wrong with bitterness?', in C. Card (ed.), *Feminist Ethics*, Lawrence: University Press of Kansas.
Martin (1997) 'Luce Irigaray: introducing time for two/education and the face-to-face relation', in M. Peters (ed.), *Naming the Multiple: Poststructuralism and Education*, New York: Bergin and Garvey.
May, Larry, Friedman, M. and Clark, A. (1996) *Mind and Morals: Essays on Ethics and Cognitive Science*, Cambridge: MIT Press.
Morrison, Toni (1992) *Playing in the Dark: Whiteness and the Literary Imagination*, Cambridge: Harvard University Press.
Nussbaum, Martha (1995) *Poetic Justice*, Boston: Beacon Press.
—— (1996) 'Compassion: the basic social emotion,' *Social Philosophy and Policy*, 13(1).
Paley, Nicholas (1995) 'Tim Rollins and the K.O.S.', in *Finding Art's Place: Experiments in Contemporary Education and Culture*, New York: Routledge.
Perry, Theresa and Fraser, James (1993) *Freedom's Plow: Teaching in the Multicultural Classroom*, NewYork: Routledge.
Pratt, Minnie Bruce (1988) 'Identity: skin/blood/heart,' in Bulkin *et al.* (eds), *Yours in Struggle*, Sinister: Wisdom Press.
Rawls, John (1972) *A Theory of Justice*, Cambridge: Harvard University Press.
Rosenblatt, Louise (1938) *Literature as Exploration*, New York: Noble & Noble.
Scheman, Naomi (1980/1993) 'Anger and the politics of naming', in *Engenderings: Constructions of Knowledge, Authority, and Privilege*, New York: Routledge.
—— (1996) 'Feeling our way to moral objectivity', in May, L., Friedman, M. and Clark, A. (eds), *Mind and Morals: Essays on Ethics and Cognitive Science*, Cambridge: MIT Press.
Simon, Roger (1994) 'The pedagogy of commemoration and the formation of collective pedagogies', *Educational Foundations*, 8 (1):5–24.
Spelman, Elizabeth (1989) 'Anger and insubordination', in Ann Garry and Marilyn Pearsall (eds), *Women, Knowledge, and Reality*, Boston: Unwin Hyman.
Spiegelman, Art (1986) *MAUS*, New York: Pantheon Books.
White, Hayden (1978) *Tropics of Discourse*, Baltimore: Johns Hopkins University Press.
Williams, Raymond (1961) *The Long Revolution*, New York: Columbia University Press.
—— (1977) *Marxism and Literature*, New York: Oxford University Press.
Witsek, Joseph (1987) 'History and talking animals', in *Comic Books as History*, Mississippi: University of Mississippi Press.

Woodward, Katherine (1990–1) 'Introduction' (special issue on 'Discourses of the emotions'), *Discourse Journal for Theoretical Studies in Media and Culture*, 13 (1): 3–11.

—— (1992–3) 'Grief-work in contemporary American cultural criticism' (special issue on 'The emotions, gender, and the politics of subjectivity'), *Discourse Journal for Theoretical Studies in Media and Culture*, 15 (2): 94–113.

Young, Robert (1990) *White Mythologies: Writing History and the West*, New York: Routledge.

Zuckerman, Mosche (1988) 'The curse of forgetting: Israel and the Holocaust', *Telos*, 78 (fall): 43–54.

Cameron McCarthy, Alicia P. Rodriguez,
Ed Buendia, Shuaib Meacham,
Stephen David, Heriberto Godina,
K. E. Supriya and Carrie Wilson-Brown

DANGER IN THE SAFETY ZONE: NOTES ON RACE, RESENTMENT, AND THE DISCOURSE OF CRIME, VIOLENCE AND SUBURBAN SECURITY

ABSTRACT

Sociology and education theorists writing on the subject of racial antagonism have tended to ignore the critical role played by popular culture and the electronic media in the reproduction of racial antagonism (Giroux, 1994b). Although there is a rise of a multicultural literature within the field that has from its inception drawn attention to the representation of minorities in educational and cultural forms, such writing has concentrated mainly on textbooks, ignoring popular culture. In the main though, as Deborah Britzman and others have argued, this literature has tended to be a-theoretical and prescriptive to the point of being overly didactic (See McCarthy and Crichlow, 1993).

The marginalization of popular culture in the sociology and education literature on race is in part a consequence of the regulative and disciplinary tendency in the educational field to keep popular culture at arm's length lest it corrupts the young and over-stimulates the old. This article takes a radically different stance towards popular culture and we argue that it is precisely in popular culture that racial identities and interests are constructed, reworked and coordinated and then infused into the expressive and instrumental orders of school life. We look at the role of the popular media – particularly film and television – as provokers and cultivators of populist racial meanings and common sense. Drawing on Nietzsche's theory of identity in *The Genealogy of Morals* (1967), we argue that the electronic media play a critical role in the production and channelling of suburban 'resentment' (what Nietzsche describes as the practice

of defining one's identity through the negation of the other and through the strategic deployment of emotion and moral evaluation). Such suburban resentment constructs the inner city as Other to itself. We look at one example of resentment – the discourse of crime, violence and suburban security – as it is produced in filmic works emerging out of the Hollywood film industry. We argue that such a discourse forms a semiotic loop in which the filmic realism of the new wave black and Latino directors participates in and colludes with television evening news and the mainstream cinema in the production of suburban resentment by presenting the inner city as the harbinger of violence and lost dreams. In the final section of the article, we draw on a recent ethnographic study conducted by one of us to show the material impact of the resentment discourse of crime, violence and suburban security on the daily lives of black and Latino youth in a Los Angeles high school. We focus here on inner-city youth accounts of police harassment. The article concludes by pointing us beyond the limitations of filmic realism and the discourse of resentment.

KEYWORDS

Resentment; identity; culture; race; representation; realism

Introduction

Contemporary sociology of education theorists writing on the topic of racial antagonism has tended to focus too narrowly on sites within the classroom and the school (Giroux, 1994a). Insights that might be gained from the study of popular media – television, film and popular music – and their influence on racial formation and racial antagonism have been forfeited. Yet, paradoxically, it is in popular culture that racial identities and interests are constructed, reworked and coordinated and then infused into the expressive and instrumental orders of school life. American middle-class white youth and adults know more about inner-city black people through long-distanced but familiar media images than through personal everyday interaction or through representations offered in textbooks.

In matters of racial formation, then, we live in the media age – the age of simulation. But in this essay, we want to go beyond the overly abstract and instrumental reading of simulation that Jean Baudrillard (1983) offers. Processes of simulation cannot be fully understood by merely focusing on the internal dynamics and logics of the new communicational systems unleashed in our late-century society as Baudrillard does. These developments are, after all, taking place in particular social-historical contexts. Instead, we point to the critical role of processes of simulation in the production of historically specific discourses of resentment – the dominant vector of racial identity formation in the post-civil rights era.

What do we mean by resentment? By resentment, we mean roughly what Friedrich Nietzsche (1967) meant by his use of the term in *On the Genealogy of Morals*: the process of fabricating one's own identity through the strategy of negating the other and the tactical and strategic deployment of moral evaluation and emotion. We are particularly interested in racial

resentment, as it is a central way in which the white middle class projects itself into the contemporary age as the subject–object of history; this, at the expense of the urban underclasses, constituted in this media age as the primordial racial other. Through this process of displacement, the middle class installs itself as the primary victim or plaintiff of public life. Contemporary media mobilize a number of discourses of resentment. This article examines how media apparatus constitutes and consolidates one discourse of resentment: the discourse of crime, violence and suburban security. News magazines, television, the Hollywood film industry and the common sense of black and Latino film-makers themselves reproduce and maintain this discourse. We also look at the impact of resentment discourses on the self-representation of black and Latino adolescents at Liberty High, an inner-city high school in Los Angeles – the epicentre of current media representations of the brutality of urban life.

Danger in the safety zone

> The crisis of the middle class is of commanding gravity. . . . The crisis is hardening the attitude of the middle class toward the dependent poor, and to the extent that the poor are urban and black and Latino and the middle class suburban and white, race relations are under a new exogenous strain.
>
> (Beatty, 1994: 70)

In a recent issue, *Time* magazine ran two articles on crime and violence almost side by side. In the first, 'Danger in the safety zone', murder and mayhem are everywhere: outside the suburban home, in the McDonald's restaurant, in the shopping mall, in the health club, in the courtroom (Smolowe, 1993: 29). The article also displayed statistics indicating that crime in the major cities had been declining somewhat while crime in the suburbs – the place where the middle classes thought they were safest – was escalating out of control. The second article, 'Holidays in hell', tracked suburban resentment abroad:

> You drool over the alluring brochures. Ah, the pristine beaches. Elegant cafes. Spectacular mountain scenery. It all sounds great. Then you look at the fine print: the beaches are in poverty-racked Gaza Strip, the cafes in bombed-out Dubrovnik, the mountains in war-torn eastern Turkey. They have got to be kidding.
>
> (Fedarko, 1993: 50)

These articles announce a new sensibility and mood in the political and social life in the US: a mood articulated in suburban fear of encirclement; a mood increasingly being formulated in the language and politics of resentment. The dangerous inner city and the world 'outside' are brought into suburban homes through television and film, instilling simultaneously desire and fear. As we approach the end of the twentieth century, conflicts in education and popular culture are increasingly taking the form of grand

panethnic battles over language, signs and the territorialization of urban and suburban space. These conflicts intensify as the dual model of the city, of rich versus poor, splinters into fragmentary communities signified by the images of the roaming homeless on network television. For our late twentieth-century Sweeney Erectus of the professional middle class (PMC) standing on the pyres of resentment in the beleaguered suburbs, the signs and wonders are everywhere in the television evening news. Sweeney's decline is registered in radically changing technologies and new sensibilities, in spatial and territorial destabilization and recoordination, in the fear of falling, and in rigid segregation (Grossberg, 1992). Before his jaundiced eyes, immigrant labour and immigrant petty bourgeoisie now course through suburban and urban streets. The black and Latino underclasses after the Los Angeles riots, announces one irrepressibly gleeful news anchor, 'are restless'. The white middle classes are experiencing declining fortunes. And the homeless are everywhere.

This new world order of mobile marginal communities is deeply registered in popular culture and in social institutions such as schools. The terrain to be mapped here is what Hal Foster (1983) calls postmodernism's 'other side' – the new simulations of difference that loop back and forth through the news media to the classroom, from the film culture and popular music to the organization of affect in urban and suburban communities – Sweeney's homeground.

Suburban resentment and the politics of affect

The America of the diverging middle class is rapidly developing a new populist anti-politics.

(Beatty, 1994: 70)

Fredric Jameson (1984) has maintained that a new emotional ground tone separates life in contemporary post-industrial society from previous epochs. He described this emotional ground tone as 'the waning of affect', the loss of feeling. While we agree with Jameson that emotions, like film, television, newspapers or school texts, are historically and materially determined and culturally bound, we disagree with his diagnosis that contemporary life is overwhelmingly marked by a certain exhaustion or waning of affect. We maintain that a very different logic is at work in contemporary life, particularly in the area of race relations. Postmodernism's other side – of race relations, of the manipulation of difference – is marked by a powerful concentration of affect or the strategic use of emotion and moral revaluation.

Central to these developments is the rise of the cultural politics of 'resentment'. Nietzsche (1967), in *On the Genealogy of Morals*, defined resentment as the specific practice of defining one's identity through the negation of the other. Some commentators on Nietzsche associate resentment only with 'slave morality'. We are here taken genealogically back to 'literal slaves' in Greek society who, being the most downtrodden, had only one sure implement of defence: the acerbic use of emotion and moral

manipulation. But we want to argue along with Robert Solomon (1990) that bourgeois resentment virtually defines contemporary cultural politics (p. 278). As Solomon maintains: 'resentment elaborates an ideology of combative complacency [or what Larry Grossberg (1992) calls "impassioned apathy"] – a "levelling" effect that declares society to be "classless" even while maintaining powerful class structures and differences' (p. 278). The middle class declares that there are no classes except itself, no ideology except its ideo-logy, no party, and no politics, except the politics of the centre with a vengeance.

A critical feature of discourses of resentment is their dependence on processes of simulation. For instance, the suburban middle-class subject knows its inner-city other through an imposed system of infinitely repeatable substitutions and proxies: census tracts, crime statistics, tabloid newspapers and television programmes, and lastly, through the very ground of the displaced aggressions projected from suburban moral panic itself (Beatty, 1994; Reed, 1992). Indeed, a central project of PMC suburban agents of resentment is their aggressive attempt to hold down the moral centre, to occupy the centre of public discourse, to stack the public court of appeal. The needs of the suburbs therefore become the 'national interests'. By contrast, the needs of the inner city are dismissed as a wasteful 'social agenda'. Resentment must therefore be understood as an emotion 'distinguished, first of all, by its concern and involvement with power' (Solomon: 1990: 278). And it is a power with its own material and discursive logic. In this sense it is to be distinguished from self-pity. If resentment has any desire at all, it is the 'total annihilation . . . of its target' (ibid.: 279). Sweeney offers his own home-made version of the final solution: take the homeless and the welfare mums off general assistance, build more prisons!

A new moral universe now rides the underbelly of the beast – late capital's global permutations, displacements, relocations and reaccumulations. The effect has meant a material displacement of minority and other dispossessed groups from the landscape of contemporary public life. That is to say, the underclass or working-class subject is increasingly being placed outside the arena of the public sphere as the middle-class subject–object of history moves in to occupy and to appropriate the identity of the oppressed, the radical space of difference. The centre becomes the margin. It is as if Primus Rex had decided to wear Touchstone's foolscap; Caliban exiled from the cave as Prospero digs in. Resentment operates through the processes of simulation that usurp contemporary experiences of the real, where the real is proven by its negation or its inverse. Resentment has infected the very structure of social value. This battle over signs is being fought in cultural institutions across the length and breadth of this society. We are indeed in a culture war. We know this, of course, because avatars of the right like Patrick Buchanan constantly remind us that this is so (Bennett, 1994; Buchanan, 1992). From the cultural spiel over family values in the 1992 and 1994 election campaigns to Bob Dole's assault on Hollywood, from rap music to the struggle over urban and suburban space, a turf battle over symbolic and material territory is under way. The politics of resentment is on the way.

A fundamental issue posed by this theory of identity formation, as it was a fundamental issue for Nietzsche, is the challenge to define identity in ways other than through the strategy of negation of the other. This, we wish to suggest, is the fundamental challenge of multiculturalism: the challenge of 'living in a world of difference' (Mercer, 1992). Resentment and racial reaction, therefore, define contemporary encounters between individuals and groups as expressed in the extent to which there has been an infiltration of a culture war over signs and identity in the practices of everyday life.

Education is a critical site of struggles over the organization and concentration of emotional and political investment and moral affiliation. The popular has invaded the schools. This battle over signs that is resentment involves strategies of articulation and rearticulation of symbols in the popular culture and in the media. These signs and symbols are used in the making of identity and the definition of social and political projects. Within this framework, the traditional poles of left versus right are increasingly being displaced by more mutable and destabilizing models of affiliation and association. A further dimension of this dynamic is that the central issues that made this binary opposition of race and class conflict intelligible and coherent in the past have now collapsed or have been recoded. The central issues of social and economic inequality that defined the line of social conflict between left and right during the civil rights era are in the post-civil rights era, inhabited by the new adversarial discourses of resentment. Oppositional discourses of identity, history and popular memory, nation, family, the deficit and crime have complicated or displaced issues concerning equality and justice. In this new phase of racial antagonism, resentment operates through processes of simulation or the constant fabrication of racial distinctions, fields of affiliation, fields of exclusion. Discourses of resentment create the pure space of the folk, the pure space of origins, the pure space of the other who is so different from 'us'.

To explore the resentment discourse of crime, violence and suburban security in greater detail, we need to get beyond abstractions and look at popular culture more closely. In the next section, we will discuss examples from television evening news, film and popular news magazines that show the variability, ambiguity and contradiction in this discourse of conflict. We will see, for example, that signifiers of the inner city as the harbinger of violence, danger and chaos loop into the mass media and the suburbs and Hollywood and back again in the constructions of both mainstream and new wave directors of the 'reality' of the 'hood – then, to the black and Latino youth audience constructed as other to itself.

'Reflecting reality' and feeding resentment

Too often, Black artists focus on death and destruction arguing that it is what's out there so we got to show it! Please!! What needs to be shown is the diversity and complexity of African-American life.

(*The Syracuse Constitution*, 1993: 5)

The logic of resentment discourse does not proceed along a straight line in a communication system of encoding/decoding. It does not work one-way from text to audience. Its tentacles are more diffuse, more rhizomatic, deeply intertextual. Resentment processes work from white to black and black to white, from white to Asian and Asian to white, and so on, looping in and out and back again across the striated bodies of the inhabitants of the inner city. The inner city is thereby reduced to an endless chain of recyclable signifiers that both allure and repel the suburban classes. The inner city is constantly prodded for signifiers of libidinal pleasure and danger.

But there is also the shared ground of discourses of the authentic inner city in which the languages of resentment and the reality of the 'hood co-mingle in films of black realism by black directors such as John Singleton and the Hughes brothers and the Latino realism of Latino director/actor Edward James Olmos. It is a point that Joe Wood (1993) makes somewhat obliquely in his discussion of the film *Boyz 'N the 'Hood* (1992), which is set, incidentally, in South Central Los Angeles. (The film features the coming of age of a black youth, Tre, in a world of temptations: of drugs, fast cars and teenage sexual promiscuity. Tre makes good in a neighbourhood of home boys who, invariably, end up on the wrong side of the law.) In an article published in the *Esquire* magazine entitled 'John Singleton and the impossible greenback bind of the assimilated black artist', Wood notes the following:

> *Boyz's* simplified quality is okay with much of America. It is certain that many whites, including Sony executives and those white critics who lauded the film deliriously, imagine black life in narrow ways. They don't want to wrestle with the true witness; it might be scarier than 'hell.' Sony Pictures' initial reaction to *Boyz* is instructive: John confides that the studio wanted him to cut out the scene in which the cops harass the protagonist and his father. 'Why do we have to be so hard on the police?' they asked. An answer came when Rodney King was beaten; the scene stayed in – it was suddenly 'real.'
>
> (1993: 64)

Here we see how evening television helps to both activate and stabilize the elements of repeatability, the simulation of the familiar and the prioritization of public common sense. Hollywood draws intertextually on the reality code of television. Television commodifies and beautifies the images of violence captured on a street-wise camera.

Singleton's claim to authenticity, ironically, relied not on endogenous inner-city perceptions, but exogenously on the overdetermined mirror of dominant televisual news. *Boyz 'N the 'Hood* could safely skim off the images of the inner city that television common sense corroborated. For these Hollywood executives, police brutality became real when the Rodney King beating made the evening news. As Wood argues:

> What Sony desired in *Boyz* was a film more akin to pornography . . . a safely voyeuristic film that delivered nothing that they did not already

believe. . . . But how strenuously will they resist his [Singleton's] showing how Beverly Hills' residents profit from South Central gangbanging, how big a role TV plays in the South Central culture.

(1993: 65)

Of course, what even Joe Wood's critical article ignores about a film like *Boyz 'N the 'Hood* is its own errant nostalgia for a world in which blacks are centred and stand together against the forces of oppression – a world in which black men hold and practise a fully elaborated and undisputed paternity with respect to their children – a world that radically erases the fact that the location of the new realist black drama, Los Angeles, South Central, the memories of Watts, etc. are now supplanted by an immigrant and a migrant presence in which, in many instances, black people are outnumbered by Latinos and Asians.

For instance, Latinos make up about 39 per cent of the city's population and blacks 13 per cent; Latinos slightly outnumber blacks in South Los Angeles (Lieberman, 1992). The Asian population is smaller than the black population; however, Asians are highly visible as small business entrepreneurs in the inner city. The complex racial ecology of the 'hood was apparent during the 1992 Los Angeles riots. According to a RAND Corporation study of 5633 adults arrested during the peak days of the riots, 51 per cent were Latino, mostly young men aged between 18–24. By contrast, only 36 per cent of those arrested were black (Lieberman, 1992). Furthermore, approximately 40 per cent of the businesses destroyed were owned by Latinos (Davis, 1992), although Korean businesses were the most targeted, partly in revenge for the murder of 15-year-old Latasha Harlins by a Korean grocer, and partly as a signal to build more black-owned businesses in the predominantly black neighbourhoods of South LA.

Like the Hollywood film industry, the mainstream news media's gaze upon black and brown America directs its address towards the suburban white middle class. It is the gaze of resentment in which aspect is separated from matter and substance undermined by the raid of the harsh surfaces and neon lights of inner-city life. In the sensationalistic evening news programmes of CBS, NBC, ABC and CNN, black and Latino youth appear metonymically in the discourse of problems: 'kids of violence', 'kids of welfare mums', 'kids without fathers', 'kids of illegals', 'kids who don't speak "American"'. The overwhelming metaphor of crime and violence saturates the dominant gaze on the inner city. News reports imply that only poor black and Latino inner-city residents use cocaine, not rich suburban whites who are actually the largest consumers of the drug.

On any given day that Jesse Jackson might give a speech on the need for worker solidarity or Congresswoman Maxine Waters on the budget, the news media are likely to pass over these events for the more juicy images of inner-city crime and mayhem. This selection of images has become the reality of urban America (Anderson, 1994). The inner city is sold both as a symbolic commodity and a fetish – a signifier of danger and the unknown that at the same time narrows the complexity of urban working-class life.

You watch network evening news and you can predict when black and brown bodies will enter and when they will exit. These bodies become semiotic cargo caught in the endless loop of the electronic media apparatus. The process is one of transubstantiation; so many black and brown bodies ransacked for the luminous images of the subnormal, the bestial, 'the crack kids', 'the welfare brigade'. The mass media's story of inner-city people of colour has little to do with an account about the denial of social services, poor public schools, chronic unemployment, and the radical disinvestment in the cities – all of which can ultimately be linked to government neglect and deprioritization as middle-class issues of law and order, more jail space and capital punishment usurp the Clinton administration's gaze on the inner city. Instead, the inner city exists as a problem in itself, and a problem to the world. The reality of the inner city is therefore not an endogenous discourse. It is an exogenous one. It is a discourse of resentment refracted back on to the inner city itself.

It is deeply ironic, then, that the images of the inner city produced by the current new wave black cinema corroborate rather than critique mainstream mass media. Insisting on a kind of documentary accuracy and a privileged access to the inner city, these directors construct a reality code of 'being there' very much in synch with the controversial gangster rappers. But black film directors have no a priori purchase on the inner city. These vendors of chic realism recycle a reality code already in the mass media. This reality code operates as a system of repeatability, the elimination of traces, the elaboration of a hierarchy of discourses – the consolidation of the familiar.

Menace II Society (1993), created and directed by Allen and Albert Hughes, places the capstone on a genre that mythologizes and beautifies the violent elements of urban life while jettisoning complexities of gender, ethnicity, sexuality, age and economy. Instead of being didactic, like *Boyz 'N the 'Hood*, the film is nihilistic. Its central character, Caine Lawson (Tyrin Turner), is doomed to the drug-running, car-stealing and meaningless violence that claim young men like himself (and before him, his father) from the time they can walk and talk. It is a world in which a trip to the neighbourhood grocery can end in death and destruction, one in which gang-bangers demand and enforce respect at the point of a gun. This point is made at the very beginning of the film when Caine and his trigger-happy buddy, O-Dog (Larenz Tate), feel disrespected by a Korean store owner. The young men had come to the grocery to buy a beer but are provoked into a stand-off when the store owner hovers too close to them. The young men feel insulted because the Korean grocer makes it obvious that he views them with suspicion. In a twinkling of an eye, O-Dog settles the score with a bout of unforgettable violence, leaving the store owner and his wife dead. One act of violence simply precipitates another. By the end of the film, Caine, too, dies in a hail of bullets – payback by the gang of a young man whom Caine had beaten up mercilessly. This film sizzles with a special kind of surface realism. There is a lot of blood and gore in the 'hood in *Menace II Society*, and the camera shots consist, for the most part, of long takes of

beatings or shootings. These camera shots are almost always close up and in-your-face. Caine's life is supposed to be a character sketch of the inevitability of early death for inner-city male youth reared in a culture of violence. We have already seen it on television evening news before it hits the big screen. Black film-makers therefore become pseudo-normative bards to a mass audience who, like the Greek chorus, already know the refrain.

These are not problem-solving films. These are films of confirmation, of black survival by any means necessary. The reality code – the code of the 'hood, the code of blackness, the code of Africanness, the code of hardness – has a normative social basis. It combines and recombines with suburban middle-class discourses about such topics as the deficit, taxes, overbearing and overreaching government programmes, welfare and quota queens and the need for more prisons. It is a code steeped in public common sense. The gangster film has become paradigmatic for black filmic production out of Hollywood. And it is fascinating to see current films like Singleton's *Higher Learning* (1995) glibly redraw the spatial lines of demarcation of the inner city and the suburbs on to a university town; *Higher Learning* is *Boys 'N in the 'Hood* on campus.

It is to be remembered that early in his career, before *Jungle Fever* (1991), Spike Lee was berated by mainstream white critics for not presenting the inner city realistically enough – for not showing the drug use and the violence. Lee obliged with a vengeance in *Jungle Fever* in the harrowing scenes of the drug addict, Vivian (Halle Berry), shooting it up in the 'Taj Mahal' crack joint and the Good Doctor Reverend Purify (Ossie Davis) pumping a bullet into his son at point-blank range (Kroll, 1991: 44–7).

While Latinos living in the inner city experience an economic and social marginality as severe as that experienced by African-Americans, representations of Latino inner-city experiences rarely make it to the big screen. Despite the numerical presence of Latinos in the cities (especially in LA, the home of Hollywood), Latino directors have not experienced the triumphs of the John Singletons and Spike Lees.[1] However, one Latino director and actor has managed to break in to make a film centred on the Latino 'hood experience. In *American Me* (1992), Edward James Olmos directs and stars in a film about Chicano LA gang life that spans the generations – from the Pachucos (Zootsuiters) of the 1940s to *La eMe* (the 'M', Chicano Mafia) of the 1960s and 1970s – and which moves back and forth between the 'hood out in the street and the carceral 'hood behind prison bars. In the carceral 'hood, gang warfare and violence are even more brutal than outside. The lifeline between the street and prison gangbangers is strong. Each needs the other for survival (and for drug-running).

American Me is based on a true story about three friends: Cheyenne, a Chicano gang leader who died in prison in 1972, J.D., the white 'Chicano brother', and Santana, the Chicano leader of *La eMe*. The film tells a story about how *la klika* (the gang) – the surrogate Chicano family – is an integral force in both the survival and dissolution of Chicano communities in East LA. In her critique of *American Me*, Rosa Linda Fregoso argues that 'the

film is about the depraved and ruined Chicano *familia*: a savage vision of Chicano gang life' (Fregoso, 1993: 123). The survival and strength of *la klika*, for both male and female members, is more precious than life itself. *La klika* is one of the only signifiers of Chicano selfhood. In this Chicano story of the reality of the 'hood, Olmos's film does vary the range of racial encounter between dominant and subordinate racial groups. Unlike *Boyz 'N the 'Hood*, for instance, resentment is not simply a black–white dynamic. Rather, it is one where at times Chicano prisoners ally with Aryan Nationalist prisoners to avenge an attack against them; where drugs bond across 'ethnic' brotherhoods; where a white homeboy is every bit as Chicano as his *klika* brother, and where, every so often, Chicanos must kill one of their own to show strength and save face. Gang life and the life of the inner city are not glorified, aspired to, or seen as a sign of exemplary nationalism. *American Me* moves in a somewhat different pseudo-normative direction. The drug-infested inner city is a sign of something gone wrong and in need of repair. What must be done, the film suggests, is to leave the family of the gang and return to the family of the home and ethnic community where love and affirmation abound. The aspiration is not, then, to flee to the border suburbs, but, rather, to evaluate the new traditions – gangbanging, drugs, violence and the like – that have led their inner-city world on a non-stop roller-coaster ride to nowhere.

By the time we get around to white-produced films like *Falling Down* (1993) directed by Joel Schumaker, the discourse of crime, violence and suburban security has come full circle to justify suburban revenge and resentment. We now have a white man who enters the 'hood to settle moral scores with anything and anyone that moves. Michael Douglas as the angst-ridden protagonist, D-fens, is completely agnostic to the differences within and among indigenous and immigrant inner-city groups. They should all be exterminated as far as he is concerned – along, of course, with his ex-wife who won't let him see his young daughter. D-fens is the prosecuting agent of resentment. His reality code embraces Latinos who are portrayed as gangbangers and Asian store owners who are represented as compulsively unscrupulous. In a scorching parody of gang culture, he becomes a one-man gang – a menace to society. In a calculated cinematic twist, the world of D-fens is characterized by a wider range of difference than the worlds of the films of black realism. However, ironically in this world, blacks are for the most part mysteriously absent from Los Angeles. On this matter of the representation of the 'real' inner city, the question is, as Aretha Franklin says, 'Who is zooming who?'

What is fascinating about a film like *Falling Down* is that it is centred around an out of control, anomic individual who is 'out there'. Armed with more socio-normative fire power than any gangbanger could ever muster, D-fens is ready to explode at the seams as everyday provocations make him seethe to boiling point. We learn, for instance, that he is a disgruntled laid-off white-collar technician who worked for many years at a military plant. Displaced as a result of the changing economy of the new world order and the proliferation of different peoples who are flooding Los Angeles in pursuit of the increasingly elusive American dream, D-fens is the kind of

individual we are encouraged to believe a displaced middle-class person might become. As Joel Schumacher, the film director, explains:

> It's the kind of story you see on the six o'clock news, about the nice guy who has worked at the post office for twenty years and then one day guns down his co-workers and kills his family. It's terrifying because there's the sense that someone in the human tribe went over the wall. It could happen to us.
>
> (Morgan, 1993: 46)

D-fens is a Rambo nerd, a Perot disciple caught in a sort of yup-draft. *Newsweek* magazine, that preternatural barometer of suburban intelligence, tells us that D-fens is the agent of a suburban resentment, depicting him as a tragic social critic somewhat overtaken by events:

> *Falling Down*, whether it's really a message movie or just a cop film with trendy trimmings, pushes white men's buttons. The annoyances and menaces that drive D-fens bonkers – whining panhandlers, immigrant shopkeepers who don't trouble themselves to speak good English, gun-toting gangbangers – are a cross-section of white-guy grievances. From the get-go, the film pits Douglas – the picture of obsolescent rectitude with his white shirt, tie, specs and astronaut haircut – against a rainbow coalition of Angelenos. It's a cartoon vision of the beleaguered white male in multicultural America. This is a weird moment to be a white man.
>
> (Gates, 1993: 48)

D-fens's reactions are based on his own misfortunes and anger over the disempowerment of the white middle class. Despite his similarities with the neo-Nazi, homophobic army surplus store owner in the film, they are not the same. Unlike the neo-Nazi, D-fens reacts to injustices which he perceives have been perpetrated against him. He is the post-civil rights scourge of affirmative action and reverse discrimination.

In *Falling Down*, Hollywood unleashes the final punctuation marks on a discursive system that is refracted from the mainstream electronic media and press on to the everyday life of the urban centres. Unlike D-fens in *Falling Down*, the central protagonist in *Menace II Society*, Caine, has nothing to live for, no redeeming values to vindicate. He is pre-existentialist – a man cut adrift in and by nature. What a film like *Menace II Society* does share with *Falling Down* is a general subordination of the interests and desires of women and a pervasive sense that life in the urban centre is a self-made hell. Resentment has now travelled the whole way along a fully reversible signifying chain as white, black and brown film-makers make their long march along the royal road to a dubious Aristotelian mimesis in the declaration of a final truth. The reality of being black and brown and inner city in America is sutured up in the popular culture. The inner city has no interior. It is a holy shrine to dead black and brown bodies – hyper-real carcasses on arbitrary display.

In these films the directors may be different colours and ethnicities, but the main characters are all the same – tough males. An understated but nevertheless significant process of resentment flows from men to women. In this world constructed by male film-makers, the identities of men are formed out of the ascribed negative or inferior attributes of women: 'It's a boyz' world they sculpt ingeniously with gunfire and gutter talk, in which the worst insult to a man is to call him a bitch' (Dowell, 1993: 30). From *Boyz 'N the 'Hood* to *Falling Down*, women are portrayed as nurturers, victims, virgins, drug addicts, beacons of hope and havens from the violent world of men. In *Boyz 'N the 'Hood*, Tre's mother is one of the few examples of female independence and agency. Yet she still cannot teach Tre to be a man. Thus, she has to give her son over to his father to nurture the boy's masculinity. After giving up her son and furthering her career, she also leaves the 'hood. These events imply two problematic images: first, single mothers cannot properly raise their sons; second, independent, professional women cannot be a part of the inner city. The remainder of the women in the film are either the mothers of sons, mothers of their sons' children or 'bitches'.

In *American Me*, the principal female character, Julie, is the quintessential nurturer, both as lover and as mother figure. Julie offers Santana, the leader of *La eMe*, experiences of which he was robbed as a consequence of being incarcerated since the age of 16. She teaches him how to dance, how to have sex with a woman and how to love. She also opens the door through which he can escape the life of the street. In the end, she changes him, but he is killed before he is fully reborn. The power of the woman loses to the power of *la klika*. Olmos claims that Julie is the heroine of the movie, the hope of the barrio. But Fregoso disagrees. She argues that this claim is suspect:

> Something about this flickering lantern that we are expected to hold up at the end of the tunnel, about this burden bequeathed by Olmos to all Chicanas, makes me suspicious. Just as in the 'real world,' Chicanas in *American Me* carry more than their share of responsibility for a man: first as the origins of Santana's deviance, and second as vehicles for his salvation. This is a very old story indeed.
>
> (Fregoso, 1993: 133)

The other major female character in Olmos's film is Santana's mother. What stands out most about her character is that she is a victim – raped by a gang of white sailors when she was a young pachuca. This violent act resulted in the birth of Santana. She is portrayed as *la Chingada* – the raped Malintzin Tenepal who many blame for the downfall of the Aztec nation, the Mexican inferiority complex and the creation of the *mestizo* (Fregoso, 1993: 132; Huaco-Nuzum, 1993: 94).

Ronnie, the main female protagonist in *Menace II Society*, is also the symbol of emotional security and motherhood – the sanctuary amidst the storm. As Pat Dowell says in 'Girlz n the hood', Ronnie 'functions not so

much as a character, but as the alternative to blood on the pavement' (1993: 30). She may have the power to nurture, but she does not have the power to save a black male from his inevitable demise. Caine, her lover, is killed in a hail of gunfire just as he and Ronnie are preparing to leave the 'hood.

Finally, the women portrayed in *Falling Down* span the gamut of popularly rehashed images of women. From the frustrated young Latina cop, Sandra, who searches for love in the white male world of the police precinct to D-fens's helpless ex-wife, Elizabeth, who runs away from her crazed ex-husband, women are viewed as defenceless, weak, crazy and helplessly romantic. Elizabeth fails to convince the police that her life is in danger – that D-fens is stalking her and her daughter. And Sandra fails to convince officer Prendergast to leave his pathetic wife for her. Neither woman is able to positively affect her life. Both women are at the whim of the men who encircle them.

Most of the women in these films are marked either as mothers or as bitches. Resentment functions negatively and positively. Yet, the positive identification of mother is not wholly positive, because the symbol of mother is circumscribed by dependency on men and sacrifice to sons – images that can be perceived as negative. This is not to say that dependency and self-sacrifice are always undesirable, but that they are negative in the sense that men are not similarly inscribed. The image of the bitch, on the other hand, has no positive moral force. It is a label ascribed to all women, except mothers. In the backdrops painted by many black film-makers, 'bitch' is the most often used noun of young inner-city men. Again, these film-makers, like the gangster rappers, argue that they are only projecting what they hear in the 'hood. Little attempt is made to problematize or critique this supposed reality. The agency of women is circumscribed through the lens of men who view women as nothing more than a plaything, a mother of their children, their mother, or their metaphoric castrator (the 'bitch', the 'man hater', the 'dyke').

Resentment effects

As the portrayals of the inner city in these films illustrate, the discourse of resentment not only has powerful rhetoric but it also has material effects. Such are the consequences for minority youth of the highly masculinized and pejorative views of the inner city underwritten in American popular and establishment cultures. Bushwhacked by the politics of 'the' deficit, the Perot brigade and their themes of crime, violence and suburban security, the democratic administration in Washington, which earlier on declared its commitment to change and a new dispensation for the cities, has rapidly sought to centre its policies towards the inner city on the agenda of the suburbs. The centrepiece of Clinton's plan for the inner city, according to a *Time* magazine article, is 'Laying down the law' (Gibbs, 1993: 23).

Inner-city school youth are surrounded by this powerful discourse of crime, violence and suburban security in which they are the constructed

other – social objects who grapple with the reality code projected from the popular media culture.[2] But their experience of the reality code is grounded in material practices such as police harassment. Black and brown youth experience the reality code as a problem of representation. The reality code is translated in the discourse of resentment. Democracy asserts its tragic limits in the urban centre. Unlike the cause-and-effect theories of the film culture, police harassment reported by high school kids in the Los Angeles school system seems random and vicious.

A good example of the material consequences and challenges of representations for minority youth is provided in the stories told by inner-city adolescents at Liberty High School in Los Angeles. Liberty High is itself an extension of the long arm of the state: The LA Unified Public School system has its own police force. Cameron McCarthy conducted an ethnographic study in this inner-city high school about six months before the Rodney King beating. This research was conducted in the summer of 1990. It involved an evaluation of Teach For America's Summer Institute pre-service teacher internship programme for its 'corps members'.[3] The following excerpt gives a sense of the students' experience with the unyieldingly negative representations of black and Latino male youth generated in the popular media. A switch point of this field of representation is their encounter with the police. The excerpt is taken from McCarthy's field notes.

We report on a class that was taught by a Teach For America intern, Christopher Morrison. Morrison is a white male who was about 22 years old at the time of the study. He hails from the South and has had some military training. His assignment to do a four-week teaching stint in Liberty High School was his first 'exposure' to an inner-city school. Christopher Morrison's cooperating teacher was a black female, Ruby Marshall, who was in her sixties and anticipating retirement. Of the seventeen students who were in Morrison's classroom, fifteen were African-American and two were Latino. This classroom under discussion was taken over by accounts of police violence. Morrison had introduced the topic of police harassment in response to some queries made by one of his students, Rinaldo, the previous day. But in the torrent of accounts offered by students, Morrison and Marshall lost control of the class. In effect the classroom became a site for a therapeutic release – a show-and-tell on harassment and the 'image problem' that black and brown male youth had with the Los Angeles police. Students detailed acts of police harassment that left them disoriented about their own sense of self and identity. One student reported that he had been stopped by the cops and searched for a gun. But in his words 'the cops had no probable reason'. Another reported that he was arbitrarily beaten up for, in his view, walking on the wrong street at the wrong time of night. One girl in the class told of friends whose houses, as she said, 'was bust into'. Many talked of intimidating stares and glares and threatening behaviour on the part of the police. The cops also participate in their language of gang-banging – keeping the peace with shiny guns and lots of leather.

Meanwhile, in this Los Angeles high school classroom, the diffusion of images of the police and the problematic relationship of some kids to the

law opened up deep wounds of adolescent insecurity and identity crisis among these inner-city, particularly black male and Latino, school youth. Students were looking for solutions to problems about self-representation, and their teachers did not seem to have any easy answers. The students were concerned about how to represent themselves in ways that might help them to maintain their sense of adolescent freedom and individual rights and yet avoid the full-court press of the cops. These adults – Christopher Morrison and Ruby Marshall – gave replies to their students and made observations about police harassment that were steeped in the common sense of the reality code – the code of mimesis, the code of resentment. Here are Ruby Marshall's comments on the students' reports of police harassment:

> I say if you walk like a duck and you hang out with ducks, then you are a duck. I believe that some of the things they [the police] do are not right. But you guys sometimes walk around without any books like the rest of the guys on the street. If you do that, they [the cops] will pull you over. . . . [Here, Ruby Marshall was speaking out of a sense of concern, even a sense of fear, about her students' confrontations with cops. Maybe, as a black woman, she felt especially responsible for telling these students about strategies of representation that might allow them to survive encounters with the police. She continued] One day I saw them [some police officers]. They had this guy spread eagle against the car. And they were really harassing him. You should not hang out with these guys. . . . Don't hang out with the Bloods, or the Crips, or the Tigers! . . . When a group of you guys are hanging out together that gives them cause for concern. You don't even carry books. You need to be as non-threatening as possible.

To the latter remark, one student replied: 'You mean to say that if I am going around with my friends at night I need to haul along a big old bunch of books over my shoulder?'

Some of the responses of the white student teacher, Christopher Morrison, conveyed a sense of ambivalence – great sympathy for the adolescent students as they reported examples of police harassment, but also a sense that the police had to rely on 'images', that they had to enforce the law, and that school youth had to exercise restraint and respect if they wished to be treated respectfully themselves. To the students' questions about free speech and freedom of movement, Morrison pointed them in the direction of the reality code where actions had real consequences: wrong was repaid by retributive sanctions, and personal errors of judgement – associating with the wrong crowd and being in the wrong place at the wrong time – were actions for which one had to accept responsibility. Just as ordinary adult citizens had to accept the consequences of their actions, adolescents who challenge the law ought to be aware of the wrath of the law. Here follows an excerpt from a testy but revealing exchange between Morrison and his black students on the topic of the aggressive actions by the police: 'Let me tell you a story about myself,' he began. ' Maybe this will help. Once I had some friends. They were hanging out on the college campus. But they did not look

like college students. They were white, but they had long hair.' A number of students interjected, 'You mean like a hippie.' 'Like a hippie,' Morrison said. Then he continued with his story:

They arrested these guys. You have to understand that the police go on images. They rely on images. They need categories to put people in so that they can do their work. And sometimes these categories are right. And if you, Morgan, had a gun [addressing the student who said the cops stopped and searched him for weapons] then you gave them probable cause. You fitted into one of their categories.

Morgan seemed utterly dismayed: 'It wasn't the gun. They were just riding through the hood. If I had given them any trouble they would have sweated me.' Morrison disagreed with this assessment of danger: 'I don't think they would do that to you. You can complain if you feel that your rights have been abused. Look, people are being blown away at a faster rate than ever in this country. Just don't give them cause. If you got something [a gun] on you, then that is giving them cause.'

On the matter of police harassment, the teachers, as representatives of the middle class, moved swiftly towards points of ideological closure. Their students – young and black and Latino and in trouble with the law – passed their adult mentors like ships in the night. The students wanted the discourse opened up in ways that would allow their voices to be heard. But the Los Angeles classroom seemed more like a court of appeal in which the students appeared to lose the battle for control over their public identities and self-representation.[4] The process of resentment had insinuated itself into the lives of the students. Black and Latino students had to contend with the burden of an always already existent complex of representations that constructs them as outsiders to the Law. The inner-city classroom, like the inner-city streets, in the language of Thomas Dunn (1993), has become an ' enclosure' for the containment of the mobility of black and brown youth. The border line between the suburbs and the traumatized inner city is drawn in public schools like Liberty High. And teachers like Ruby Marshall and Christopher Morrison stand guard on the front lines – agents of resentment guarding the border zone erected to protect suburban interests.

Conclusion

In many respects, then, the resentment discourse of crime, violence and suburban security that now saturates American popular culture indicates the inflated presence of the suburban priorities and anxieties in the popular imagination and in political life.[5] It also indicates a corresponding lack of control that blacks and Latinos (particularly black and Latino youth) and other people of colour have over the production of images about themselves in society – even in an era of the resurgence of the black Hollywood film and the embryonic Latino cinema. The discourse of crime, violence and suburban security also points to deeper realities of abandonment, neglect and social contempt for dwellers in America's urban centres which are now

registered in social policies that continue to see the inner city as the inflammable territory of ' the enemy within' and the police as the mercenary force of suburban middle classes. In these matters, 'all of us are involved, all of us are consumed', to use the language of the Guyanese poet, Martin Carter (1979: 44).

With the politics of resentment now widely diffused throughout society, we have entered a whole new phase in race relations in education and society. These relations are propelled by the processes of simulation built into historically specific resentment discourses such as crime, violence and suburban security. Of course, it should be noted that both majority and minority groups use resentment discourses. Eurocentrism and Afrocentrism are two such discourses that thrive on the negation of the other. Proponents of these two world views attempt to reify moral centres, in opposition to supposed peripheries, not realizing that these moral centres are simulations of reality. In the popular film and television culture both these discourses have been refracted on to the inner city with a vengeance. In this period of 'the post', there are no innocent or originary identities (Bhabha, 1994). With the politics of resentment, we are descending the slippery slopes of the war over signs. The traditional divisions of left versus right no longer hold. As Baudrillard (1983) argues, opposition becomes only a hypersimulation of opposition. Collusion of supposed extremes is the more common result. The battle lines over signs are now being drawn down in and around predictable constituencies, and whole new categories of association of affect enter the fray. The war over signs and symbols pits respectable suburban society against the amoral inner city; the nuclear-family residents of the sterilized PMC environments against the urban children without fathers. It pits supporters of academic freedom against the politically correct; a field of affect in which we see Marxists such as Eugene Genovese form a blood pact with slick proto-capitalist Third World immigrants like Dinesh D'Souza. Together they harangue embattled indigenous First World minorities. So much for the conservative wing of the travelling theorists.

Resentment is therefore negative and positive, decentring and recentring. While the inner city flounders under the weight of government disinvestment and the scarcity of jobs and services, old and new patriotic and fundamentalist groups led by Rambo, Ross Perot, the NRA and Teach For America sing Rush Limbaugh's refrain: 'We must take back America.' Resentment themes may pit the organicists against the polluters or Bill Clinton, Rush Limbaugh, Tipper Gore, Bob Dole and the cops against the hip hoppers. The battle over moral leadership, as Nietzsche once noted, is 'drenched in blood'. In a time of the fear of falling, the suburban middle-class subject stabilizes itself by dressing in the garb of 'the oppressed' – people whose fortunes have been slipping despite their moral steadfastness. It is the middle class that feels increasingly surrounded by the other, its public space overrun by the homeless, its Toyotas and BMWs hijacked by the amoral underclass.

But as those who deploy resentment have shown, affect is a highly contradictory field of conversion, mobilizing unpredictable constituencies. A

case in point is the type of alliances and disarticulations reflected in the public responses to the New York City *Children of the Rainbow Curriculum Guide: The First Grade* (NYCCSB, 1991). The New York City Central School Board's attempts to develop multicultural curricula that address gay and lesbian identities precipitated alliances among the religious communities historically associated with the civil rights movement, white conservatives, many of whom are members of the Christian Coalition (Moral Majority), and religious Latinos. The controversy that ensued illustrated that homophobia cuts across many identity groups and that one's experience of oppression and marginalization does not necessarily lead to empathy for those similarly oppressed.

But how do we get beyond the cruel and destructive articulations of resentment and the rigidities of privileged experiences, privileged epistemologies and the like? Our task must be to try and think our way out of the paradox of identity and the other, the paradox of oppressor and oppressed. First, we must affirm and demonstrate that affective statements, sensibilities and projects can be inclusive and expansive and can articulate and rearticulate individuals and groups into broader coalitions and communities of interdependence and resistance. Such a framework should lead, for instance, to a problematizing of the exorbitant discourses of crime and violence and the reality of the 'hood. It would mean that we put a wider range of interests, needs and desires into the public discourse about the inner city; that would include issues of education, jobs, health care, child care and so on. It would also mean a recognition of a wider range of realities and groups in the inner city than are currently in play in the suburban mythologies of the mainstream media and the constricted discourse of 'the' 'hood in some forms of black and Latino filmic realism. There are girls as well as boys in the 'hood, gays as well as straights, love as well as war, agency and momentum as well as defeat and setback.

A few films have constructed just such a complex map of inner-city life, but they have not received the exposure of the new wave black male films. *Just Another Girl on the I.R.T.* (1993), directed by Leslie Harris, is about how the pressures of the 'hood affect a teenage girl and potentially stifle her dreams. Against such odds, Chantel, the female protagonist, manages to give birth to a baby *and* go to college, while her boyfriend takes care of household responsibilities – an alternative to the traditional representations of teenage fathers. *Zebrahead* (1992) by Anthony Drazan, is a story of how an interracial relationship in a Detroit high school leads to violence, but also to hope and a chance to challenge stifling social norms. *Strapped* (1993), an HBO original movie directed by Forrest Whitaker, explores how guns ruin the lives of inner-city residents every day with abandon and without reason. And *Straight Out of Brooklyn* (1991), produced and directed by Matty Rich, is a story about the despair of young blacks in the inner city and the shattered dreams of the people in their community. The moral messages of both *Strapped* and *Straight Out of Brooklyn* are that despair is destructive and that the solutions to despair and senseless violence are complex.

Unlike the popular black realist cinema, these four films dispense with the now commonplace glorification of crime, violence and the drug lore of the inner city. Yet these films are not immune to Hollywood typecasting. For instance, most portray only a circumscribed sector of the inner city; namely, low-income residents who are in crisis. There are precious few stories about the everyday struggles and small victories of the people who live in American inner cities. Nevertheless, these alternative films critique mainstream constructions of resentment and open paths for change and positive identity formation.

Those of us who are privileged but in some ways condemned to look at the world as perpetual voyeurs – Sweeneys of the sightless eyes warming in the glow of our ethereal hearths – cannot forever retreat from this multicultural world of difference. We are part of a world of difference in which our needs and interests must be problematized and our sense of identity and community challenged. Chela Sandoval (1991), in her essay 'U.S. third world feminisms: the theory and method of oppositional consciousness in the postmodern world', challenges us in precisely this way. She effectively replaces suburban resentment metaphors of space and identity with what she calls the trope of 'differential consciousness'. By this she means, in part, that progressive actors must be willing to recognize the mobility of a wide array of interests, needs and desires within the body of subaltern constituencies. As artists, as intellectuals, as cultural actors and as members of embattled social groups, we must find the will to affirm the new communities struggling for representation, even in our midst. For some of us, this might be our first steps beyond the prison house of the academy and the paralysis of educational suburbia.

Notes

1 In fact, *American Me* – Olmos's directorial debut – did not make a profit while the first feature films of African-American directors, like John Singleton (*Boyz 'N the Hood*) and Mario Van Peebles (*New Jack City*), made significant profits (Fregoso, 1993; Jones, 1992).

2 For excellent and contrasting views of the representation of inner-city youth in contemporary film see Dyson (1994) and Giroux (1994b).

3 Teach For America is the much talked-about voluntaristic youth organization that has sought to make a 'difference' in the educational experiences of disadvantaged American youth. The organization, modelled on the can-do humanism of the Peace Corps, recruits graduates from elite universities and colleges around the country to serve a two-year stint in the inner city and rural school districts in need. At its Annual Summer Institute held at the University of South California, corps members or teacher recruits are exposed to an eight-week crash course in teaching methods and classroom management. Four of these weeks are spent in the form of an internship in Los Angeles inner-city schools such as Liberty High.

4 We should note here that these concerns over representation and identity are not limited to minority youth. Like the students of Liberty High, adult residents of the inner city fight for control over and offer critical reflections on the

representations of people of colour produced in the media. For example, the community-based small newspaper, *The Syracuse Constitution*, used some of its column space to denounce *Menace II Society* and the current wave of films of inner-city realism:

> In the midst of the cheering accolades and praises for the movie *Menace II Society*, lies an even more sinister and controversial subject that needs to be addressed – the devaluation of Black life under the camouflage of entertainment fed to an unsuspecting and unconscious Black Public anxious to see themselves on the big screen. At stake is the image of an entire community seeking to speak its own special truth to a world gone mad in the throes of a Eurocentric propaganda war which vulgarizes Black life by unwitting and non-thinking black folk masquerading as social critics/film makers. These social film critics argue that they are 'doing the right thang' by perpetuating hopelessness and glamorizing gangsters as the epitome of Black life.
>
> (*The Syracuse Constitution*, 1993: 5)

What this quotation indicates is the deep anxiety that resides within urban communities themselves about the filmic realism that reduces and, in the end, dehumanizes their lived existence.
5 For a fascinating discussion of the prioritization of middle-class interests in the debate over crime and gun violence, see Josh Sugarman and Kristen Rand (1994: 30–43).

References

Anderson, E. (1994) 'The code of the streets',*The Atlantic Monthly*, May: 80-94.
Baudrilliard, J. (1983) *Simulations*, New York: Semiotext(e).
Beatty, J. (1994) 'Who speaks for the middle class', *The Atlantic Monthly*, May: 65–78.
Bennett, W. (1994) *The Book of Virtues,*. New York: Simon & Schuster.
Bhabha, H. (1994) *The Location of Culture*, New York: Routledge.
Buchanan, P. (1992) 'We stand with President Bush', C-SpanTranscripts (eds), *1992 Republican National Convention*, Lincolnshire, Illinois: Tape Writer:6–9.
Carter, M. (1979) 'You are involved', *Poems of Resistance*, George Town, Guyana: Guyana Printers Ltd: 44.
Dash, J. (1992). *Daughters of the Dust: The Making of an African American Woman's Film*, New York: The New Press.
Davis, M. (1992) 'Urban America sees its future: In L.A. burning all illusions', *Nation* 254(21), 1 June: 743–6.
Dowell, P. (1993) 'Girlz n the hood', *In these times*, 17(19), 9 August: 30–1.
Dunn, T. (1993) 'The new enclosures: racism in the normalized community, in R. Gooding-Williams (ed.), *Reading Rodney King*, New York: Routledge: 178–95.
Dyson, M. (1994) 'The politics of black masculinity and the ghetto in black film', in C. Becker (ed.), *The Subversive Imagination: Artists, Society and Social Responsibility*, New York: Routledge: 154–7.
Fedarko, K. (1993) 'Holidays in hell', *Time*, 23 August: 50–1.
Fiske, J. (1990) *Introduction to Communication Studies*, New York: Routledge.
Foster, H. (1983) *The Anti-Aesthetic*, Seattle: Bay Press.
Fregoso, R.L. (1993) *The Bronze Screen. Chicana and Chicano Film Culture*, Minneapolis: University of Minnesota Press.
Gates, D. (1993) 'White–male paranoia', *Newsweek*, 29 March: 48–53.

Gibbs, N. (1993) 'Laying down the law', *Time*, 23 August: 23–6.

Giroux, H. (1994a) 'Doing cultural studies: youth and the challenge of pedagogy', *Harvard Educational Review*, 64 (3): 278–308.

—— (1994b) 'Cultural studies and the challenge of pedagogy', *Harvard Educational Review*, 64(3): 278–308.

Grossberg, L. (1992) *We Got to Get out of this Place*, New York: Routledge.

hooks, b. (1990) *Yearning: Race, Gender, and Cultural Politics*, Boston: South End Press.

Huaco-Nuzum, C. (1993) 'American me: despair in the barrio', *Jump Cut*, 38: 92–4.

Jameson, F. (1984) 'Postmodernism, or, the cultural logic of late capitalism', *New Left Review*, 146, July–August: 59–82.

Jones, J. (1992) 'The accusatory space', in G. Dent (ed.), *Black Popular Culture*, Seattle: Bay Press: 106–11.

—— (1993) 'The new ghetto aesthetic', *Wide Angle*, 13: 32–43.

Kennedy, L. (1992) 'The body in question', in G. Dent (ed.), *Black Popular Culture*, Seattle: Bay Press: 106–11.

Kroll, J. (1991) Spiking a fever, *Newsweek*, 10 June: 44–7.

Lieberman, P. (1992) '52% of riot arrests were Latino, study says', *L.A. Times*,18 June: B3.

McCarthy, C. and Crichlow, W. (eds) (1993) *Race, Identity, and Representation in Education*, New York: Routledge.

Mercer, K. (1992) '"1968": periodizing postmodern politics and identity', in L. Grossberg, C. Nelson and P. Treichler (eds), *Cultural Studies*, New York: Routledge: 424–49.

Morgan, S. (1993) 'Coastal disturbances', *Mirabella*, March: 46.

New York City Central School Board (NYCCSB) (1991) *Children of the Rainbow Curriculum Guide: The First Grade*, New York: New York City Central School Board.

Nietzsche, F. (1967) *On the Genealogy of Morals*, trans. W. Kaufman, New York: Vintage.

Reed, A. (1992) 'The urban underclass as myth and symbol: the poverty of the discourse about the discourse on poverty', *Radical America*, 24(1): 21–40.

Sandoval, C. (1991) 'U.S. third world feminisms: the theory and method of oppositional consciousness in the postmodern world', *Genders*, 10: 1–24.

Smolowe, J. (1993) Danger in the safety zone, *Time*, 23 August: 29–32.

Solomon, R. (1990) 'Nietzsche, postmodernism, and resentment: a genealogical hypothesis', in C. Koelb (ed.), *Nietzsche as Postmodernist: Essays Pro and Con*, New York: SUNY: 267–94.

Sugarman, J. and Rand, K. (1994) 'Cease fire: a comprehensive strategy to reduce firearms violence', *Rolling Stone*, 10 March: 30–43.

The Syracuse Constitution (1993) 'A menace to society', in *The Syracuse Constitution*, 2 August: 5.

Wallace, M. (1992) '*Boyz N the Hood* and *Jungle Fever*', in G. Dent (ed.), *Black Popular Culture* , Seattle: Bay Press: 123–31.

Wood, J. (1993) 'John Singleton and *the* impossible greenback of the assimilated black artist', *Esquire*, August: 59–108.

SANDHYA SHUKLA

BUILDING DIASPORA AND NATION: THE 1991 'CULTURAL FESTIVAL OF INDIA'

ABSTRACT

This article discusses the production of Indian ethnicity in the United States through a close reading of the Cultural Festival of India, an event that took place over four weeks in 1991 in Edison, New Jersey. The festival, organized by the Gujarati Hindu sect, Bochasanwasi Swaminarayan Sanstha, presented an extravagant and general vision of 'India' for Indian as well as non-Indian Americans through arts performances, shopping displays, food stands and cultural exhibits. The Cultural Festival of India can be seen as an occasion for a new type of 'imagined community', or as an instance of diasporic nationalism, that is, produced by immigrant Indians intent on projecting a positive image of themselves, and is steeped in romantic notions of the home country.

As Indians in First World countries form larger and more visible populations, they begin to develop elaborate strategies for constructing associative identities. In the United States, the Indian middle class has chosen the terminology and the historical precedents of 'ethnicity' to construct itself as a group within the political and cultural landscapes of a 'multicultural' nation. The rapidly expanding Indian capitalist economy simultaneously procures foreign investment through connections maintained with these overseas Indians as well as through a new image projected abroad of India as a source of progress. Nationalism, diaspora, culture and identity become confounded both as theoretical categories and as material forces. The Cultural Festival of India illustrates these developments through the reification of Indian 'culture', the portrayal of idealized Indian social values and the celebration of technological innovation. Through an examination of the festival, the article explains the continuities in colonial and postcolonial strategies of building national and transnational communities.

KEYWORDS

diaspora; nationalism; South Asian Americans; ethnicity

This is indeed India! The land of dreams and romance, . . . of tigers and elephants . . . The country of a hundred nations and a hundred tongues,

cradle of human race, birthplace of human speech, mother of history, grandmother of legends, great grandmother of tradition.

(Mark Twain)

These words appeared on a *New York Times* advertising supplement for the Cultural Festival of India. Without leaving their homes, *New York Times* readers 'toured' India as they flipped through a promotional brochure filled with pictures of waterfalls, tigers and the Himalayas. The legitimacy of this travel in the North American cultural marketplace emerged both from the evocation of the prototypical American Mark Twain and the assemblage of exotic sights presumed to comprise India. The final authentication of this consumption came not from booking a flight to Bombay, but from a voyage to Edison, New Jersey to visit a spectacular exhibition of Indian culture.

From 12 July to 11 August 1991, Bochasanwasi Swaminarayan Sanstha, a Hindu sect with United States headquarters in Queens, New York, sponsored the Cultural Festival of India. The thirty-five million dollar, thirty-day extravaganza featured dance and musical performances, educational workshops, shopping displays and a food bazaar, among other things. Edison, New Jersey, once an industrial working-class town with large white ethnic populations (Italian and Irish), now has a relatively young and significant contingent of middle-class immigrant Indians. As a town with such a rapidly changing racial landscape, Edison served as a symbolic backdrop for a new type of nation-building, or a new process of 'imagining community'. The Cultural Festival of India in Edison lavishly constructed 'India' through implicit dialogues with the ghost immigrant populations and their histories, contemporary racial conflicts involving resident Indians and the broader imperatives of United States interest group politics.

My own visits to the Cultural Festival of India (three in all) provoked questions about the nature of Indian immigrant experience and ethnic identity in a primarily United States context, but with an eye to the more international Indian diaspora. Emerging as it did out of a constellation of interests – Indian, Indian American and otherwise American – the Cultural Festival generated questions about common ground: where was it and how did it function? If it was culture that provided the space here for all these constituencies to coalesce, the category of nation (as it referred both to the India of the festival title and the United States, for its geographical immediacy) offered a profoundly relevant interpretive frame for the ways that a phenomenon like this inserted itself into and constructed imaginings of individual and group identity. The Cultural Festival of India deliberately intertwined culture, nation and identity in its production of metaphors and myths. With the synchronous developments of international capitalism and diasporic nationalism, we see infinitely complex realms of cultural production; the Cultural Festival of India illustrates the representative dissolution of boundaries between what has come to be known as 'the local' and 'the global'. A reading of the festival may help us to identify various diverse forms of Indian immigrant experience as well as begin to answer the larger theoretical questions that loom large in any study of 'ethnicity'.

To many Americans, India remains little more than an abstraction. Making India 'real' was the intricate feat that the creators of the Cultural Festival accomplished through a fair with material products like food, musical recordings, dancers and calculators. But the brilliance of the gesture lies in the festival's concurrent ability to retain the broader imaginative possibilities of 'India', as an integrated whole, in a world where nations and cultures are deeply fragmented. The extravagance of the festival signifies the magnitude of such ideological work.

As the attendee entered the festival, she walked under two archways, the Mayur Dwar (Peacock Archway) and the Gaj Dwar (Elephant Archway). The huge (30–40 feet high) ornate pieces built in India and transported to the United States served a number of purposes; the peacock and the elephant are among the most colourful and 'exotic' animals found in India and have historically appeared in prosaic Western images of India. That these animals are really quite common in India seems not to be the point, for they became rare or wondrous in their current setting. The festival participant herself became framed upon entrance by these images even before officially partaking in the making of a picturesque culture.

On meticulously organized grounds, a set of exhibits and performances immediately followed the welcome brigade. The participants were invited to peruse a series of handicraft booths (tie and dye, paper pulp objects, stone carvings, brass work) in the part of the fair entitled 'India village', decorated with a banner that read 'Experience rural India'. Craftspeople direct from India were producing the pieces in each of the booths; the public was invited to watch the process as well as periodically to participate in the activities. Quite unlike the real Indian village, nothing was for sale in these booths, nor were visitors ever directly addressed. We might read this particular experience of India as presenting what is old, what is quaint, and finally what is authentic. What is made by hand becomes the most compelling trope for antiquity; not only is this true for the contemporary United States, but also for nationalist struggles in the Third World; the handloom was the prevailing Gandhian metaphor for all that was untouched by or resistant to (modern) colonialism and imperialism.

Juxtaposed to this authenticity and directly following the handicrafts were stalls for Indian American businesses, many of which specialized in electronics products.[1] Modernity hit the viewer rather materially – it seemed that entire blocks of Jackson Heights, Queens (where a lot of these stores reside) had been moved to this festival in Edison, New Jersey. Perhaps that modernity became postmodernity when the visitors were invited to join long lines to make free calls to India and Britain, courtesy of AT&T.[2]

Here, India is a commodity in authentic and commercial form; the Cultural Festival blurs the traditional modernist distinctions. Anthony Appiah (1991) has described in detail the intermingling of the past and present in articulations of nationalism; he uses novels in a way that we might consider the text of the Cultural Festival of India: 'they authorize a "return to traditions" while at the same time recognizing the demands of a Weberian

rationalized modernity.' This festival recognizes a more contemporary imperative than Weberian principles: the technological age.

As in other ethnic fairs, food occupied centre-stage in the Cultural Festival of India. Detailed descriptions of a variety of delicacies filled the literature, and meal tickets were sold at the door. Food accrues considerable significance in this text because of the sheer number of social practices (weddings, deaths, religious rituals) that occur around the preparation and consumption of food in Indian culture. In addition, Indian restaurants abound in Britain and the United States; Indian food is one commodity that has achieved popular currency in the Western context. Thus it is hardly surprising that the food section spanned the largest area of the fair. The booths were arranged according to product (nothing was replicated), very much like an Indian bazaar. The difference, perhaps, was in the obsessive attention to cleanliness; trash cans were everywhere, and it was in this section that the most volunteers could be found, selling food and picking up after visitors.

Atop a hill and in front of the Lady Liberty, an endpiece which resembled the Statue of Liberty, sat three huge tents housing the exhibitions 'Beautiful Borderless World', 'India, A Cultural Millionaire', and 'In the Joy of Others'. The visitors walked towards the three ideologically crucial exhibitions physically sated. The first two tents were quite crowded and the third had very few people in it on all the occasions I visited the festival.

Unlike the other parts of the festival, these exhibitions were full of written text; placards and banners with explanatory descriptions adorned all aspects of the shows. The introduction of the glossy fifty-two page booklet laid out the motivations of the producers in detail:

Welcome . . . the Festival celebrates India's universal culture that welcomes all. Beautifully spread over forty acres of land, the thirty day festival displays the feelings and fascinations of India through five majestic archways, four temple monuments, twenty-two artifacts and three exhibitions.
The exhibitions form the heart of the festival, containing the essence of Indian culture. Deep insight, authentic research, clear visualization, meticulous planning and a great deal of effort has gone into creating the three themes. . . .
Here, the ancient wisdom of India and the modern media of communication have been artistically blended to achieve a unique impact. We, Bochasanwasi Swaminarayan Sanstha, are confident that the exhibitions will provide a deeper understanding and appreciation of Indian culture and promote ethnic harmony and peace. . . . We hope that this much demanded guide book . . . is instrumental in preserving the glory of Indian culture for generations to come.[3]

The architects of the exhibitions and the festival began their appeal with a common rhetorical strategy; the festival 'welcomed' and pretended to include everybody. The formulation of India was for the moment something universal rather than specific and so adhered to secular paradigms. Conflict and disagreement were forestalled when everybody was included laterally, at the same level: there were no differences.

Yet all this did not preclude a presentation of cultural essence, because that in fact was the real goal of the Cultural Festival of India. The 'ancient' and the 'modern' existed almost coevally in that process of producing Indian essence. In what has become a fashionable multicultural gesture, the text intimated that the concretization of 'Indian-ness' would promote peaceful ethnic relations. The text proposed a mosaic-approach to ethnicity rather than the older melting-pot theories of social science, where differences can exist side by side in their fullness as in a mosaic and need not 'melt' together. The organization of the festival was deeply self-conscious; the moment of construction and formulation (of 'the glory of Indian culture') would be documented and preserved. The text made the exhibitions central to the social vision and imbued them with authority and legitimacy. The introduction, with its pretence of inclusiveness, manipulated the tourists and fellow-travellers at the very outset, before they even walked through the doors of the first tent.

'Beautiful Borderless World' began with a universalistic message on an overhead sign:

Our World was born with borders.
Today it is caged and confined,
torn and tortured by a thousand divisions.
Let us not further disunite and disfigure it.
As children of mother earth,
We ought to heal her wounds, promise to be
nice to her, to each other and help
rebuild a BEAUTIFUL BORDERLESS WORLD.

The placard introduction noted further: 'It is a contemplative trek into the deep realities that create borders.' This preface served to locate agency in each and every person that is human, or a child of mother earth. But this message of universalism was *not* communal or collective; as it was contemplative, the vision remained highly individualized and very much in the style of popular New Age thinking. Terms like 'nature', 'the mother earth', 'inclusion' and 'healing' figure prominently in this contemporary social discourse. Further, one could argue that New Ageism has successfully transformed the New Left notion of 'the personal is political' into one that fetishizes individual experience. The intertextuality between the articulations of the exhibit 'Beautiful Borderless World' and New Ageism was suggested by the list of research references that included *Diet for a New America* by John Robbins.[4]

The discourse that encoded universalism and liberalism drew the participants into the experience of the exhibition. However, in a common religious strategy, that general vision became more and more specific. Initially the messages were secular, but as the exhibition continued, quotations from the Upanishads became more common and facilitated the propagation of religiosity, and ultimately of Hinduism. Yet the effect was subtle, as the quotations seemed to innocently hang above more generalized and purportedly 'objective' text.

A display entitled 'Cream of Cultures' was accompanied by the thematic quotation 'Let noble thoughts come to us from all sides'. The explanatory text read:

To cull out the cream of all cultures, is the first step towards world harmony. In Vedic Times, Indian seekers, in search of the Eternal Truth, resorted to meditation in seclusion, Yoga and Pranayam, worship of nature, and Yagna for blessings. Their experience raised their consciousness to sublime heights where all discord dissolved, and unified peace prevailed.

This dangerous passage foregrounded the Hindu method, comprised of meditation, Pranayam and Yagna, *in seclusion*. Such a panacea presupposed that individual conscience, and acting on one's own, in of itself, eliminates all social conflict; furthermore, a quasi-religious conversion could best enable personal agency. Finally, the strategy eclipsed differences, elevated personal struggle and also militated against any kind of politics based on interests other than culture. Culture appeared in a rather ungeneral form here, because the goal was to 'cull out the cream', to determine a hierarchy of cultural formations.

In this language, 'borders' denoted differences of all kinds: social, economic and ideological. The desire for a utopia marked the beginning of a series of exhibits on social pathologies; the introduction reads:

A world without borders seems a wishful dream yet it is possible. We can still pick up the pieces and make it whole again. But first we must understand and eliminate the root reasons that split our world, the real elements that create borders.

Optimism turned into simplicity in the first exhibit on marital difficulties entitled 'Border of Thorns'. The description began: 'Very often, a husband and wife turn against each other, repel and split apart because of Doubt.' There was no attempt to explain this vague term of 'doubt'; yet the separation of husband from wife seemed to shake 'our world'.

Predictably, the heterosexual marriage and the nuclear family formed the cornerstone of this presentation. In the ideological processes of reproduction, the family is a crucial site for the aims of individuation, privatization, gendering and moral education, all of which had already been propagated in some form or another in the exhibition. By caricaturing the differences which might threaten that unit ('doubt' and 'suspicion'), the exhibition sent very real divisions to the margins, or 'borders'. The vision of the family literally and metaphorically consumed and integrated the messages of all subsequent panels, on issues of anger, violence, alcohol and drugs. The connection was tacit; nevertheless, one tour guide explicitly noted: 'Here we see all the things that break up the family and make for social ills.'

In very current fashion, this quite conservative ideology can be propagated alongside an antiracism, pacifism and humanitarianism, those doctrines that today carry a progressive gloss. One panel description read:

What a distortion we create when we cage ourselves in compartments, saying: I'M BROWN, I'M BLACK, I'M WHITE, I'M YELLOW. Racism is rooted in Prejudice which reflects a grotesque image of humanity. Even a small PREJUDICE is like a Brick that slowly builds up into barriers between Cultures and Races.

Here, racism was articulated in terms of individual perceptions and images; an almost pre-1960s consciousness was evident in the use of the dated term 'prejudice'. Vast divisions of economics and history were levelled in the return to the formulation of racism as a problem of attitude. A false universalism, in the title of 'humanity', made intelligible the apparent contradiction between, at first, derision towards colourist classification, and then acceptance of separate cultures and races. While the lexicon may seem rooted in the1960s, the political gesture itself echoed very 1980s and 1990s multiculturalist compulsions.[5] Finally, the borderless world with no brick walls captured all individual consciousnesses; like any religious appeal, it required a leap of faith.

The last section of the exhibit, entitled 'Peace through Purity', outlined the specific codes of adherence requisite for an enactment of the ecumenical project. The introduction brought the universal project (of peace) to hinge unreservedly on individual agency:

To rebuild the whole world, we must begin, brick by brick. Purifying our thoughts will refine our acts; our acts will make our lives; our lives will shape our society. To inspire 'Peace through Purity' . . . Lord Swaminarayan has given moral and spiritual guidelines. They are practical and universal, helpful to anyone who sincerely wishes to improve his or her life and personally contribute toward making the whole world more Homely and Peaceful.

The second sentence made the transitions from introspection to individual agency to social good with only two semicolons. Hinduism (and particularly Lord Swaminarayan's precepts) did not require full-scale conversion; instead they provided a system of knowledge for those who might at that point be wondering how to implement these 'suggestions'. The codes of morality were the bread and butter of conservative ideology; the didactic placards included recommendations of abstinence from narcotics and alcohol, vows of chastity, a commitment to the marriage contract (no adultery) and respect for private property. Lest we miss the resonances of this proposal with 1980s United States neo-conservative politics, there was an anti-drug videotape from the United Way (one of George Bush's 'points of light') showing continuously to the side of the displays. The only distinctively 'Indian' alterations, one might argue, were the pleas for vegetarianism and non-violence, though even these two aspects figure prominently in New Age versions of a 'new politics'. 'Indian' and North American conservative critiques of the current state of affairs in the United States converged in exhortations about contemporary culture. Two panels sounded this theme: one noted that 'bad magazines and wrong books are private

habits picked up from our permissive society', the other that 'parties and bars are alluring alleyways into a world of alcohol and drugs and immorality'.[6]

The submerged irony of an exhibit entitled 'Beautiful Borderless World' in a fair called the 'Cultural Festival of India' was assuaged by the second exhibition, 'India – A Cultural Millionaire'. This exhibition bestowed cultural precedence on the metaphorical and material force that is India. Again, Mark Twain's quotations aided and abetted the development of a cultural arrogance that had only been alluded to in 'Beautiful Borderless World': 'India is the only millionaire . . . the one land all men desire to see . . . [and] would not give that glimpse for the rest of the world combined.' This exhibition provided a portable historical and cultural narrative of India. The architects of the festival disclosed their objectives in the introductory panel:

> A Cradle of Civilization – India has a luminous culture more than 5,000 years old that has blossomed into the largest democracy in the world. . . . This Exhibition is a measured journey into the colorful story of India that begins with Her Glory and Grandeur, then eloquently speaks of Her crucial contributions to world culture and finally ends with Her priceless messages to Mankind. *It is a captivating story, Ageless in Beauty, Limitless in Variety and Timeless in Spirit.*
>
> (My emphasis)

The authors of this piece made no coy, qualifying pretence at contextualization; they said that they would present a master narrative that is intentionally universal, all-encompassing and transhistorical.

'India – A Cultural Millionaire' opened to a room filled with banners of quotations from writers, politicians and imperial apologists (such as Lord Macaulay). The first quotation was from Dr Arnold Toynbee and glibly delineated the underlying premises of the festival:

> It is already becoming clear that a chapter which had a Western beginning will have to have an Indian ending, if it is not to end in the self-destruction of the human race. At this supremely dangerous moment in human history, the only way of salvation for mankind is the Indian way.

In a mirror image of Hegel, here India was the solution for the future because it was at once stunningly exotic, wildly diverse and very old. Accordingly, the first section of the exhibition documented the natural wonders of India with huge photographs and lengthy descriptions of the coastline, the mountains, the rains, rivers and forests, the animals, the flowers, the arts, and finally, the faces of people. A descriptive panel asked the question that may already have been in the minds of curious fellow-travellers: 'What do we mean by an Indian face?' A Benetton-like photograph was accompanied by the words:

> All these faces belong to India. Covering the entire scale of skin tones . . . from sharp and squarish features to the roundish mongoloid features of the Gurkhas, India comprises a surprising diversity, matched by no other

Nation. Yet a common lustre of hospitality and friendliness binds them to the soul of India that remains eternally One.

This construction of a nation assumed diversity and difference, indeed even racial difference, while at the same time asserting that spirituality or 'soul' held it all together.

Contemporary debates on issues of different peoples within state boundaries often blithely accept the newness of the phenomenon of diversity. While India itself serves as a factual counterpoint to such claims, a reflection on British colonial strategies testifies to the ways that 'the problem' has been historically figured. The Cultural Festival of India might be understood within that trajectory of political and cultural practices.

In the 1860s-1870s, the British colonial government undertook a massive ethnographic enterprise to document the varied forms of Indian culture and Indian peoples (Watson and Kaye, 1872). This 'People of India' project, instead of pointing to the difficulties of national cohesion, provided justification and *information* for colonial rule. Indeed, the careful attention to historical and cultural detail of the different peoples of India in no way asserted national similarity but instead proposed that these British subjects were highly diverse. Surprisingly, also absent in this text was any effort to make the peoples or their characteristics analagous.

Likewise, the British colonial administration's 1877 Imperial Assemblage to institute Queen Victoria as the royal head of India heralded diversity rather than submerging it. Lord Lytton, the Viceroy of India at that time, remarked at the Assemblage that one could see the splendid results of royal rule in the very empire, 'multitudinous in its traditions, as well as in its inhabitants, almost infinite in the variety of races which populate it, and of the creeds which have shaped their character' (Cohn, 1983). These examples concretized and propagated the construction of India, for the British Empire, for the Indian aristocracy and for the outside world as well. The British colonial administration shrewdly understood that nation formation, and a concrete though broad proposition of what was Indian, would establish the terms of the debate and ultimately make an extremely diverse entity conquerable.

Bernard Cohn suggests that British colonial authority was exercised as much through an *idiom* as through sheer physical suppression and that this British idiom served to codify what was Indian for Western eyes. This idiom, I would argue, became a more general discourse on India for those inside and outside of India; governing a diverse group of peoples while respecting the plethora of (discrete) cultural traditions has been the lexical means for the Indian state to maintain a relative degree of legitimacy, and for it to contain dissent. As this festival conceded the same 'Indianness' that the British themselves formulated, our established notions of which texts are 'postcolonial' may be troubled. There is a deep continuity in and intermingling of masterful strategies. The proposition of a nation is not new; it is, if anything, very old. The Cultural Festival, too, acknowledged diversity in a national construction; in a twist, though, this event gave *migrant*

Indians authority over traditional and modern India and so moved one step beyond the imperialist nostalgia that would simply romanticize the India of old. The allowances made for new technologies and the specifically United States ideological landscape inscribed this festival in the present.

In the Cultural Festival of India, diversity seemed at first to extend even to religion. Large, well-lit boards in one section of 'India – A Cultural Millionaire' described various religions, including Islam, Christianity, Sikhism, Judaism, Buddhism and Hinduism, that comprise the panoply of paths to knowledge. Details of the history, the founders, the practices and the populations of each religion were listed on each board; in fact there was so much text to absorb that it was difficult to see at first glance any real distinctions. However, a closer reading revealed that Hinduism, unlike *all* the other religions, 'had no human founder', asserting that spirituality emanates from Hinduism rather than from any of its worldly counterparts. In this gesture, the festival ideologues disrupted the egalitarian multiplicity that had previously been organized.

The message of 'India – A Cultural Millionaire' and of the festival as a whole was found in the last section of the exhibit entitled 'Message of India'. The introductory text illustrated the perspective of the organizers:

> India has always implied to the world, the luminous light of wisdom which is more needed today. . . . Her lofty ideals of non-violence, peace and purity are not superficial but filter through . . . Indian culture is an eternal stream of human values that continues to inspire the youths, the men and women of the world.

In one fell swoop, the festival resolved the very complicated and convoluted debates on the culture concept: culture was about values.

The last displays in this section elaborate the twin themes of culture and values. The 'ideal student youth', Ekalavya was an industrious boy who applied to but was rejected by an archery school. Ekalavya persisted and became the best archer in the world through hard work. As 'Ekalavya represents concentration and faith in unending perseverance', the story itself of the ideal youth recalled other capitalist parables like those of Horatio Alger. Work, concentration and perseverence are important code words in the language of capitalism, and also in the language of ethnicity; here, the capitalist values *were* Indian.

The second exhibit, the 'Message of India . . . To the Woman', brought sexism to the surface of the festival text. The coupling of gender roles to the studied preservation of the nuclear family made the woman one who 'nourishes children, who is chaste and religious and becomes the soul of her husband'. Sita, the wife of Ram in Hindu mythology, prototypically was unmaterialistic, devoted to Rama, and chaste (she looked upon all other men 'as father or brother'). She was the ideal woman because she was the ideal wife, she suspended her own critical faculties and put 'full faith in her husband's words and deeds'. The other exemplar was Mother Queen Jijibai, who inculcated valour and morality in her son, the 'strongest Hindu king', Shivaji. In the festival description, Jijibai was the keeper of the faith and

made men strong. The final descriptive sentence was manipulatively ungendered: 'Her ideal motherhood gave the world an ideal human being.'

The festival ideologies were presented as 'message(s) of India', yet they uncannily resound with a new politics of ethnicity that is counterposed to various histories of racial formation. Representations of Asians in the United States fulfil stereotypes of American success through the tropes of hard work and strong family structure. Interpellated by the media in these ways, Asian Americans in particular, as economic citizens of capitalist democracy, can be counterposed to racially 'other' groups like African Americans, who remain alienated from the productive market because they are perceived to lack the ability to work hard and maintain a strong (that is, male-headed family) household. Substantial demographic shifts in urban and suburban spaces only further fuel such problematic and regressive uses of 'the other' in the popular imagination.

Immigrants from areas previously under colonial rule are rapidly entering and forming communities in United States cities and towns. In the past few years, this immigration of *non-white* groups has become the subject of increased focus for a range of scholars, policy-makers and community organizations. Debates about how to address these demographic changes abound in secondary and higher education. The controversy on affirmative action has taken a new turn, with neo-conservative immigrants actively attacking the guiding philosophy that supports stated opportunity for minorities (D'Souza, 1991), and other immigrant groups noting that their ethnic group is unaccounted for in such formulations. The state has responded to these developments with a statistical fetish – a focus on 'getting the numbers right' for immigrant groups; in fact, debates about the 1990 census centred around immigration rather than race for the first time.[7]

The Indian population in the United States provides an interesting lens for these demographic shifts, because Indians are relatively recent immigrants who can be seen to be located in the 'new racial landscape'. In 1987, a Jersey City Indian was beaten to death in Hoboken, New Jersey, by a racist youth gang which called itself the 'Dotbusters' (*New York Times*, 12 October 1987), and Indian community leaders disturbed a mayoral news conference to protest at what they described as a rash of racially motivated attacks (*New York Times*, 8 October 1987). In January 1992, an Indian American girl on a bus in the Bronx was physically assaulted by African Americans who said that they mistakenly thought she was white (*The Times of India*, 11 January 1992). And, in Edison, New Jersey, home of the Cultural Festival of India, an anti-Indian gang called 'The Lost Boys' was charged with intimidation of and attacks on resident Indians in July 1991 (*India Abroad*, 5 July 1991). These incidents point to the very complicated patterns of racialization of an immigrant group that is also perceived in 'ethnic' terms. United States court cases dating back to the late 1800s demonstrate that the racial identity of Indians has always been a point of contention; alternately perceived as white and 'coloured', Indians' racial classification, like that of other Asian American groups, has never neatly fitted into United States paradigms (Takaki, 1989).

Today, Indians are the second fastest-growing Asian American immigrant group in the country (*New York Times*, 12 June 1991). Although they are currently only 0.3 per cent of the population, the million or so people are not evenly dispersed across region, occupation or economic class. The 1960s to 1970s waves of immigrants converge in professional occupations, but the more recently immigrated and fastest-growing portion of this population dwells largely in East Coast urban areas where racial and ethnic tensions run high. Certainly, they are *known* in a very different way from another decade. Indians themselves are well aware that they are becoming more and more visible as a minority in this country.[8] The instability of racial and ethnic identifications in the United States context such as minority, ethnicity, racial group, etc., as well as the material reality and demands of United States interest group politics, produce in Indians the need and desire to formulate themselves as a group, both for their current country of residence and for the outside world. Growing concentrations of Indians in many urban areas, the increasing vilification of 'unproductive' immigrants and the intensifying poverty of people of colour in the inner city lend a measure of urgency to these middle-class efforts to develop a positive self-representation. To avoid the pejorative connotations of racialization, Indians must portray their identity as rooted not in the United States system of racial hierarchies, but in a place much further away.

It is within these circumstances that an event like the Cultural Festival of India predictably appears. The Cultural Festival presents India in dazzling form and, in so doing, narrates a story of a nation because in order to have authority, immigrant Indians must have a usable and defined past.[9] The enigmatic authorship of the festival by Bochasanwasi Swaminarayan Sanstha, a Gujarati Hindu sect, betrays the impossibility of 'pure' representation. The delicate balance and contradictions between the general goal of presenting 'India' and the specific agenda of the Swaminarayan group can be seen in material products of the festival and in the organization and process of execution.

The workforce was comprised of 2600 men and women,[10] and spanned a range of middle-class occupations; professionals and college students had taken between three and twelve months off from their jobs to work on the festival, in some cases performing extremely mundane tasks like selling food. Various Indian American organizations had solicited volunteers; some people came from India, Britain and East Africa and some had come off the street to volunteer. The mechanisms for inclusion, then, were both flexible and thorough; I myself got a call in New Haven during March 1991. The organizer said that he had received my name from an immigrant organization to which my father belonged (a cultural, not a religious group) and had wanted to know if I would like to spend my summer in Edison, New Jersey, for a 'noble cause'. He did not ask if I believed in the Swaminarayan temple nor what I did for a living; presumably 'Indianness' and/or 'Hinduness' in speculation qualified me for inclusion.

Given the wide diversity of people working on the festival, I was taken aback by the content similarities in their comments about the festival.[11] At

times, it seemed only that regional accents distinguished the men, women, Indians, Indian Americans, Indian British, teenagers, businessmen, English majors and CEOs from one another. I asked these people a variety of questions and made sure to evoke different themes in my presentation. Empirical questions about the size of the festival, the make-up of the workforce, and the visitors to the festival were answered directly and specifically; but any questions about the hierarchical structure of the organization or the sentiments in the ranks were shunted to evocations of the greatness of Indian culture and the prominence of Pramukh Swami Maharaj, the spiritual saint of Bochasanwasi Swaminarayan Sanstha. This disciple-like reasoning constructed itself on the two fronts of culture and religion at once.

The presentation of India at the Cultural Festival was meticulous and studied. Volunteers scrupulously policed the exhibitions; I was sitting on the ledge of an exhibit for less than thirty seconds during two different visits when workers politely asked me to stand up. When I asked the workers any specific questions about the rationale behind any of the pieces, they referred me to the accompanying text without fail. I spoke to a number of Indian American business people and academics who were assigned the task of overseeing the events. The striking thing in all these conversations was how little these men knew. In prototypical capitalist fashion, even the managers were unaware of the larger strategies and effects of production. The *sadhus*, or priests, maintained ultimate financial, administrative and ideological control over the event. For example, the functionaries had no knowledge of financial details, yet the festival had an extremely organized process for collecting money; tickets for food and craft items were sold in only a few booths at a central location at the start of the festival. Such organization also echoes colonial administrators' obsession with detail and procedure in India for the smooth running of the British Empire. Here, the project is the making and presentation of India as well, but for other purposes.

The control of Bochasanwasi Swaminarayan Sanstha and the omnipresence of Hinduism suggest agendas both inside and outside of the West. It seemed to me, from overhearing conversations in Gujarati and Hindi, that the majority of Indian festival-goers were Northern and Western Indian. In light of current turbulent ethnic and regional conflicts in India, the submergence of regionalism in the material presentation of the festival was astonishing. The only physical indication that the state of Gujarat might be of special interest to the architects of the festival was in the larger space accorded to that state's pavilion in 'India – a Cultural Millionaire'. The whole and integrated India was of primary concern to the festival ideology in a context where nations matter. The link between that national articulation and religious absolutism was highly suppressed by the overt messages of the festival (and by the ever persistent myth of Hindu tolerance), but seeped out from the cracks. During one visit, I spoke to a security volunteer who was Gujarati; I was with my Gujarati father and his friend and we were all conversing in that language. As we were talking, a Sikh man was being led to the exit by the police. When I asked what had happened, the unruffled security

volunteer responded that he did not know the details of this incident but that the police had been notified that if they saw a turban they were to be extremely observant. He then launched into a tirade about Khalistan and how the Sikhs were destroying 'Indian unity'. Any articulation of difference, most especially religious difference, threatens the sanctity of the 'India' that is propagated by the Cultural Festival, much as it threatens the state back home. The contradiction between this truth and the universalism and diversity displayed in 'Message of India' remains at the fringes of the event and, as it were, behind the scenes. When difference and possible opposition to the hegemonic ideology appear, they are physically controlled; thus this cultural festival becomes a powerful political analogy.

The external agenda for the festival has an important economic subtext. As Indians in First World countries increasingly see themselves as political minorities and/or interest groups, simultaneously their 'home' country has engaged in a full-scale effort to attract foreign investment by relaxing regulations for the percentage of foreign ownership and especially encouraging Non-Resident Indian (NRI) participation in Indian companies. The feasibility of such corporate endeavours lies as much in an image of India as a source of progress as it does in the concrete profitability that a site like India might promise. The 'commercial' aspects of the festival, such as the electronics products, which at first seem out of place, are indeed a crucial part of the making of India for both the Indian and Western imaginations. The Indian economic diaspora utilizes the discourse of nationalism to achieve its goals as much as it relies on an international capitalism that propagates the free crossing of state boundaries. It is this paradoxical and very contemporary form of nationalist articulations that the Cultural Festival of India elaborates.

The festival is an occasion for the construction of a new kind of *diasporic* nationalism, a nationalism that produces an abiding sense of identity through the concretization and essentialization of culture. The identity produced is national and transnational at the same time; both the local interests (of the site in which the festival occurs) and the more global referents are very important for an understanding of this kind of cultural production. My detailed reading of the Cultural Festival of India has been intended to unpack this complex ideological formation. As many subjects of cultural studies have done in the past, the festival points to the interrelation between culture, politics and the economy and portrays the theoretical confounding of nation, culture and identity through the category of ethnicity.

In recent academic history, Benedict Anderson (1983) has most celebratedly excavated the history of nation-making; he argues that nationalism developed out of the very modernist need to develop affiliations among people in contexts that had undergone tremendous social and political upheaval. The social actors utilized cultural and political resources to imagine and construct 'communities' with which they may or may not ever have had real contact.

Nation was far too expansive a concept to remain within state-geographical boundaries; and as various colonial empires developed, and

eroded, the concept of nation provided a helpful salve for migrants all over the world. Homi Bhabha has explored in detail the desire for nation among groups of people who strive to formulate a cultural identity in the midst of contradictions and uncertainty in the various spaces they occupy. Bhabha notes: 'The scraps, patches, and rags of daily life must be repeatedly turned into the signs of a national culture'(1990: 297). What results is a delicate balance between the pedagogical (the didactic intimations that 'this is India'), and the performative, that dynamic process by which both viewers and actors elaborate their cultural longings in a distinctively public space. As cultural identity must be located in a place, advertisers must provide a story for that place. Narration and fictionalization become ideological processes for the purpose of providing a functional and *national* history. With this type of theorization, Bhabha moves us beyond the nation-state towards an understanding of more international communities of migrants.

The actual process of constructing a nationalist sensibility within another nation has a time and location, which is to say that it is historically specific. In the contemporary United States, that formation occurs through articulations of 'identity', and particularly those of *ethnicity*. Etienne Balibar has described the relationship between nationalism and identity using the term 'fictive ethnicity':

By constituting the people as a fictively ethnic unity . . . national ideology does much more than justify the strategies employed by the state to control populations. It inscribes their demands in advance in a sense of belonging in the double sense of the term – both what it is that makes one belong to oneself and also what makes one belong to other fellow human beings.

(1991: 96)

While for Balibar's European examples, ethnicity is produced through language and race, recent United States ethnicities, I would argue, are produced through more vague frameworks of 'culture'.

Ethnicity provides the illusion of cohesion for experiences and formations that are anything but homogeneous. Indian Americans are an extremely diverse population; earlier waves of immigrants occupy the middle and upper classes while more recent immigrants reside in urban areas and obtain a living through the service economy. The makers of ethnicity, or the middle-class 'ethnicity entrepreneurs',[12] reserve the nation of India and the identity of 'Indian' for themselves; they establish authority and control over this narrative, and in an act of discursive violence, repress any possible competing discussions of identity, again by lifting the category of 'culture' out of the everyday world.

In the introduction to his latest work, Edward Said lays out a two-pronged definition of culture that premises his studies:

First of all it means all those practices, like the arts of description, communication, and representation, that have relative autonomy from the economic, social and political realms and that often exist in aesthetic

forms, one of whose principal aims is pleasure. . . . Second, and almost imperceptibly, culture is a concept that includes a refining and elevating element, each society's reservoir of the best that has been known and thought.

(1993: xii–xiii)

These definitions of culture, often pitted against one another, seem to be the most prevalent ones in the theory and practice of recent cultural studies.

However, the example of the Cultural Festival of India produces the need for a definition of culture that is both highly active and undiscrete and connected to the '(other) realms' of economics and politics. Undeniably, a festival like this *is* a form of culture, albeit one that is neither deeply aestheticized nor pregnant with politically utopian possibilities. Middle-class (in) formation is deeply relevant to the ways that we understand the construction and representation of groups of people. To emphasize culture as a broader category is to trouble local–global and also textual–'real-life' dichotomies that have been inadequately dealt with in recent theoretical scholarship. Indeed, the less politically progressive forms of culture are comprehensible only through a treatment of flows of capital and conflicts between political states; authorship is not easily surmised in such phenomena nor is the experience of participation in these cultural formations ever static. Finally, if we separate out the different realms of influence (culture, the economy, etc.), we run the risk of reifying culture in much the same way as do events like this one.

Texts like the Cultural Festival portray the dynamics of culture by breaking apart the easy separation between strategies of the colonizer and the colonized (Suleri, 1990). The story being told is colonial, postcolonial and migrant at one and the same time; 'India village', AT&T, family values and multiculturalism speak to a global politics. Although the rendering of nation is hardly *subtle*, there *is* a complex ideological interaction of what are understood to be First and Third Worlds. Postcolonial criticism, as it is most effectively concerned with narrative strategies, might find a different category for middle-brow culture that deserves as complicated a reading as Rudyard Kipling.

Much of postcolonial criticism has overlooked the fact that many battles for nation and culture are fought on the grounds of, in the locale of, and with the backdrop of racial and ethnic formation. In the United States, the new politics of ethnicity elides questions of race for middle-class immigrant groups in ways that it perhaps could not in a place like Britain. Middle-class Indian Americans do experience a racialization that is different from southern and eastern European immigrants, therefore they must construct new narratives of their experience; in this way, ethnicity is both 'invented' and socially produced (Sollors, 1989). Yet there are ideological obstacles; class ascendancy has a discursive correlation with whiteness, not only because of class culture but also because of the history of racial formation in the United States. To disturb this connection between race and class, the cultural translators of middle-class immigrant groups develop ethnic stories and myths

about their identity; in effect, they opt out of the *racial* hierarchy to cash in on their class privilege. Middle-class Indians in the United States have very specifically chosen the language of ethnicity rath er than race to construct their group identity, not only because their experiences differ so radically from African Americans but also because ethnicity allows this class to form without the heavy baggage that race bestows on contemporary United States culture. For more recent Indian immigrants, of course, who live below the poverty line and who work in jobs from which their middle-class counterparts distance themselves, the ability to move out of the local context, to imagine India, and to 'choose' a class-specific ethnicity to assuage a racial condition, may not be an urgent need or an imminent possibility.

The framework of discrete ethnic identities is accessible to groups of people in the United States on both political and cultural levels. Interest group politics, and particularly ethnic shares of power have been the successful strategies of Irish, Italian and Jewish interests. Indians frequently cite Jewish Americans as a model for ethnic formation. The decline of the melting-pot model of ethnicity comes as no great loss to immigrants who could never e-race themselves; indeed, the mosaic approach to ethnicity serves their purposes well (Glazer and Moynihan, 1975; Peterson *et al.*, 1982). Multiculturalism, the educational incarnation of mosaic-ethnicity, speaks to such needs by integrating the experiences of non-Western groups into the general vision of the United States. But, as we have seen in this festival, multiculturalism also sells out the future with its emphasis on the immediate present and because it never questions the larger categories, of nation, of history, of family – those notions which have well-developed ideological and structural mechanisms to tyrannize those who are 'different'. The central dilemma underlying this study has been how to discuss the attempts to control what is a deeply chaotic process. Despite the recent theorization of hybridity and cultural mixture, essential cultural identities continue to motivate people all around the world for a variety of political and social ends. Experiences of displacement and political and economic changes in the world have been intelligible through the concepts of belonging and identity, as Stuart Hall notes:

> we've assumed that there is something which we can call our identity which, in a rapidly shifting world, has the great advantage of staying still. Identities are a kind of guarantee that the world isn't falling apart quite as rapidly as it sometimes seems to be.
>
> (1991: 10)

Because cultural moments like the Cultural Festival of India are so prevalent, we need to take a hard look at the varied forms of culture and 'the local' (not just the insurgent) and at what is not necessarily politically progressive. This means that we need to explore diversity in the 'postcolonial' experience itself; exile may simply not be the same for Third World literary critics and South Asian business people.

As diaspora continues to be articulated with economic internationalism, cultural integrity is the explanatory narrative of choice. That is to say that the activities of international bourgeois classes have *cultural* effects, and the Cultural Festival is but one example.[13] Although the massive divisions in the home country may be in the subconscious of many Indians, the more accessible languages of ethnicity and identity production produce at times a willful disregard for such complexities. Finally, contemporary politics produces a number of paradoxical discourses: international capitalism, diasporic nationalism and religious communalism get articulated *together*. The Cultural Festival only reflects such confusion in its propagation of 'unity in diversity'. This making of ethnicity ironically strives to take us out of history – a history which is one of conflict and division – and asks us to believe in 'something else'.

While the Cultural Festival is a very thick and tightly conceived ideological occasion, this is not to say that there are no unplanned consequences for an event like this. Indeed, many of the young Indian women I was with during one visit were quite outraged by the sexism and racialism of a number of the exhibits and consequently were amazed at the ability of Bochasanwasi Swaminarayan Sanstha to maintain such a large youth group. There are always gaps and contradictions in a cultural text, and the participants are often engaged in a very active experience with this festival.

It bears reiterating that immigrant consciousness is an extremely diverse phenomenon. Generational differences, differences of class and political identification produce a whole range of cultural forms; as much as the Cultural Festival of India constructs a good deal of its rhetoric around 'today's youth', so too does the British Indian singer Apache Indian proclaim unity among transnational racial youth groups for politically (and culturally) utopian ends (Back, 1993).

And as a metaphor, India has political possibilities. The history of India offers us an entrée into some important theoretical questions; we need only witness the proliferation of work that complicates the construction of India in colonial and postcolonial polarities. Scholars like Gayatri Spivack and others from the Subaltern Studies group have considered India an important subject of study to illuminate questions of power, representation, language and identity.

Yet the Cultural Festival of India can be seen as a kind of marker for Indian cultural production just as the 1877 Imperial Assemblage was for cultural elaboration of the British Empire. The very contemporary (and also historical) links between global capital and global culture are illustrated here; in this way the festival is not accidental or peripheral to the ways that immigrant groups are formulating themselves in ethnic terms. The rise of the Bharatiya Janata Party in India and other religious and cultural fundamentalisms in the diaspora are unfortunate reminders that while we must work for and celebrate hybridity, we must also speak to the 'ethnic behaviour' that arises out of profound uncertainty and leads to a suspension of critical analysis.

Acknowledgements

I would like to thank Jean-Christophe Agnew, Hazel Carby, Michael Denning, Paul Gilroy, Thomas Klubock and Sara Suleri-Goodyear for advice and encouragement on this article.

Notes

1 Interestingly enough, this part of the festival seemed to be the only one that was not mentioned in the promotional brochure.
2 In the last few years, long-distance telephone carriers have developed a multitude of special plans to cater to recent immigrant populations; of these groups, Indians form a 'substantial share of the market' (telephone interview with an official at AT&T, 27 July 1994). AT&T, in particular, is quite visible at Indian association functions, advertising how it provides for the special needs of the Indian community.
3 This brochure has no title, except for those of the exhibits which appear on the front cover. Its publisher is Swami Ishwarcharandas Aarsh (Akshardham – A Centre for Applied Research in Social Harmony), A.P. Swaminarayan Temple, Shahibag Road, Amdavad–4, Gujarat India. I will be quoting from this text, which exactly replicates much of what appeared in the exhibits, but since there are no page numbers I will not footnote the citations. If there are items which do not appear in the booklet, I will specify accordingly.
4 This list also includes biographies of the liberal American icons Martin Luther King and Abraham Lincoln in books such as *Lincoln the Unknown* by Dale Carnegie and *Let the Trumpet Sound* by Stephen B. Oates.
5 Carby (1992) provides an excellent discussion of the complications surrounding multiculturalism. I shall return to this issue.
6 Panels 'AT-16' and 'AT-18' of the exhibit. Citations from this repressive and explicit critique of United States society do not appear in the accompanying text; it is one of the few omissions that I have noticed.
7 For example, the 1990 census figures occasioned a rethinking of the populations of New York State. The fact that the majority of immigrant populations in New York City comprised groups of colour changed how people saw the category of 'racial composition' (*New York Times*, 22 February 1991: B12).
8 Testament to this consciousness is the efflorescence of immigrant organizations, and also political groups like 'Indians for Florio' and 'Indian American Republican Group'.
9 For an important elaboration of these processes, see Bhabha (1990).
10 From official literature of the Cultural Festival of India.
11 Informal interviews conducted at the festival, 5 August 1991.
12 I take this wonderfully descriptive term from Kasinitz (1989).
13 See various other international 'Indian organizations'; the Bharatiya Vidya Bhavan (or the Institute of Indian Culture) is an extremely well-funded one and has branches in the United States, Britain and India, and will develop more in East Africa and Mexico.

References

Ahmad, Aijaz (1992) *In Theory*, London: Verso.
Anderson, Benedict (1983) *Imagined Communities; Reflections on the Origin and Spread of Nationalism*, London: Verso.

Appiah, Kwame Anthony Appiah (1991) 'Is the post- in postmodernism the post-in postcolonial?', *Critical Inquiry*, 17: 336–57.

Back, Les (1993) 'The unity beat', *Guardian*, 13 October.

Balibar, Etienne (1991) 'The nation form: history and ideology', in Balibar and Immanuel Wallerstein, *Race, Nation, Class: Ambiguous Identities*, London: Verso.

Barringer, Felicity (1991) 'Immigration brings new diversity to Asian population in the U.S.', *New York Times*, 12 June: A1,D25.

Bhabha, Homi (1990) 'Dissemination: time, narrative and the margins of the modern nation', in his (ed.), *Nation and Narration*, London: Routledge.

—— (1994) *The Location of Culture*, London: Routledge.

Carby, Hazel (1992) 'Multicultural Wars', *Radical America*, 54: 7–18.

Cohn, Bernard (1983) 'Representing authority in Victorian India', in Eric Hobsbawm and Terence Ranger (eds), *The Invention of Tradition*, Cambridge: Cambridge University Press: 165–209.

D'Souza, Dinesh (1991) *Illiberal Education*, New York: The Free Press.

Glazer, Nathan and Moynihan, Daniel P. (eds) (1975) *Ethnicity: Theory and Experience*, Cambridge: Harvard University Press.

Hall, Stuart (1991) 'Ethnicity: identity and difference', *Radical America*, 23: 4.

Kasinitz, Philip (1989) *Caribbean New York*, Ithaca: Cornell University Press.

Peterson, William, Novak, Michael and Gleason, Paul (1982) *Concepts of Ethnicity: Selections from the Harvard Encyclopedia of American Ethnic Groups*, Cambridge: Harvard University Press.

Said, Edward (1993) *Culture and Imperialism*, New York: Alfred A. Knopf.

Sollors, Werner (1989) *The Invention of Ethnicity*, New York: Oxford University Press.

Suleri, Sara (1990) *The Rhetoric of English India*, Chicago: University of Chicago Press.

Takaki, Ronald (1989) *Strangers from a Different Shore; A History of Asian Americans*, Boston: Little, Brown & Co.

Watson, J. Forbes and Kaye, John William (1872) *The People of India; A Series of Photographic Illustrations of the Races and Tribes of Hindustan*, Volumes 1–8, originally prepared under the authority of the Government of India, and reproduced by Order of the Secretary of State for India in Council, London: India Museum.

Articles cited

'In Jersey City, Indians protest violence', *New York Times*, 12 October 1987.

'Jersey City Indian community protests rash of racial attacks', *New York Times*, 8 October 1987, II, 3:2.

'Ethnic Indian teenager attacked', *The Times of India*, 11 January 1992, p. 11.

'Thirteen Charged with Indian Attacks', by Paul Murphy, *India Abroad*, 5 July 1991, p. 29.

JOHN HARTIGAN, JUN.

UNPOPULAR CULTURE: THE CASE OF 'WHITE TRASH'

ABSTRACT

This article examines 'white trash' as a rhetorical identity in a discourse of difference that white Americans deploy in deciding what will count as whiteness in relation to the 'social bottom'. Surveying historiographic efforts to valorize 'poor whites' in contrast to 'white trash', and tracking the redemption of 'redneck' as a popular identity, the author delineates how a pollution ideology maintains a portion of whites as fitting problematically into the body of whiteness. Rather than finding an authentic voice in the numerous, current uses of 'white trash' in a range of popular culture production, the author instead summarizes 'white trash' as an other within the popular – an unpopular culture.

KEYWORDS

discourse; pollution ideology; whiteness; redneck; popular culture; class culture

This brings us to the emergence of a white underclass. In raw numbers, European-American whites are the ethnic group with the most people in poverty, most illegitimate children, most women on welfare, most unemployed men, and most arrests for serious crimes. And yet, whites have not had an 'underclass' as such, because whites who might qualify have been scattered among the working class. Instead, whites have had *'white trash'* concentrated in a few streets on the outskirts of town, sometimes a Skid Row of unattached white men in the large cities. But these scatterings have seldom been large enough to make up a neighborhood. An underclass needs a critical mass, and white America has not had one.

Charles Murray, *Wall Street Journal*, 29 October 1993, my emphasis)

In the legion of others that haunt and ratify a 'mainstream' white American identity, 'white trash' is a most troubling, problematic figure. What is 'white trash'? The question is easily posed, and perhaps too easily answered. In response to the question, I have found that people readily reel off a list of attributes that designate 'white trash', with complete confidence and assurance that they are in no way connected to such people. In a political moment

when derogatory labels and innuendoes for ethnic groups are being rigorously policed in social and institutional exchanges, 'white trash' still flies with little self-conscious hesitancy on the part of the user. The confidence with which people are labelled 'white trash' derives from a long tradition of social contempt and a complex process of intraracial othering.[1]

'White trash' continues to be sustained socially by an almost unconscious naturalness, which culture critic, Greil Marcus, has noted in his own upbringing:

> I mean, I grew up in a very liberal household, where no word said about black people would be tolerated, a household very sensitive to bigotry. But there was one group that I somehow got the message that it was okay to be bigoted about, and those were the backward, white Southerners – white trash. I'm not saying that I got the message from my parents, but I did get it somehow.[2]

The term's debilitating effects are receiving something of a public airing, but primarily through the debasing forum of television talk shows, as evidenced in a recent episode of the *Oprah Winfrey Show*, 'Tired of Being Labeled "White Trash".'[3]

The status of 'white trash' has reached an interesting threshold: it is passing very rapidly from an unambiguously derogatory label to a transgressive sign under which certain whites are claiming a public speaking position. 'White trash', until very recently, was used solely in a disparaging fashion, inscribing an insistence on complete social distance from problematic white bodies, from the actions, smells and sounds of whites who disrupted the social decorums that have supported the hegemonic, unmarked status of whiteness as a normative identity in this country.[4] But in popular cultural productions, 'white trash' is used increasingly as a means of self-identification. Such usages were rare prior to 1980.[5] Assertions of 'white trash' as a form of self-designation, though, have not dispelled the term's negative connotations; rather, they coexist in a confusing series of cultural exchanges, largely between whites of distinct class backgrounds.

The purpose of this article is to provide a sketch of the current moment during which instances of 'white trash' in popular culture have proliferated, and to consider the complicated function of 'white trash' as a cultural object and identity. This moment is a fusion of a number of ongoing social and economic processes in the United States. In cursory form, these include: 'the transformation of white identity' (Alba, 1990; Lieberson, 1985), whereby a broad segment of the white population in this country, largely in response to the politicized articulation of ethnic identities by minority groups, is increasingly claiming membership in an ostensively ethnic collective ('unhyphenated whites' in Lieberson usage); multifaceted critiques and challenges – demographic and political – to the hegemonic status of whiteness as a normative social order; and subtle changes in the production of popular culture whereby certain 'poor whites' are beginning to gain a limited degree of control over their own public representations. This compacted series will be elaborated more fully below. But before

proceeding further, I want to provide a brief sketch of my own interests in this 'contaminated' identity.

I first became interested in 'white trash' in the course of conducting ethnographic fieldwork in West Virginia in 1985. In the southern coalfields of West Virginia, the term 'white trash' named those families deemed most backward (socially and economically) by the residents of the coal camps. In each holler, it seemed, there was always one family which was used to mark the edge of sociality, either through their unruly behaviour and lifestyle, or their isolation from the rest of the community. While the name designated a singular, shameful condition established in relation to the local community, 'white trash' also entailed a set of consistent features or characteristics that were commonly recognized throughout the Appalachian region and the South in general. In this regard, 'white trash' named a strange collective order, one that only manifested locally in detached isolation; there were no 'white trash' tribes or neighbourhoods; just particular, solitary families and individuals.

'White trash' also had another striking feature in this area. As we searched out and studied the culture of the coal camps, the 'natives' consistently directed us to some of these spectacularly 'grotesque' families. In one holler, people continually asked me if I had visited the W____ family, a brood of about eleven parentless teenage and pre-adolescent children – most reputed to be 'retarded' – living in a sprawling shack surrounded by half-cannibalized car bodies with their indigestible innards chaotically strewn about. The family bore every feature of the 'white trash' stereotype. Rather than cover up this profusion of 'backwardness', the locals directed us to them, assuming that it was this stereotypical instance of Appalachian culture that we were really after. These natives were familiar enough with the variously reproduced images of 'mountaineers' that they reified our interests as researchers quite effectively.

By the end of the 1980s, I noticed an emerging currency of 'white trash' in numerous popular cultural productions. These instances of the term (detailed below) are quite removed from the way 'white trash' typically operates in West Virginia, Tennessee and Kentucky. While in Appalachia the name bears an immediately infuriating and shameful charge, the uses of 'white trash' in popular cultural productions carry an invigorating, assertive edge. I began to carefully track uses and instances of the name in an attempt to understand the process by which 'white trash' became nationalized, spreading from its very particular usage in a certain region to becoming a form of common currency in popular culture. This article is the result of that tracking.

The difficult matter that needs to be addressed first in considering 'white trash' as a cultural object is the problematic conflation of its derogatory and valorized usages. The negative connotations are, to this point, an irreducible remainder, active and proximate even when the name is used as a means of positive self-identification. While a redemptive approach to the people and lifestyles labelled 'white trash' would attempt to refute or eschew the contemptuous aspects of the term, I think it is critical to

maintain an attention to the function of these less-than-savoury conno-
tations. But this conflation of degrading and positive terms of identification
is a tricky matter to analyse as a unified form of cultural identity in the
United States.

The problematic status of 'white trash' as a cultural identity comes into
greater resolution with the benefit of two theoretical assertions about the
name's significance: first, that 'white trash' is a rhetorical identity in a dis-
course of difference; second, that the term is a function of a subtle yet per-
vasive pollution ideology through which white, middle- and working-class
Americans evaluate the behaviours and opinions of other whites of similar
or lower class status. Instances of 'white trash' in popular culture objectify
how racial and class boundaries are rhetorically established and ideologi-
cally maintained. Some may argue that the term's history of stigmatization
makes it necessary to discard 'white trash' in favour of a more neutral term
for 'those people', but it is exactly this confidence in a mythic, neutral space
where disparaging social judgements can be rendered more politely that
gives 'white trash' part of its enduring momentum. We cannot begin to
understand 'white trash' by trying to transcend its provisional and con-
taminating (i.e. rhetorical and polluted) operations.[6]

In its long career,[7] 'white trash' has always been a means of what Werner
Sollors has referred to as 'rhetorical boundary construction', an operation
whereby, from a certain perspective, 'contrastive strategies – naming and
name-calling among them – become the most important thing about eth-
nicity.' The examples that Sollors draws on to make this point are all taken
from minority racial groups in the US.

> A series of recent slurs, often hurled by some in-group speakers against
> other people who threaten the fixity of mental boundaries based on race,
> scolded blacks as Oreos, Asians as bananas, Indians as apples, and Chi-
> canos as coconuts – all with the structurally identical criticism 'they're
> white inside!' The warning had no specific cultural content but served as
> an interchangeable exhortation to maintain boundaries.
>
> (1986: 27–8)

'White trash' derives from a similar contrastive strategy or rhetorical
boundary construction by which whites have long demarcated a certain
form of racial detritus, composed of other whites who, through their
poverty and ungainliness, fit insecurely within the body of whiteness as a
hegemonic order of political power and social privilege. In one regard, no
one is white trash unless they are so labelled by somebody else. This rhet-
orical 'tradition' remains quite supple. Rather than referring to a static list
of character traits and bodily features, 'white trash' continues to be applied
in innovative manners.[8] As a rhetorical identity, instances of the name offer
a certain perspective on the formation of white identity and demonstrate a
means by which whiteness is maintained via an intraracial contest in which
the active marks of otherness are read on ill-fitting white bodies.

Recognition of the culturalness of 'trash' can also be drawn from the
work of Mary Douglas, who detailed the constitutive role of pollutions in

establishing and maintaining cultural orders. Dirt, garbage and trash are all materials that must be excluded from a cultural system in order that its modes of identity be maintained as naturalized conditions. Out of place, these materials rupture the smooth decorum of conventionalized existence. In this regard, instances of the name 'white trash' should be read as inscriptions of racial pollutions, moments when the decorum of the white racial order has been breached and compromised. 'White trash' is used to name those bodies that exceed the class and racial etiquettes required of whites if they are to preserve the powers and privileges that accrue to them as members of the dominant racial order in this country.[9]

Douglas argued that instances of dirt and trash provide a means of discerning 'the underlying system of norms and categories' at work in a culture, revealing 'the structures of signification which govern the assignment of meaning to objects and event' (1966: 9). From this perspective, it is easy to understand how a certain normative cultural (racial, classed and gendered) identity is maintained through a series of exclusions that are achieved by inscriptions of pollutions as stigmatized, threatening excesses. Jonathan Culler summarizes Douglas's reading of cultural forms as an insistence that 'dirt is vital evidence for the total structure of thought in a culture because it is an omnibus category for everything that is out of place. To investigate what counts as dirt helps to identify the categories of the system' (1985: 2).

Tracking 'white trash' as the manifestation of a pollution ideology and the mobilization of a rhetorical identity in a discourse of intraracial differences provides a perspective on a particular naming strategy that is a basis for maintaining the unmarked status of whiteness. It also enables a means for understanding how such an unpopular cultural form provides a representational dumping ground in which excessive forms of whiteness that blur racial boundaries can be exorcized. As an unpopular culture, the images and instances of 'white trash' in mainstream media productions work as examples of what whites cannot afford to be if the propriety of their implicit racial privileges are to be maintained. Rather than simply providing a glimpse of a certain social group, instances of 'white trash' open a perspective on the broad social order from which they have been exorcized, and which they daily transgress.

I use the notion of an unpopular culture here in order to objectify the tensions inherent in assessing the status of 'white trash' in popular cultural productions.[10] 'White trash' is difficult to place in the polarized realms of 'high' and 'low' cultural forms, primarily because it is a term that is used to maintain these two realms as absolute divides. And it is a mistake to consider 'white trash' as simply a 'popular' expression of an aesthetic value of 'the people', because the term is often also used by lower-class whites to stigmatize whites who fall even lower than themselves down the social ladder. Rather than constituting a unique cultural object or identity, 'white trash' manifests as a complex and charged cultural poetics (Hartigan, 1992). The meanings, effects, tendencies and images which the name assembles do not simply reside in individual bodies or a group of bodies but, rather, are

generated in complex code struggles between classes and races, and over what will count as sexuality or gender. In this sense, white trash 'exists' as much in middle-class fears and fantasies as it does in the 'trashy' bodies of poor whites and their shared stories and talk.[11]

Before turning to current instances of the name and an attempt to understand the economy of examples that operate under the sign of 'white trash', I want to offer a quick sketch of how the term became nationalized, evolving from a very specific term in local use to a sign under which an expanding range of cultural operations is taking place.[12] However, I must stress that this cursory outline of the national expansion and movement of the stereotype 'white trash' is not the same as a social or even cultural history of 'white trash'. There are several recent works that have attempted to portray a social history of 'poor whites', such as Charles Bolton's *Poor Whites of the Antebellum South* (1994), Bill Cecil-Fronsman's *Common Whites* (1992), I.A. Newby's *Plain Folk in the New South* (1989), J. Wayne Flynt's *Poor but Proud* (1989) and Grady McWhiniey's *Cracker Culture* (1988). These social historians, conducting something of a salvage operation in the wake of broad master narratives of American history, largely constitute their objects of study in contradistinction to 'white trash'.[13] In their efforts to construct a sympathetic account of the 'poor' or 'plain white' tradition, they explicitly discount the application of 'white trash' to their subjects. I.A. Newby makes the case most forcefully in his Introduction, 'Plain folk, "poor whites", and "white trash" ' (1989: 1–19). He asserts that his object of study is

> roughly the poorer half of the white population . . . who had never evoked much sympathy and whose history has been more often overlooked or caricatured than studied systematically and evenhandedly. Alternately disparaged, patronized, and ignored, these people have never received what every group is entitled to – a sympathetic look into their history that seeks to understand them on their own terms. Historians, like other people, have stigmatized all or many of them as 'poor whites,' 'white trash,' 'crackers,' 'rednecks,' or 'lintheads,' and smeared them with the demeaning qualities those terms convey – benumbing poverty, social wretchedness, assorted bigotries, moral and physical degeneracy. Few labels of wide currency have embodied, and still embody, more elitism and sanctimony than those, and only the kinds of racial and ethnic slurs no longer admissible in public discourse have served so widely as substitutes for informed and open-minded inquiry....Terms that embody such prejudices are not useful for historians and should be discarded. They are epithets at best, moral judgments at worst. Even the most neutral of them – 'poor whites' – focuses attention exclusively on the economic aspect of identity and, in turn, on victimization and degradation.
>
> (1989: 3–4)

Newby makes a strong case for discarding such loaded, derogatory nominations as 'white trash' in order to compile a 'sympathetic' account of a

disparaged and exploited people. But such a tack is counter-productive when attempting to make sense of current uses and instances of 'white trash' where what is of critical interest is the operation of social contempt mobilized by the term. If images of poor whites in popular cultural forms were reduced to a generic, neutral form of reference, the rhetorical identity of 'white trash' as a function of a discourse of difference would evaporate and be rendered unintelligible. We should not hold out for a better approximation (a more valorized) account of the social bottom of whiteness. Rather, by tracking the dirty racial work performed by 'white trash', we can directly see the means of boundary maintenance through which a bottom, or outer bulwark, of whiteness has operated, containing or expelling certain whites from the social and political body of whiteness.[14]

Tracking the nationalization of 'white trash' is no easy task and I can only offer a brief sketch of such a cultural archaeology by suggesting the landmark instances that promoted 'white trash' in the national consciousness.[15] Two enormously successful novels that became films offer a good starting point: *Gone with the Wind* (1936) by Margaret Mitchell, and Harper Lee's *To Kill a Mockingbird* (1960). While other novelists, travel writers and journalists had conveyed explicit instances of 'white trash' to an interested American public, these two works have a prominence based on the continued fascination with their figures and plot, particularly in the case of *Gone with the Wind*.

These works can be linked to the broadcast of a convenient myth of 'white trash' that still informs its uses today. As representations of white decorum, honour and pride, these dramas rely on objectifications of 'white trash' to undermine, threaten and finally restore cultural order. These two works presented views of the South to the nation at large, depicting a decorum-laden world in which social orders were naturalized and enduring. Though *Gone with the Wind* featured that world turned upside down, when the social order was restored following the close of reconstruction, not only were blacks still disenfranchised but the social contempt directed towards impoverished whites also remained unchanged. The 'white trash' family, the Slatterys, gall and disgust Scarlett – their images recur throughout the novel. They 'kill' Scarlett's mother by infecting her with typhoid; they stake an unrightful claim to Tara, attempting to acquire the plantation for the cost of back taxes; the unrelenting dread of sinking as low as these whites drives Scarlet insatiably to reverse her desperate slide in social status. While (white) Americans' attractions to this story are disparate, surely its most alluring aspect is the images of a social world in which racial power and privilege were absolute; a world where blacks 'knew their place', and poor whites, as well, were maintained at a conventionalized, contemptuous remove from polite society. References to 'white trash' play a critical role in naturalizing this version of society.

To Kill a Mockingbird offers a scathing indictment of this society, and dramatizes the perverse maintenance of a racially segregated social order, where whites brutally maintain their dominion. Lee's tale, though, also depends on 'white trash' to make its point. While the proper whites, who

are willing to believe the false accusations of a 'white trash' girl, are hyp-ocritical and morally corrupt for condemning an innocent black man, the most sinister figures in this novel are the 'poor whites'. And while Lee's drama made a compelling case for contesting and overturning the opera-tions of everyday life in the South, which were so brutally effective in grinding down blacks, what remains unquestioned in his exposé is that a certain class of whites are always to be held beneath contempt. Defence attorney, Atticus Finch, sums up Mayella, the 'pathetic' 'white trash' accuser:

> She committed no crime, she has merely broken a rigid and time-honored code of our society, a code so severe that whoever breaks it is hounded from our midst as unfit to live with. She is the victim of cruel poverty and ignorance, but I cannot pity her: she is white. She knew full well the enor-mity of her offense, but because her desires were stronger than the code she was breaking, she persisted in breaking it.
>
> (1960: 206)

Both before and since *To Kill a Mockingbird*, the blight of white racism has been conveyed to those whites who must confront and change it via images of the fury and rage, manipulativeness and desperation, of poor whites. The question, here is not whether or not such depictions are more or less accurate in their portrayals. The 'white trash' myth allows an insidious belief to stand: that it is only 'those people' who are racist; only those women who are so licentious; only those men who are that cruel and violent. The dramatic background projected by both *To Kill a Mockingbird* and *Gone with the Wind* are etiquette-drenched worlds, where instinctive, naturalized differences between whites are indelible. Even in a work such as Lee's, which promotes a hope and insistence that whites, broadly speaking, change their views and understandings of the position of black people in this country, the 'Ewells', the 'white trash' family, are held up as that which cannot ever change. They remain in the end as the 'kind of men you have to shoot before you say hidy to them. Even then, they ain't worth the bullet it takes to shoot 'em' (1960: 272). This assessment is passed on transgressions quite apart from their connection to racism and the oppression of blacks.

In these nationally broadcast images of 'white trash', part of what is reproduced is what historian Joel Williamson (1984) has referred to as the 'grits thesis', a certain class interpretation of politics and race relations in the South, championed by conservative, white elites who located the blame for racial violence solely among 'the great unwashed' population of poor whites. Promoted strongly around the turn of the century when populist stirrings threatened to expand the franchise first extended under Jackson-ian democracy, this 'grits thesis' obfuscated the fact that 'upper- and lower-class whites have actually worked in tandem on the racial front. They have functioned, not against each other, but both against the Negro, the inter-mittent, sporadic, open violence of one complementing the steady, per-vasive, quiet violence of the other' (1984: 294–5).

What Williamson found disturbing in the 'grits thesis' is its endurance,

and the effective means it provides for masking the pervasiveness of white racism.[16] He notes:

> The Ku Klux Klan of the Reconstruction era was at first organized and headed by upper-class whites, and studied terror and violence were its chosen instruments. Turn-of-the-century mobs included 'respectable' persons sometimes as participants and ordinarily as spectators. When the physical subjection of the black man was achieved, when he was down and out and seemingly promised to stay there, the necessity for violence decreased, and upper-class Southerners could very well afford to see themselves as the even-minded children of light and peace. The whole idea of a specially vicious attitude towards blacks prevalent among lower-class whites is an upper-class myth. It was primarily a technique that the elite used to divorce itself from unflattering deeds no longer productive, and thus to arm itself to take the lead in peacefully putting things back together in a lasting order with itself at the top.
>
> (1984: 295)

As Douglas has argued, pollutions function 'as analogies for expressing a general view of the social order' (1966:13). One of the pollutions which 'trash' is used to name and achieve some distance from are largely those volatile social dangers of racism and sexism. Part of what the epithet 'white trash' expresses is the 'general view' held by whites that there are only a few extreme, dangerous whites who are really racist or violently misogynist, as opposed, for instance, to a notion that racism is an institutional problem pervading the nation and implicating all whites in its operation. In this naming operation, 'bad' whites perform as examples by which the charges of racism can be contained. Sociologist David Wellman, in *Portraits of White Racism* (1977), details some of the discursive strategies by which middle-class professionals depict their efforts at preserving racial privilege as distinct from the prejudiced sentiments of poor whites. Wellman also notes the persistence of sociological placements of prejudice in the 'poorly educated; the aged; those living in rural areas; poor minorities; dogmatic religious groups; those of low socioeconomic status; social isolates; people raised in authoritarian families. If Archie Bunker is fiction, sociological theories about prejudice have helped create him' (1977: 9). Instances of 'white trash' in popular culture function as an economy of examples which delimits certain social contagions as pollutions and negotiates confusions, anxieties and uncertainties over racial, gender and class identities. 'Trash' is the label applied when a white social decorum is ruptured. In tracking 'white trash' we discern the structure and texture of a decorum – a class and racial etiquette – that is too often invisible, conventionalized as a normative condition upon which others are marked by their racialness.

The proliferation of instances of 'white trash' in popular cultural productions has been noticed by a variety of commentators. *Vogue* pointed to this trend in 1988. 'While books, magazines, and TV have been wallowing in the lifestyles of the rich, richer, and famous, a counter-trend

has evolved – downmarket chic. Part nostalgia, part condescension, it's a campy attitude toward trailer parks and diner food, redneck rock and inarticulate heroes, bowling-for-fun and the Mafia school of interior decorating.' Reporter Margo Jefferson went on to offer as explanation that:

> The rich are clearly more different from you and me than we might hope, and the poor are clearly less different than we would like. And so there seems to be a change of focus. Our insatiable curiosity, our desire to spy on, gape at, fantasize about, and revel in the doings of the wealthy elite has shifted; now we want to spy on, gape at, fantasize about, and revel in the doings of the downscale and the declasse. You see the impulse in the graffiti and the trailer-park photography that fills art galleries, and in the self-proclaimed 'white trash' cookbooks and guide books. You see it in the rise and spread of hitherto 'ethnic regional' and 'underclass' music like Cajun and rap, and in the popularity of decorative accessories like plastic flowers and thick layers of chunky costume jewelry. What was once considered the province of people who didn't know any better has been claimed, upgraded, estheticized, and turned into chic Americana.
>
> (1988: 344–5)

Following this exposé in *Vogue*, several journalists have attempted to explain the rampant interest in 'white trash'. Amy Spindler called attention to the emergence of 'white trash' in popular cultural forms in an essay, 'Trash Fash' in the Sunday *New York Times* (1993). Spindler commented that, '[t]he trendy genre film of the 90's seems to be trash run amuck. And whether it is Ms. Arquette in "True Romance," Drew Barrymore in "Guncrazy," Ione Skye in "Gas, Food, Lodging," or Juliette Lewis in "Kalifornia," ' Hollywood has mobile-home-park fashion pegged to the last tattoo and peekaboo bra strap.' This interest in 'white trash', Spindler noted, has spread from the realm of movie fantasy to the fashion industry, as evidenced in Arquette's posing for Armani, and the 'lawn chairs, carnival rides and, of course the omnipresent house trailer' featured in Wayne Maser's photo spreads for Guess? jeans and album covers for John Cougar Mellencamp. Such explanations for this current fascination with 'white trash' are keyed largely on the realm of aesthetics: 'Part of it seems to be pop culture's romance with the disenfranchised. The fascination with trailer-park esthetics neatly parallels a trend that has left whites by the side of the road: hiphop and gangster rap, with their emphasis on impoverished roots and violence. This is poverty and violence in a white setting.'

This attention on aesthetics as the central register by which 'white trash' is evident in popular culture has advantages and drawbacks. Like the subject itself – diffuse, sprawling and unattainable – 'trash' is grasped clearly and succinctly in images from movies and advertising. But in this mode of attention it is easy to trivialize the demographic and social shifts underway in America's class structure. In a wide-ranging survey of popular culture and politics, Tad Friend, in the magazine *New York*, links the

emergent 'age of white trash' to the expanding 'white underclass' (1994: 24). Unfortunately, as is common with any invocation of the 'underclass', Friend immediately cites 'behaviour' as the defining feature of this group, rather than suggesting that class identities are relational, changing as economic transformations develop and unfold. 'What's alarming is not so much the burgeoning number of people with low-rent circumstances as the exponential spread in stereotypically white-trash *behavior*, whether exhibited by those in the underclass or by figures like Roseanne Arnold or Bill Clinton' (1994: 24; emphasis in original). The end result of a singular attention to behaviour is an inevitable implicit or explicit assertion of simple 'childishness' at root. Friend concludes: 'True trash takes what it needs and claims it's what it deserved. True trash is one long boiling tantrum, primed to explode. True trash is the terrible twos forever. The culture is in a panic to find its collective inner child. Well, here he is' (1994: 30).

An alternate mode of tracking the significance of 'white trash' requires shifting attention from the consumers to the producers of these fascinating subjects. While interests of the middle class provide a key momentum to the proliferation of 'white trash' in the realms of popular culture, it is also the case that poor whites are grudgingly gaining certain degrees of control over their own representations. Performers and writers, more than ever before, are now actively willing to claim the identity. The following quote is taken from Mojo Nixon, who gained renown on MTV for such works as 'Debbie Gibson is pregnant (with my two-headed love child)' and 'Don Henley must Die!' Mojo:

> When I sing about Cheez Whiz and barbecue and Beenie Weenies, its all part of this weird white trash sensibility. I call them the front porch food groups. You see, we were supposed to pretend to be middle class, but I come from a group of people who grew up in small towns in North Carolina during the depression. Their whole modus operandi was to try to deny that – to try to be the 'Donna Reed Show.' But I'm the next generation and I can embrace all that stuff that made them so uncomfortable.[17]

In Mojo's reading, there has been a distinct generational shift in how whites negotiate the assumptions and impositions of class decorums; a few whites who have grown up hopelessly removed from, and incapable of assimilating to, the normative markers that more privileged whites have maintained as an unmarked cultural order, find themselves able to fashion their remove and distance from the body of whiteness as an expressive and articulate position.

From *Roseanne* to *Trash* (by Dorothy Allison), it is possible to read images of 'white trash' as a carnivalesque aesthetic, a transgressive celebration of the 'grotesque' body (with its illicit sexuality and propensity for cathartic emotions) that will not be restrained by the constraints of (white) middle-class social decorums. But such a reading would simplistically valorize the anti-authoritarian aspects to the name and the image, while losing sight of how socially uninhabitable the space is that 'white trash' designates.

Turning now to those who use the term as a means of self-designation, the contours of social contempt and tenuous economic standing are increasingly apparent. And in these contours, the struggles to resist the contaminating connections of 'trash' are amplified. No matter how valorized, what is irreducible in 'white trash' is the inscription of social difference that is relentless even among members of the white working class. Considering 'white trash' as an unpopular culture maintains an attention to the tendency with 'popular culture' as a critical, objectifying term, to homogenize producers and consumers of everything that does not count as high culture.

As mentioned above, only recently has 'white trash' been deployed in cultural productions as a mode of self-naming or as a means of invoking a positive group identification. But even in such uses there is frequently a provisional, accompanying qualification. Even in attempts to treat the name positively, to redeem it as a cultural identity, there is an active remainder that cannot be fully expelled; 'white trash' continues to serve as an irresistible referent to those that rupture white social etiquette. In *White Trash Cooking* (1986), an 'authentic' effort to depict a cultural tradition in relation to food, Ernest Mickler, in the first line of the Introduction, claims an inability to ' write down on paper a hard, fast definition of White Trash'. What he comes up with, though, is the statement that 'the first thing you've got to understand is that there's white trash and there's White Trash.' The lower-case is common and worthless; the upper-case has tradition and pride. Even when the name is being redemptively put forth as a prideful identity, 'white trash' is divided against itself and is still called upon to perform the distancing duty of designating 'those people' as low-down and beneath contempt.[18]

This play of upper- and lower-case namings of 'trash' is also at work in the writings of Hunter S. Thompson, whose dexterity in assigning the term authoritatively both derives from and serves to efface his more personal connection with the identity. The following quotes appeared in his syndicated weekly column.[19]

No more wretched example of high-powered White Trash exists in America today than Lester Maddox. When the Great Scorer comes to write against Lester's name, he will get the same chance as Knute Rockne. There will be no question of whether he won or lost but how he played the game. And there will be a special dung heap in the low-rent section of hell for that brute.

(14 July 1986)

Oral Roberts is a greed-crazed white trash lunatic who should have been hung upside down from a telephone pole on the outskirts of Tulsa 44 years ago before he somehow transmogrified into the money-sucking animal that he became when he discovered television.

(30 March 1987)

These two instances, the capitalized and the small-case namings, squirm between deeply powerful evil (Lester Maddox) and the merely disgusting

and contemptuous (Oral Roberts, a case of white trash that obviously did not know its place or disrupted too many assumptions about how power and money work in this country).[20] It is hard to imagine the name standing for anything other than these most familiar forms of usage. If we accept that there is something that simply and objectively is 'white trash', these would most likely be the representative connotations. But 'white trash', like any symbolic material, is eminently 'good to think with', and rather than leading to a facile sketch of cultural types, the following uses of 'trash' all demonstrate a term at work, marking and negotiating the social distinctions that keenly concern the white working class.

Uses of 'white trash' in Country Western music give a broader sense of the cultural complexity to the term. While other derogatory referents for poor whites, such as 'Redneck' and 'Hillbilly' have gradually become valorized terms of self-identification where the badge of the labels' social contempt is worn proudly, 'white trash' remains too contaminated and volatile.[21] The progression of 'hillbilly', from derogatory label to a raucously claimed identity, is illustrative of the processes involved with such transformations. 'White trash', of course, follows in the wake of a more grudgingly neutral designation of the music produced by lower-class rural whites – 'hillbilly'. The progression of 'hillbilly' to an accepted, neutral term for the tradition has been quite long. The shift was perhaps first noted by Charles Seeger, who suggested in 1946 that ' Hill-billy music seems to be a super-hybrid form of some genuine folk elements which have intruded into the mechanism of popular culture.'

Folklorist Archie Green claims that 'the term hillbilly music was born out of the marriage of commercial industry – phonograph records and some units of show business – with traditional Appalachian folksong' (1965: 205). To this day, though, 'hillbilly' carries a remnant of its once solely contemptuous marking; it remains critically useful for designating a certain cultural style that remains removed from a broader identification with the 'mainstream' of the white middle class. Green summarized the ambiguous nature of the term's historical connotations: 'not only does High Culture frequently downgrade the artifacts that document hillbilly music – record, folio, radio transcription, barn dance show, rural drama – as trash, but for two centuries it has labeled the very people who produced the music as poor white trash' (1965:206). The term 'hillbilly' has developed an ability to refer to a valorized past before the commercial success of this music. 'White trash' has not experienced a similar transformation.[22]

Of course, part of the transformation of 'hillbilly', like 'redneck', is linked to the broad rise in social mobility experienced by many country music fans and performers. Richard Peterson (1992) notes that the numerous songs that have 'redefined the word "redneck" are important not simply because a term of derision was turned into a positive, but because it was made into a kind of badge voluntarily worn. To call oneself a redneck is not so much to be a redneck by birth or occupational fate but rather to identify with an anti-bourgeois attitude and lifestyle' (1992: 58). Peterson quotes one of country music's most influential disc jockeys, Hugh Cherry, who notes that

'While being a "hillbilly" was something you were born to and fated to remain in the 1930s, anyone who is a "hillbilly" today is a "hillbilly" by choice. By the latter 1980s, all of these terms of prideful identification [redneck, hillbilly, country boy] had become virtually interchangeable with each other in connoting a working-class lifestyle and consciousness. Thus, using any of these terms was tantamount to evoking working-class consciousness' (ibid.). 'White trash' retains the indelible imprint of the stigma of poverty and unending social deprivation that sets it apart from these other means of self-identification.

In country music, 'white trash' has never received much prominence. With rare exceptions, it is still used largely as a means of differentiating between whites at the bottom of the social and economic ladder. The megagroup, Sawyer Brown, had a hit in 1992 with ' Some Girls Do' . The chorus: ' Well I ain't first-class, but I ain't white trash/I'm wild and a little crazy too/ Some girls don't like boys like me, but some girls do.' Clearly 'trash' has yet to stray far from its contemptible inscriptions. Interestingly, one of the other few references to 'white trash' comes in Reba MacIntyre's recent remake of the late 1960s classic, 'Fancy'. This song recounts a dying mother's last ditch attempt to move her daughter 'uptown' by making her into a socially viable, sexually marketable attraction. The song features the daughter's defiant assertion, 'I may have been born just plain white trash but Fancy is my name.'

Such sexualized images of 'white trash', though, easily shift from self-motivation and social 'betterment' to painfully comic immobility. The hugely successful Bellamy Brothers had a hit with ' Redneck Girl' ; they followed it up with a parodic song that leaves little valorous ground for poor white women. The chorus runs: 'She's trash, white trash/ Shooting that bull and slinging that hash/ long on nerve and short on cash/ she ain't nothing but white trash.' This song, as well as providing a sense of comic distancing from the vulnerability implicit in valorizing the ideal 'Redneck Girl', highlights the sexual charge carried in degraded objects. This remains the most common usage of the name in country music today, as evidenced in Confederate Railroad's hit, 'Trashy Women': 'I like my women a little on the trashy side/ When they wear their clothes too tight and their hair is dyed/ Too much lipstick and too much rouge/ gets me excited leaves me feeling confused/ I like my women just a little on the trashy side.'

Extremely rare for males is the use of 'white trash' to name the bitter social discrimination and scorn for lower-class whites. Steve Earle who, following his early success strayed from the fold in Nashville, deployed such a usage in the title cut on his *Copperhead Road* album, in a song that relates the story of three generations of men in a backwoods, white trash family. In this case, 'white trash' names those whites who, along with blacks and Hispanics, bore a disproportionate burden in Vietnam.[23] 'I volunteered for the army on my birthday/ They draft the white trash first round here anyway/ Done two tours of duty in Viet Nam/ I came home with a brand new plan/ Take seeds from Colombia and Mexico/ Just plant 'em down the holler on Copperhead Road.' A similarly self-debasing usage of 'white

trash' is Dwight Yokum's mumbled, 'I'm gonna take this white trash on out of here' in the song 'Long Black Cadillac'.

If country music performers and producers are not exactly enamoured of the term, there are others who actively invoke the phrase. Today, 'white trash music' seems to largely refer to the producers of 'grunge' or 'heavy metal' sounds. These are certainly the genres that claim the name most often, with group names ranging from White Trash to Cracker, the White Trash Debutantes and Dirty White Boy.[24] Rather than drawing on any regional origins or 'family tradition' of social standing, these bands make productive use of the transgressive, shocking position which the label effects. Grunge bands, though, hardly have a monopoly on the term. The 'tradition' that is forming of this position/identity can be loosely sketched from Edgar Winter's *White Trash* live album (Epic, 1972) to Alice Cooper's *Trash* record (Epic, 1989), and includes Bad Religion's cut, 'White Trash', off of their *How Could Hell be Any Worse?* album (Epitaph). It is continued in Exene Cervenca's 'White Trash Wife' on *Old Wives' Tales* (Rhino, 1990), and The New Duncan Imperials' 'White Trash Boogie' (*The Hymns of Bucksnort*, Pravda, 1993). Of course, this 'tradition' parallels other usages, ranging from 'high art' to 'folk', from Orchestral Movements in the Dark's 'White Trash' on *Junk Culture* (A&M Records) to the collection of East Coast up and coming folk artists, *White Trash: N.Y. Folk, Volume One* (109 Record, 1989).[25] As with 'hillbilly', in grunge or 'alternative' music, the current popularity of 'white trash' perhaps indicates a loosening of the visceral inscription of class identities, and the cultural capital earned in effectively transgressing certain white versions of mainstream culture.

The role of 'white trash' in other expressive cultural forms, such as literature, is also complicated. There has been a long tradition of deploying figures and images of trashy whites in popular writings in the US. While it would be interesting to compile a list of authors and works that feature such whites, the present space is insufficient to analyse the ideological content and function of such images. A more succinct tack, though, is to consider the 'expressive' role of 'white trash' authors, and the problematic question of an authentic 'voice' of trash. Here I would only like to frame the problematic by looking at two recently successful authors, Carolyn Chute (*The Beans of Egypt, Maine* (1985); *Letourneau's Used Auto Parts* (1986)) and Dorothy Allison (*Trash* (1988); *Bastard Out of Carolina* (1992)).[26] Both Chute's and Allison's work revolve around stories of poor whites, based on their personal experiences of poverty. Critics have applied the label to each of their hosts of characters, but the authors have responded quite differently to these assignations.

The difference between these two writers is that Chute rejects the label 'white trash' as just another instance of the class contempt that maintains the painful stigmas of poverty. Chute has objected to the use of ' white trash' as a means of identifying herself or her characters, and has reacted furiously to the numerous reviewers, like Bertha Harris in the *New York Times Book Review*, who have used the phrase to describe 'her people'.[27] Allison,

however, promotes the name, and chose to call her first collection of short stories *Trash*. Allison's approach to writing is openly biographical. Her recent novel, *Bastard Out of Carolina*, is, in part, a careful chronicling of the author's developing understanding of the social position in which the inscription, 'white trash', placed her and her family. Indeed, the central character, Bone, laments early in the novel:

> Just for a change, I wished we could have things like other people, wished we could complain for no reason but the pleasure of bitching and act like the trash we were supposed to be, instead of watching how we behaved all the time.
>
> (1992: 66)

The contrasting relations of these two authors to the label 'white trash' emerges, in part, from their distinct positions in the markets for novels in the US. Chute's works have been presented for a 'general' audience (published by Warner Books and Harper & Row), and reviewers have questioned the suitability of her subject matter. Allison (published first by Firebrand Books and latter by Dutton), on the other hand, who offers very personal accounts of her developing lesbian sexuality, has been marketed to an 'alternative' audience that is attracted to transgressive actions and identities.[28] To assert a shared 'white trash' voice or identity to these writers would be to ignore the distinct positions from which the correspondences in their lives and styles arise.[29] Chute's discomfort with the term being applied to her work by well-educated, cultural critics points out that, as purveyors of the popular, we cannot simply blithely assign the term to any object or product that matches a mental checklist of what 'white trash' supposedly is. The term, wielded by a member of the middle or upper classes, cannot be neutralized of its stigmatized charge simply by the good intentions of the user.

But despite Chute's discomfort with the label, there are tempting reasons to use 'white trash' in relation to work, primarily because she so effectively conveys the intimate clashes between the social bodies differentiated by 'white trash'. Apart from Chute's characters and general style, the dramas that she depicts offer a compelling version of what is at stake in 'white trash'. More so than Allison's writings, Chute conveys the civic stage on which classed conflicts between upper- and lower-class whites continue to be waged in small towns all over America. In this regard, she objectifies the gaze that inscribes 'white trash' and the position that cultivates the reservoir of social contempt that animates the term's usage.

The narrative of *Letourneau's Used Auto Parts* features the efforts of the city council to pass and enforce building codes that will eradicate the precarious groupings of trailers at the edge of town. The novel follows the steady strides of the 'Code Man' and the sheriff's deputies as they make their rounds, and the people who are driven from their trailers and to suicide or random acts of violence. It is the charged class context that makes the connection with 'white trash' tempting. Scenes throughout the book

position 'trash' in a way that makes the political and economic stakes quite clear in instances that only seem to involve a contest over aesthetics. In a scene where 'bad neighbourliness' might be the simple middle-class effort at thematizing an incident, Chute's account articulates another perspective. In the following description, Maxine has just been told by her new (more up-scale) neighbour to stop her guests from turning around in his driveway and not to park in front of his property.

> Maxine's thick neck quivers. 'What do you care where people park. . . . This aint Connecticut. This is the WOODS!' She is starting to tell him about how she has no control over what her company does, about how one of them might whip right into his dooryard to turn around before she could stop them . . . but he is walking away from her.
>
> After his trailer door closes, the quietest door-closing Maxine has ever heard, she heads for her door. She has to step high because of no porch. Inside, she crosses the kitchen to the sink, stands there looking into the drain.
>
> 'What happened, Mama?' Ryan asks. He comes up behind her and gives her pretty blue cowboy shirt a little pull.
>
> The usual,' says Maxine, mashing her Tiparillo in the sink. 'The usual half-brained idiotic mother-fucking crap represented by eighty-nine percent of the human being population. . . . Damn them all to hell. I've HAD it.
>
> What are you going to do?' he asks, looking around at the bright open door to the yard.
>
> I don't know,' she snarls. 'We're outnumbered, for crissake.'
>
> (1986: 81)

Does 'white trash' name a minority discourse?[30] Does 'white trash' refer uniquely to that minor population of poor whites whose lives and dreams are ground down in the interests of (white) middle-class desires and projects? This is just one of the complex confusions of critical namings and political agendas which an interest in white trash encounters. But as a front in the continued internal wars of capitalism, the exclusionary strategies and the disciplinary tactics which disperse the recognition of class conflict into multifaceted bodily concerns (over hygiene, over decorum, over consumerism) make of 'white trash' a vulnerable, threatened social position. The attacks come from within a body labelled 'trash' in the forms of self-doubt and self-contempt, as much as from the neighbours. This makes 'positions' difficult to articulate. But the heavily naturalized investments in middle-class order (such as lawn care and quiet streets) and the support they receive in legislation and policing, needs to be named as an aspect of class conflict. And the violent forms of anxiety and contempt must be named in relation to the base of power from which they derive. The use of 'white trash' in this article attempts to implicate those very interests in status that police public discourse against such unpleasantries. 'White trash' insists on the ties that bind the detached, well-composed observer in a particularly nasty way to this disturbing object.

There is another key site of popular culture that offers a broad collection of instances of 'white trash' – the movies.[31] In this realm of cultural productions, there is less of a question of ' authenticity' or 'voice'; with scant exceptions, 'white trash' do not produce their own stories in Hollywood.[32] The compelling question about films that feature 'white trash', though, is whether or not their images are objectifications of a contemptuous other to (white) middle-class moviegoers, or have Americans recently found in 'white trash' a figure that, in symbolic terms, is quite good to think with? What differentiates *Kalifornia* from *True Romance?* In my opinion, *Kalifornia* offers up an extreme caricature of white, class positions and, through their polarized interplay, presents a keen rendition of how class operates intraracially in the United States today. While *True Romance* has been cited as a drama about 'white trash', the film is more of an idealized fantasy that is compelling and dramatic because of the desperate financial straits of its central characters. Running from mob hit men is not the same as driving in a car cross-country, sitting side by side with a contemptible and dangerous class other.[33]

But rather than attempt an authoritative listing of which films 'really' are, or are not, about 'white trash', I prefer to point to a few ways such characters have been used to figure and refigure shifting subject positions and identities in the 1990s. The year 1991 offers three prime instances of films relying on 'white trash' characters to think through or to ground shifting cultural orders and social realities: *New Jack City, Silence of the Lambs*, and the remake of *Cape Fear.*

In *New Jack City*, a great deal of attention is given to economies of vision relating to the 'inner city'. The vast majority of the characters are black, and there is a well-developed tension over the white gaze and the participation of whites within the drama. As well, *New Jack City* highlights the precarious basis of black male bonding between 'brothers' on the street and the confused connection between blackness and 'the streets'. In order to authenticate the white man's position in the film, and to establish the depth of his sincere interest in the drama's outcome, the white cop, Nick Paretti (Judd Nelson), is designated as 'white trash'. There are few objective indicators of his status as trash, but in the crucial bonding scene between him and Scotty Appelton (Ice T), he names himself as 'white trash'. When his presence is most tenuous, after their undercover connection, Pookey (Chris Rock), has been murdered by the gangsters, Paretti asserts, on a rooftop drinking scene with Ice-T, that 'I used to be Pookey'.

An incredulous T replies, 'Hows that?
Paretti answers, 'I was a poor white trash Pookey.'
After a dramatic silence, this claim allows Paretti to speak the moral of the film:
'This whole drug thing. . . . Its not a black thing; its not a white thing. Its a death thing. Death doesn't give a shit about color.'

The 'white trash' figure, in this film, breaks down the racial barriers and reveals that the nature of underclass entrapment, despair and devastation transcends racial lines.

Silence of the Lambs, a brooding, tension-filled film on the perversity of transformations, deploys a completely different usage of 'white trash'. Agent Starling (Jodie Foster), a young woman, initially desperately out of place in the fiercely male institution of the FBI, transforms herself through a series of humiliations and moments of intuitive brilliance into a professional agent. Aside from her gender, what makes her alteration so gruelling is the class divide that she must first cross. In her first meeting with Hannibal Lector (Anthony Hopkins), he blunts her efforts to 'dissect' him, and turns the objectifying gaze back upon her. Lector reads her:

'You're so ambitious aren't you?
You know what you look like to me, with your good bag and your cheap shoes?
You look like a rube, a well-scrubbed hick.
Good nutrition's given you some length of bone, but you're not more than one generation from poor white trash. Aren't you Agent Starling? And that accent you try so desperately to shed – pure West Virginia.'

The beat-up Ford Pinto to which she retreats, distraught, in the parking lot seems to confirm his reading. Her background is both a blemish and the means that enable her to track the murderer, since the killer stalks women in the small towns of West Virginia and along the river in Ohio. As she tracks the killer to his lair, she comes face-to-face with the women she might have become if she had not transformed her class identity and left behind these backwater towns. In the end, Agent Starling's triumph effaces any trace of her connections to the past, a past that had haunted her and that she was required to eradicate.

Cape Fear offers a more 'traditional' use of 'white trash', but one that, like the film itself, was updated for the 1990s. As with the succeeding generations of *The Terminator* or *Freddy*, the second version of Max Cady is 'white trash' with a vengeance, more terrifying than most previous male 'trash' figures. The momentum of rage derives from a particular class vengeance: a lawyer, knowing his client, Cady, is illiterate, deprives him of effective counsel, insuring that he will be found guilty. The new *Cape Fear* depicts a nightmare of the 'underclass' rising up and lashing out: in jail Cady learned to read and discovered the true nature of the crime against him. The original film featured a suave, if ominous, Robert Mitchum as Cady, and the extent of his social failings are conveyed in the now mild designations 'rock bottom' and 'the lowest'. With Robert DeNiro's tattoo-covered body and the repeated references to 'white trash', there is no ambiguity about the class divides between these whites. Cady describes being raped by white men and black men in prison, invoking the kind of perversity that has long been an accent on 'white trash' figures. The 1990s *Cape Fear* still explores the durability of the social system to protect 'decent, law-abiding citizens', but the depths of the class divide between privileged and underprivileged whites has spawned new terrors that would have seemed unimaginable in the 1950s and early 1960s.

This film offers a good opportunity to return to the quote from Charles Murray that opened this article. The appearance of 'white trash' on the pages of the *Wall Street Journal* demonstrates that the name remains an acceptable term of derision. And such derision requires that cultural critics be extremely cautious in using the name. I refer to Murray, here, not simply because of the contemptuous way he uses 'white trash', but because he is trying to come to terms with a drastic reconfiguration of social status in the United States. There is indeed a 'white underclass' now forming, and how that 'class' will come to speak or be represented in popular cultural forms is quite open-ended at the moment. On the one hand, there is Murray's usage, which he deployed more caustically (to a more receptive audience) in the *National Review*, in an article boldly entitled 'White welfare, white families, "White Trash"'. In this work, he pointedly tried to revive old stigmas in the term, just as he and his colleagues have attempted to re-stigmatize female-headed households and out-of-wedlock births. Through changes in welfare policy between 1960 and 1980, he claims, '[w]e manu-factured large numbers of people who behave in the same ways as the people our grandparents called trash' (1986: 33).

In this article, in order to counter the 'myth' that illegitimacy among whites was spread evenly over the social classes (what he referred to as the 'Farrah Fawcett Hypothesis'), Murray asserted the accuracy of the 'White Trash Hypothesis' which, he notes, 'has been around for as long as parents have lectured children, and which says that illegitimacy is essentially a lower-class phenomenon' (1986: 31). After listing all the drawbacks entailed in single-(female)parenthood, he rhetorically asks, '[a]re so many poor people really so stupid? In thinking about the answer to that question, the old White Trash Hypothesis fits uncomfortably well. Let me recast it in more polite lan-guage' (1986: 33). His more 'polite' characterization of the poor divides them simply into 'the people who can cope and the people who don't or can't'.

What is irreducible in all of the usages of 'white trash' reviewed here is the rhetorical quality of the name and the contaminated charge of 'trash'. From any position, these two aspects of the name are active; there is no stable referent to the term: uses continue to be fashioned; new bodies and speakers emerge that are inscribed with old labels; positions are established and contested in acrimonious exchanges of 'white trash'.

This article has been an attempt to survey the recent uses, and strange history, of 'white trash'. Instances of the name, related here, are in compli-cated and often confusing agreement. In thinking through the future 'career' of 'white trash', in tracing its further dissemination, it is important not to become obsessed with assuring that its uses remain 'authentic' or true to a certain presumed origin. The term will continue to be unevenly used. The reactions that I have evoked when I tell people of my interests in 'white trash' vary greatly by regions. In Tennessee and West Virginia, people con-sistently respond with the suspicious, loaded question: 'who are you calling "white trash"?' In California, people have been enthusiastic about a means of naming whites that transgress or reject the etiquette that maintains

whiteness as hegemonic. In this state, with so many 'rootless' whites, 'white trash' is an oddly comfortable assertion of a self-identity. These disparate reactions belong to the same moment, but point to the always critical matter of position and location that fundamentally determine the meanings and effects of 'white trash'.

One means for considering all of these varied usages is to think of 'white trash' as an unpopular culture. It is not the product or the sign of an undifferentiated 'people' from a 'mass audience' in the United States. Though aspects of its connotations aptly fit the carnivalesque aesthetic that Mikhail Bakhtin (1968) has described as the relational, competitive other to the 'classical' forms of 'high culture', the negative markings of the term make it equally active as a means of differentiating among partisans of 'low culture'. And whether or not it is taken as a self-identity or applied as an inscription of social difference, the relentless core of 'white trash' remains its remove from the mainstream of proper class and racial identities among whites. While other derogatory terms for lower-class whites have been transformed, it seems that 'white trash', at least for the time being, will remain an improper name.

Notes

1 The otherness of 'white trash' is an aspect of the regional otherness that Appalachia has served for white Americans at least since the last century. The region's general 'backwardness' has been objectified and represented in multiple genres – travelogues, scientific studies, novelistic settings and characters, and industrial rampages (Batteau, 1990). This sense of cultural otherness has hardly dimmed today (Stewart, 1996).

2 Interview in *Metro*, 'Wholly Greil', 30 April to 6 May, pp. 19–25, 1992.

3 'Tired of being labelled "white trash"' aired on 3 February 1992, and later rebroadcast on 12 June 1992. White women who had been called 'white trash' as children discussed the 'contagious' nature of the shame felt by their parents for their social shortcomings.

4 I draw the reference to whiteness as an 'unmarked identity' from Ruth Frankenberg's *White Women, Race Matters* (1993). See also Alexander Saxton (1990) and David Roediger (1991, 1993).

5 One notable, pre-1980 exception is the collection, *White Trash: An Anthology of Contemporary Southern Poets* (Stone and Grey, 1976). In the work's Introduction, George Garrett noted: 'Some southern writers would rather die slowly and badly than admit to a touch of trash. They will go to great lengths to deny there's any such (of a) thing as a Cracker in their gene pool or a Redneck in the woodpile. But the truth is every southerner has a streak of trash just as every selfsame southerner has a drop (just a tad) of Plantagenet blood. Some have the strength of character and well-developed mixed feelings (what editors fairly enough call "irony") to admit it and even enjoy it' (1976: xi). Stone and Grey add, ' if the news media, the philosophers of the instantaneous, continue to tout the Sun Belt, the South can expect a tsunami of tourists, retirees, and industry. White trash may then be in for the kind of attention that invites sayings from a lot of fake trash, so that anybody who can imitate William Faulkner or Tennesse Williams will be put in a book' (1976: xiv).

6 I use this phrase following Kathleen Stewart's (1991) call for 'contaminated cultural critique', which deconstructively 'disrupts the distance between observing subject and the "real" world of objects'.

7 The *Oxford English Dictionary* credits the first derogatory usage of 'trash' to Shakespeare in *Othello* (1604). Other early instances of the term in Britain all bear a distinctly gendered edge: 'Prostitutes, actresses, dancing women and that sort of trash.' In the US, the term has always been racially based. Eugene Genovese (1976: 22–5) and many commentators attribute the origins of 'white trash' to black slaves.

8 'Trash' demonstrates remarkable versatility; it is applied in a host of novel cotexts such as the band Cracker's song about a 'Eurotrash girl'. The term has also found use in computer hacker subcultures. See *Data Trash* by Arthur Kroker (1994).

9 What I am basically suggesting is that certain conflations of racial and class identities occur, such that whiteness is most identified with the lifestyles and behaviours of upper-class whites; working- and lower-class whites have their connection to a racial collective often challenged in subtle and implicit ways. This point is partly illustrated in David Roedigger's *The Wages of Whiteness* (1991).

10 I draw the notion of an 'unpopular' culture from the efforts of Stuart Hall (1981, 1994), Fredric Jameson (1990), and Renato Rosaldo (1994) to problematize readings of the 'popular' as a largely undifferentiated, homogeneous cultural realm. Each of these theorists have revised understandings of the 'popular' by emphasizing both the heterogeneous groupings of classes under the signs of elite and subordinate cultures and the relational basis of key categories and identities. It is tempting to read the figure of 'white trash' as a carnivalesque expression of the 'proletarian body'. John Fiske demonstrates the theoretical grounds for such a reading by describing the 'working-class body' as a 'dirty and threatening' figure that challenges the 'bourgeois sterilized body' (1992: 97–9). But taking 'white trash' as an expression of an undifferentiated 'people' would miss the stigmatizing use of the name which also operates among the white working and lower classes. In the United States, even just among whites, there are a host of disturbing cultural orders that disrupt an easy assertion of purely 'popular' cultures. Susan Harding's (1991) work on Fundamentalists in the US is an excellent example of such internal cultural others.

11 'Trash', here, emerges as a mapping of what Peter Stallybras and Allon White referred to as those 'discursive sites where social classification and psychological processes are generated as conflictual complexes. It is precisely here where the realms of ideology and fantasy conjoin. . . . Thus the logic of identity-formation involves distinctive associations and switching between location, class and the body, and these are not imposed on a subject-identity from the outside. They are the core terms of an exchange network, an economy of signs, in which individuals, writers and authors are sometimes but perplexed agencies' (1986: 25). See also Jonas Frykman and Orvar Lofgren (1987).

12 In my dissertation, *Cultural Constructions of Whiteness: Formations of Race and Class in Detroit* (Hartigan 1995), I approach the problem of the nationalization of a linked term, 'hillbilly', from a somewhat different perspective. The great migration, which transformed cities in the industrial Midwest, brought both black and white Southerners into culturally conflicted zones in the North. 'Hillbilly' came into wide usage in the Midwest as a means of denigrating the unassimilatable portion of this migrant white population. Like 'Okie', 'hillbilly'

developed a national recognition in relation to massive shifts of regional population.

13 In the earliest attempt that I know of to treat 'poor whites' as a 'real' cultural group, A.N.J. Den Hollander (1935) defines them by noting that the term is used only on a subgroup of poor whites. 'The "poor-whites" were those who were both poor and conspicuously lacking in the common social virtues and especially fell short of the standard in certain economic qualities. Laziness, carelessness, unreliability, lack of foresight and ambition, habitual failure and general incompetency characterized them' (1935: 414).

14 Some literary critics have tracked the development of images of the 'poor white' in fiction as a cultural figure used to ground certain shifting moral orders and social mores. This approach has been less extensively pursued than the social historical study of poor whites, but the primary works, Shields McIlwaine's *The Southern Poor-White: From Lubberland to Tobacco Road* (1939) and Sylvia Cook's *From Tobacco Road to Route 66: The Southern Poor White in Fiction* (1976), are quite excellent. However, these critics treat images of the 'poor white' generically, rather than concentrating on specific uses of 'white trash'.

15 My argument on the nationalization of 'white trash' is not meant to suggest that such a process has occurred only once, or that I have thoroughly covered it here. Nicole Rafter, in her edited collection of eugenic field studies done on poor whites, asserts that the type or figure of the poor white (though interestingly not the actual name 'white trash') was mobilized in the course of the eugenics movement to provide a formative image: 'The family studies also appealed as a myth of the origins of social problems. Like other myths, they masquerade as historical while incorporating a deliberate vagueness about the remote past, in this case the time when a half-human ancestor lumbered into a primitive land and began sowing spermatic destruction. It is a myth that invents a menace, the half-witted, Grendel-like stranger who likes to live in hollow logs and decrepit shanties – a White Trash myth, to be sure, but with the dimensions of danger. Much social science literature analyzes social problems; this genre creates one' (1988: 29–30).

It is likely that the medicalization of 'white trash' as a public health concern, a process that involved the continuing cultural conflicts between Northern and Southern whites following the end of reconstruction, is a key means to how the figure became nationalized. Alan Marcus and Elizabeth Etheridge both address this process in separate essays in *Disease and Distinctiveness in the American South* (1988). Marcus, in particular, suggests that 'the idea of American nationality and southern distinctiveness converted the white cracker from an appalling curiosity of local color writers and other observers . . . into a social problem. As a problem, they became an important subject for investigation because their existence demanded an explanation and their situation amelioration if the South was to shed its foreignness and assume its rightful place within the nation. The group's Anglo-Saxon heritage only compounded the difficulty; it made it hard to ascribe their repulsiveness to defective or inferior racial stock' (1988: 89).

16 Williamson tracks how the 'grits thesis' first 'sank into the academic mind', and has continued to be reproduced in media interpretations of the civil rights movement in the 1960s. 'But in recent years the thesis has shown a capacity for life anew. The resurgence is dangerous because it is no more true today than it was true then. Upper-class Southern whites are still no more specially sympathetic to black people than are lower-class whites. There is and there has been a difference

between the racism of upper-class Southern whites and that of the lower orders. But the difference is not one of essential assumptions and consequent attitudes' (1984: 294).

17 Interview in *San Jose Mercury News*, 'Mojo Nixon: Rock's joker with a social conscience', 12 October 1990: 1E, 16E.

18 See review of this book in *People Weekly*, 'Cookbook author shows true grit . . .', 26(21), 24 November 1986: 73–8.

19 Reprinted in Hunter Thompson (1990). Thompson's attention to 'white trash' goes back to his first book, *Hell's Angels* (1967); drawing the lineage of these bikers through the migratory waves of oakies, arkies and hillbillies that made their way to California in the Depression era – citing Nelson Algren's *A Walk on the Wildside* as 'one of the best historical descriptions of American white trash ever' (1967: 199) – he suggests that 'nobody who has ever spent time among the inbred Anglo-Saxon tribes of Appalachia would need more than a few hours with the Hell's Angels to work up a very strong sense of deja vu. There is the same sulking hostility towards "outsiders," the same extremes of temper and action, and even the same names, sharp faces and long-boned bodies that never look quite natural unless they are leaning on something' (1967: 202).

20 Tom Arnold's quote about the status of himself and his now ex-wife, Roseanne, is most apropos: 'We're America's worst nightmare – white trash with money.' See 'By any name, Roseanne, is Roseanne is Roseanne', in the *New York Times* Art and Leisure section, 18 August 1991.

21 Jeff Foxworthy is the penultimate example of how 'Redneck' has been publicly valorized. Certainly, in his routines, the term retains the ambivalence that profoundly accompanies 'white trash'. But with his sitcom on ABC, double-platinum comedy album '*You Might Be a Redneck If . . .*' and his six million-plus selling books, it is clear that Foxworthy has tapped an identity that millions of whites are willing to wallow in gladly.

22 It should not be assumed that 'hillbilly' operates unequivocally as a positive, identifying term. Bill Malone, in *Country Music, U.S.A.* (1985), points out that '[c]ountry music fans have always reacted ambivalently to the term, sometimes resenting it as a presumed denigration of their music and the way of life it supposedly represents, but often proclaiming it proudly as an accurate description of their musical and cultural tastes. Many country entertainers, such as Waylon Jennings, Loretta Lynn, and Tammy Wynette, still privately describe themselves as hillbillies, but respond bitterly if someone else calls them that' (1985: 40).

23 James Branscome (1978) points out that West Virginia led the nation in per capita deaths in Vietnam with twenty-five per 100,000 being killed while the national average was seventeen per 100,000 soldiers. More bleakly, though, fatalities from mining accidents in the region were more than double the number of US fatalities in Vietnam over the course of the conflict.

24 In addition to those bands whose self-naming asserts claims an identify as 'white trash', there are the Screaming Trees, the Melvins, and I'm sure a few more. See reviews of these bands in *Melody Maker* (10 August 1991: 62; 27 June 1992: 13; 2 October 1993: 12–13).

25 A perfect example of the proliferation of references to 'white trash' is the *Phonolog Record Catalogue*. When I first checked listing under 'white trash' in 1988 there were four references. Checking again in 1994 I found ten titles, which included ZuZu Petals' 'White Trash in Love' (Twintone) and Southgang's 'White Trash with Cash' (Charisma Music). But a notably less celebratory use

of the term appears with the band, Southern Culture on the Skids. In their song, 'White Trash', the constant refrain is 'don't call me that'.

26 Another author that could be considered here, if space allowed, is Harry Crews. In addition to his works, such as *Feast of Snakes* (1986) and *Body* (1990), see Frank Shelton's (1988) overview of Crew's class position.

27 I am indebted to Renny Christopher's excellent discussion of reviews of Chute's work in her essay, 'Lower class voices and the establishment: the reception of Carolyn Chute' (1993, unpublished manuscript).

28 The overlap between social and moral/sexual transgressions under the sign of 'white trash' repeats for other gay artists who are at a great remove from the economic conditions traditionally associated with the term. Ronald Kraft, in an article on architect Brian Murphy, whose designs have been called 'white-trash modern', conveys a debate over whether or not Murphy's style is only possible to maintain because he is an openly gay man. See 'This Gay House', in *The Advocate*, 24 August 1993: 56–9. The sign of 'white trash' is hardly an oddity in gay aesthetics. See the travel essay by Michael Lane and Jim Crotty, 'Westwego is our kind of place – Pure White Trash', in *The Advocate*, 26 February 1991: 79.

29 The other key distinction is that Chute's first novel, *The Beans of Egypt, Maine*, appeared in 1985, several years ahead of Allison's collection of short stories. Critics were apparently not ready to accept 'voices' of poor whites as literature. Chute, also, was accused of being a 'class traitor' because she took the profits from her book and moved out of her tiny trailer. To my knowledge, Allison's success has not led to charges that she has thereby become inauthentic.

30 This reference to minority discourse is cautiously drawn from Abdul R. Jan-Mohamed and David Lloyd's introduction to the issue of *Cultural Critique* (1987). The purpose of this connection is not to make a claim that certain whites are damaged and truncated by hegemonic forces in the United States, even though 'white trash' too is characterized 'as inauthentic, perverse, criminal, and underdeveloped in relation to the white middle class' (1987: 7). Rather, I want to note that their call for 'double vigilance' needs to include the troubling body of 'white trash'. This insulting term is susceptible to the strategic recuperations which minority discourses in general must contest. In Florida, in 1991, the first prosecution proposed under the state's harsh Hate Crimes Act was of a black man who called a white police office a 'cracker' while the officer was trying to arrest him. The charge, under the Hate Crimes act, was an extension of the assault charge based on the black man's threat to shoot the officer: 'I'll shoot you, white cracker' (reported in the *New York Times*, 28 August 1991). The assault charge was later dropped, so the prosecution for the use of this racial epithet was also abandoned. Yet the ease with which a legal apparatus designed to protect minorities was recuperated by a certain white power structure in the process of invoking a concern for working-class whites is a disturbing and complicated event.

31 Films are a key example of the profusion of 'white trash', though tracking when the term is actually used, or simply critically applied, is complicated. Eugenia Bone (1994) notes: 'The white trash oeuvre has a long and venerable history in Hollywood. From class trash like Tennessee William's "Babydoll" to the mosaic of mangy characters in "Short Cuts," stars just can't say no to playing trigger-happy ignoramuses with voracious appetites for carnal pleasure. Alarmed by the recent plethora of trailer-park dramas and jalopy adventurers, we have conducted a study of the genre – the greasy incurable romantics, the synthetic

fabrics, the inexplicably good dental work.' Bone lists the following films as examples: *Kalifornia, Guncrazy, True Romance, Short Cuts, Flesh and Bone, A Perfect World*. These movies are only the most recent in a tradition that arguably begins with *Poor White Trash* (1957), Peter Graves' screen debut. Like *Deliverance*, it gained notoriety for a rape scene which exceeded the 'bounds of decency' in the 1950s. Originally, it was released under the title *Bayou*, but did poorly and was re-released as *Poor White Trash* in 1961.

32 Roseanne has used 'white trash' several times in her show. The first time that I am aware of was in the 1992–3 season. In an episode after Dan was arrested, she announced, 'well people have been saying it for years . . . and this proves it: we are white trash!' In the 1994–5 season, in an episode dealing with how racism is passed from parent to child, Roseanne refers to real racists as 'those barefoot, banjo-playing, cousin-dating, embarrassments to respectable white trash like us'.

33 As well, 'white trash' is not used in *True Romance*, while in *Kalifornia*, at the film's opening, Brian Kessler (David Duchovny) says, 'If you looked in the dictionary under "poor white trash," a picture of Adele and Early would be there'.

References

Alba, Richard (1990) *Ethnic Identity: The Transformation of White America*, New Haven: Yale University Press.
Allison, Dorothy (1988) *Trash*, Ithaca: Firebrand.
—— (1992) *Bastard Out of Carolina*, New York: Dutton.
Bakhtin, Mikhail (1968) *Rabelais and His World*, Cambridge: MIT Press.
Batteau, Allen (1990) *The Invention of Appalachia*, Tucson: University of Arizona Press.
Bolton, Charles (1994) *Poor Whites of the Antebellum South: Tenants and Laborers in Central North Carolina and Northeast Mississippi*, Durham: Duke University Press.
Bone, Eugenia (1994) 'Trailer-made', *Premiere*, 7(7): 36.
Branscome, James (1978) 'Annihilating the hillbilly: the Appalachian's struggle with America's institutions', in Helen Mathews, Linda Johnson and Donald Askins (eds), *Colonialism in Modern America: The Appalachian Case*, Boone, NC: The Appalachian Consortium Press.
Cecil-Fronsman, Bill (1992) *Common Whites: Class and Culture in Antebellum North Carolina*, Lexington: University Press of Kentucky.
Chute, Carolyn (1985) *The Beans of Egypt, Maine*, New York: Warner Books.
—— (1986) *Letourneau's Used Auto Parts*, New York: Harper Co.
Crews, Harry (1986) *Feast of Snakes*, New York: Atheneum.
—— (1990) *Body*, New York: Poseidon Press.
Culler, Jonathan (1985) 'Junk and rubbish: a semiotic approach', *Diacritics*, 15 (3): 2–12.
Douglas, Mary (1966) *Purity and Danger: An Analysis of Concepts of Pollution and Taboo*, New York: Praeger.
Etheridge, Elizabeth (1988) 'Pellagra: an unappreciated reminder of Southern distinctiveness', in Todd Savitt and James Young (eds), *Disease and Distinctiveness in the American South*, Knoxville: University of Tennessee Press.
Fiske, John (1992) *Understanding Popular Culture*, Boston: Unwin Hyman.

Flynt, J. Wayne (1989) *Poor but Proud: Alabama's Poor Whites*, Tuscaloosa: University of Alabama Press.

Frankenberg, Ruth (1993) *White Women, Race Matters: The Social Construction of Whiteness*, Minneapolis: University of Minnesota Press.

Friend, Tad (1994) 'The white trashing of America', *New York*, 27 (33): 22–30.

Frykman, Jonas and Lofgren, Orvar (1987) *Culture Builders: A Historical Anthropology of Middle-Class Life*, New Brunswick: Rutgers University Press.

Genovese, Eugene (1976) *Roll, Jordan, Roll*, New York: Vintage Books.

Green, Archie (1965) 'Hillbilly music: source and symbol', *Journal of American Folklore*, 78 (309): 204–28.

Hall, Stuart (1981) 'Notes on deconstructing "The Popular"', in R. Samuel (ed.), *People's History and Socialist Theory*, London: Routledge & Kegan Paul.

—— (1994) 'Cultural studies: two paradigms', in *Culture/Power/History: A Reader in Contemporary Social Theory*, Nick Dirks, Geoff Eley and Sherry Ortner (eds), Princeton: Princeton University Press.

Harding, Susan (1991) 'Representing fundamentalism: the problem of the repugnant cultural other', *Social Research*.

Hartigan, John (1992) 'Reading trash: *Deliverance* and the poetics of white trash', *Visual Anthropology Review*, 8 (2): 8–15.

—— (1995) *Cultural Constructions of Whiteness: Formations of Race and Class in Detroit*, Santa Cruz: University of California Press.

Hollander, A.N.J. Den (1935) The tradition of 'poor whites', in W. T. Crouch (ed.), *Culture in the South*, Chapel Hill: The University of North Carolina Press.

Jameson, Fredric (1990) 'Reification and utopia in mass culture', *Signatures of the Visible*, New York: Routledge.

Jan Mohamed, Abdul R. and Lloyd, David (1987) 'The nature and context of minority discourse II', *Cultural Critique*, 7 (Fall).

Jefferson, Margo (1988) 'Slumming: ain't we got fun?', *Vogue*, 178 (8): 344–7.

Kroker, Arthur (1994) *Data Trash: The Theory of the Virtual Class*, New York: St Martin's Press.

Lee, Harper (1960/1962) *To Kill a Mockingbird*, New York: Popular Library.

Lieberson, Stanley (1985) 'Unhyphenated whites in the United States', in Richard Alba (ed.), *Ethnicity and Race in the USA: Towards the Twenty-first Century*, Boston: Routledge & Kegan Paul.

McWhiniey, Grady (1988) *Cracker Culture: Celtic Ways in the Old South*, Tuscaloosa: University of Alabama Press.

Mallone, Bill (1985) *Country Music, U.S.A*, Austin: University of Texas Press.

Marcus, Alan (1988) 'The South's native foreigner: hookworm as a factor in Southern distinctiveness', in Todd Savitt and James Young (eds), *Disease and Distinctiveness in the American South*, Knoxville: University of Tennessee Press.

Mitchell, Margaret (1936/1973) *Gone With the Wind*, New York: Avon Books.

Murray, Charles (1986) 'White welfare, white families, "white trash"', *National Review*, 38 (5): 30–4.

—— (1993) 'The coming white underclass', *Wall Street Journal*, 29 October.

Newby, I.A. (1989) *Plain Folk in the New South: Social Change and Cultural Persistence, 1880-1915*, Baton Rouge: Louisiana State University Press.

Peterson, Richard (1992) 'Class unconscious in country music', in Melton McLaurin and Richard Peterson (eds), *You Wrote My Life: Lyrical Themes in Country Music*, Philadelphia: Gordon & Breach.

Rafter, Nicole (ed.) (1988) *White Trash: The Eugenic Family Studies, 1877-1919*, Boston: Northeastern University Press.

Roediger, David (1991) *The Wages of Whiteness: Race and the Making of the American Working Class*, London: Verso.

—— (1993) *Towards the Abolition of Whiteness: Essays on Race, Politics, and Working Class History*, London: Verso.

Rosaldo, Renato (1994) 'Whose cultural studies?', *American Anthropologist*, 96: 524–9.

Saxton, Alexander (1990) *The Rise and Fall of the White Republic: Class Politics and Mass Culture in Nineteenth-Century America*, London: Verso.

Seeger, Charles (1946) 'Conference . . . on folklore', *Journal of American Folklore*, LIX: 512.

Shelton, Frank (1988) 'The poor whites' perspective: Harry Crews among Georgia writers', *Journal of American Culture*, 11 (3): 47–50.

Sollors, Werner (1986) *The Invention of Ethnicity*, New York: Oxford University Press.

Spindler, Amy (1993) 'Trash fash', *New York Times*, 12 September: 10.

Stallybras, Peter and White, Allon (1986) *The Politics and Poetics of Transgression*, Ithaca, NY: Cornell University Press.

Stewart, Kathleen (1991) 'On the politics of cultural theory: a case for "contaminated" critique', *Social Research*, 58 (2): 395–412.

—— (1996) *A Space on the Side of the Road: Cultural Poetics in an 'Other' America*, Princeton: Princeton University Press.

Stone, Nancy and Grey, Roberts (1976) *White Trash: An Anthology of Contemporary Southern Poets*, Charlotte: New South Company.

Thompson, Hunter (1967) *Hell's Angels*, New York: Ballantine Books.

—— (1990) *Generation of Swine: Tales of Shame and Degradation in the '80s*, New York: Vintage Books.

Thompson, Michael (1979) *Rubbish Theory: The Creation and Destruction of Value*, Oxford: Oxford University Press.

Wellman, David (1977) *Portraits of White Racism*, Cambridge: Cambridge University Press.

Williamson, Joel (1984) *The Crucible of Race: Black and White Relations in the American South Since the End of Emancipation*, New York: Oxford University Press.

DUKE UNIVERSITY PRESS

Questions of Travel
Postmodern Discourses
of Displacement
Caren Kaplan
Explores the various metaphoric uses
of travel and displacement in literary
and feminist theory,
Post-Contemporary Interventions
256 pages, £15.95 paper

Entertaining the Third Reich
Illusions of Wholeness in
Nazi Cinema
Linda Schulte-Sasse
". . . sets new standards in the domain of
the analysis of ideological mechanisms at
work in cultural products."—Slavoj Zizek
Post-Contemporary Interventions
408 pages, 67 b&w photos, £17.95 paper

The Third Eye
Race, Cinema, and Ethnographic
Spectacle
Fatimah Tobing Rony
". . . an extraordinary contribution to
both film history and the theorization
of the ethnographic gaze."
—Lisa Cartwright
328 pages, 50 b&w photos, £16.95 paper

Sex Scandal
The Private Parts of Victorian Fiction
William A. Cohen
Never has the Victorian novel appeared
so perverse as it does in these pages—
and never has its perversity seemed so
fundamental to its accomplishments.
Series Q
272 pages, £15.95 paper

Immigrant Acts
On Asian American Cultural Politics
Lisa Lowe
264 pages, £15.95 paper

Gaze and Voice as Love Objects
SIC 1
Renata Salecl and Slavoj Zizek, editors
"A marvelous collection of essays . . .
[ranging] over an amazing topography
of issues."—John Mowitt
SIC
304 pages, 9 b&w photos, £15.95 paper

Chinese Modernism in the Era of Reforms
Cultural Fever, Avant-Garde Fiction,
and the New Chinese Cinema
Zhang Xudong
This book offers both a historical
narrative and a critical analysis of the
cultural visions and experiences of
China's post-Mao era.
Post-Contemporary Interventions
496 pages, 12 b&w photos, £20.95 paper

Vampires, Mummies, and Liberals
Bram Stoker and the Politics
of Popular Fiction
David Glover
Vampires, Mummies, and Liberals
reconstructs the cultural and political
world that gave birth to *Dracula*.
240 pages, £15.95 paper

Cultural Institutions of the Novel
Deidre Lynch and William B. Warner,
editors
472 pages, £20.95 paper

The Lettered City
Angel Rama
Translated and edited by
John Charles Chasteen
Post-Contemporary Interventions
176 pages, £13.95 paper

AUPG, 1 Gower Street, London WC1E 6HA, Tel/Fax: (0171) 580 3994/5

·REVIEWS·

The complexity of exhibitionary complexes
Robert W. Rydell

■ Tony Bennett, *The Birth of the Museum: History, Theory, Politics* (New York: Rout-ledge, 1995) 278 pp., ISBN 0-415-15387-0 £14.99 Pbk.

Over the past few years, scholars interested in the politics of cultural representation have examined a variety of exhibitionary institutions, including international exhibitions, museums, department stores and zoos as primary outfitters of the modern world. Too often, however, studies of these cultural institutions, especially museums and fairs, have moved along parallel tracks. Now, with the publication of Tony Bennett's *Birth of the Museum*, more emphasis will have to be given to points of convergence. Bennett makes a powerful and convincing argument that museums and fairs were parts of a larger whole – an 'exhibitionary complex' – that provided the cultural infrastructure for the modern state. That some scholars will argue that the 'exhibitionary complex' is even more complex than Bennett's study allows will only underscore the significance of this book for redirecting the way we think about cultural institutions.

Considered as a theoretical project, there is much to admire in this book. As he explains in his introduction, Bennett is interested in seeing museums and exhibitions through lenses borrowed from both Michel Foucault and Antonio Gramsci. These enable him to argue that exhibitionary institutions functioned at once as disciplinary agencies geared towards 'behaviour management' (p. 7) and as vehicles of cultural hegemony organized 'to win the hearts and minds of their visitors' (p. 68). As Bennett aptly puts it: 'To identify with power, to see it as, if not directly theirs, then indirectly so, a force regulated and channelled by society's ruling groups but for the good of all: this was the rhetoric of power embodied in the exhibitionary complex – a power made manifest not in its ability to inflict pain but by its ability to organize and co-ordinate an order of things and to produce a place for the people in relation to that order' (p. 67). Bennett's point here is not that Foucault and Gramsci would see the exhibitionary complex in the same way or that a synthesis of their work is necessary or desirable. Rather, he insists that the different concerns each theorist brings to the project of modern state formation, namely Foucault's interest in disciplinary mechanisms that made the populace governable and Gramsci's interest in understanding the consent bourgeois publics gave to being governed, both have merit for sharpening our focus on the cultural functions of exhibitionary networks that underwrite state power and authority.

To understand those functions, Bennett divides his book into three sections devoted respectively to 'history and theory', 'policies and politics' and 'technologies of progress'. They are worth taking up in order.

The first third of the book is devoted to charting the rise of the museum and inter-national exhibition in the late eighteenth and early nineteenth centuries in the

Cultural Studies 11(2) 1997: 345–368

context of the immense political and social upheaval precipitated by the French Revolution and the forces of industrialization. Functioning as disciplinary apparatuses that emphasized 'a wholly conscious technology of regulation', these institutions made their visitors into 'objects of each other's inspection' (p. 52). Long before the close of the nineteenth century, a hand-in-glove relationship existed between museums and fairs, with some fairs actually serving as the catalysts for creating museums as was the case in the relationship between the 1851 Crystal Palace Exhibition and the Victoria and Albert Museum and the 1893 Chicago World's Columbian Exposition and the Field Museum of Natural History.

The second part of Bennett's book builds on his earlier arguments about the political and cultural functions of museums and goes to the core of many contemporary debates about the nature of cultural representations within museums. In chapters devoted to open-air museums, Glasgow's People's Palace, and to public art galleries, Bennett calls attention to the power of contemporary museums to construct history and to shape public discussion about the future. Readers looking for specific policy recommendations will find some here, especially in Bennett's insistence that museums become 'a critical resource to prompt active participation in public debate concerning future paths of national development' (p. 135). Such a museum, Bennett suggests, should be 'democratic' in its orientation and not simply a 'populist' historical heritage site that seeks to capitalize on nostalgia as a means of attracting tourist dollars.

The third section of this book, 'technologies of progress', carries the story of nineteenth- and early twentieth-century fairs and museums into the present and returns to the disciplinary function of exhibitions. Bennett is careful to tell us that he is not so much concerned with representations of technology as with 'the different ways in which those representations were organized as performative resources which programmed visitors' behaviour as well as their cognitive horizons' (p. 10). The three chapters that develop this argument centre on the Pitt-Rivers' Museum, Brisbane's Expo '88 and Blackpool's Pleasure Beach.

There are many reasons to admire *The Birth of the Museum*. With its chronological sweep, its cross-cultural institutional comparisons and its theoretical sophistication, Bennett's volume is a notable contribution to museum studies and to cultural studies more generally. As such, it will occasion much debate and some dissent.

The chief criticism that will be levelled against this account is one that Bennett tries to deflect at the outset. In telling us what his book is about, he writes: 'My concern in this book is largely with museums, fairs and exhibitions as envisaged in the plans and projections of their advocates, designers, directors and managers. The degree to which such plans and projects were and are successful in organizing and framing the experience of the visitor or, to the contrary, the degree to which such planned effects are evaded, side-stepped or simply not noticed raises different questions which, important though they are, I have not addressed here.' (p. 11) Bennett is right about the importance of these issues. They are so important, in fact, that he concludes his book with this insightful observation about Blackpool's Pleasure Beach: 'Far from imposing its "regime of pleasure" on a series of individuals, construed as puppets of its organization, the Pleasure Beach is used and negotiated in different ways by different groups in accordance with the cultural relations and processes characterizing the group concerned.' (p. 244) The same could be argued about world's fairs and museums.

The point here is not to suggest that Bennett is wrong in his thinking about museums and fairs. To the contrary, he is absolutely right to argue that the exhibitionary complexes that spanned the globe in the nineteenth and twentieth centuries

were intended to function in disciplinary and hegemonic ways. Exactly how far they succeeded – and continue to succeed – in realizing those intentions is an issue that really does deserve another book. One can only hope that it will be as insightful as this one.

'Being Together with Strangers': citizenship and public space

Terry Threadgold

■ Sophie Watson and Katherine Gibson (eds), *Postmodern Cities and Spaces* (Oxford: Basil Blackwell, 1995) 269pp., ISBN 0-631-19404-5 £13.99 Pbk.

This is a book about space, time and social being, about human geographies, the making of histories and the place of societies. It is a book which begins with the heterotopia (a term coined by Michel Foucault and used here by Soja, Lechte and Patton as well as the editors), the figure of the flaneur as imagined by Baudelaire and Benjamin (Wilson and Lechte), and the chora (Grosz and Lechte), that space named by Plato in which place is made possible, symbol of everything masculinist representations have expelled, collocated with dwelling, maternity, pregnancy (Grosz p. 51) – and for Lechte with the flaneur and homelessness, lack of a dwelling – the focus of work by Kristeva, Derrida, Irigaray and de Serres. These terms are all redolent with recent critical theory, the last particularly of recent feminist theory. In this context, they mingle and dialogue, without the slightest incongruity, with readings of postmodern cities and accounts of the encounters between modernist urban planning and decidedly postmodern realities – in Los Angeles, Jamaica, Hong Kong, South Africa, Bombay, Papua New Guinea and Israel's Galilee region – written by authors from a wide range of different disciplinary and interdisciplinary backgrounds. Urban planning, geography, history, philosophy, sociology, fine arts, media studies, cultural and women's studies are all represented. This in itself, it seems to me, is a remarkable editorial achievement. As the editors say in their Preface to the book there are 'theoretical' and 'empirical' pieces –a binary opposition they then immediately refuse – asking the reader to join them in the pleasures (and politics) of a different cartography where a new route map will allow these different approaches to be read together so that the oppositions and conflicts between them can be made productive.

The book was launched with another jointly edited by the same authors, *Metropolis Now: Planning and the Urban in Contemporary Australia* (Pluto Press, 1994), and the paired books were launched on successive days in Sydney and Melbourne by, in each case, a senior female academic and a then deputy prime minister and a former prime minister. I found this, at the time, and I still do, fascinating in terms of its politics of gender and space/place. The Melbourne launch of this feminist text took place in The Australian Housing and Urban Research Institute, epitomizing the way in which the book itself brings together feminist and postmodernist theory with contemporary policy and planning concerns, productively, effectively and with no concessions. Thus Elizabeth Grosz's arguments that feminist readings of chora might 'reorient ways in which spatiality is conceived, lived and used' were actually heard in spaces where the flaneurs included politicians and the formerly invisible flaneuses, somewhat rewritten, but clearly visible and audible, who are represented in the book in the chapters by Elizabether Wilson and Gillian Swanson.

Wilson is concerned with the continuing problem of the fraught relationship between women and cities, whether women are seen as a problem for cities or cities

as a problem for women. Rereading the work of a number of feminist writers on women in the nineteenth-century city – Mary Poovey, Janet Wolff and Griselda Pollock – she concludes that they overemphasize the passivity and victimization of women, assuming rather than contesting the nineteenth-century bourgeois and philosophical (from Hegel to Mrs Beeton) construction of a clear demarcation between the public and the private, the virtuous and the fallen woman. In the process she rewrites the figure of the prostitute as a public woman, and points to the usually neglected aspect of the masculine flaneur, the desperation which motivates his wanderings (p. 73) so that he becomes 'a shifting projection of angst rather than a solid embodiment of male bourgeois power' (p. 74). The connections she makes with the flaneur and this century's preoccupation with 'the male gaze' and between the flaneur and the serial killer of popular culture are then indications of the 'challenge to patriarchal thought and existence made by the presence of women in cities'. Her conclusion is that these problems have not gone away and that current debates about rape, pornography and sexual harassment testify to that (p. 76). Here it is interesting to compare Elizabeth Grosz's analysis of the much more philosophical issue of the chora.

Grosz's argument is that in order to sustain their own fantasy of auto-production and self-determination men have to relegate women to the position of 'support and precondition of the masculine' – which she says is precisely the function of the chora in the platonic tradition. This amounts to the containment of women within a dwelling they did not build, a homelessness within the home itself. However, this colonization of women and space has its costs in psychoanalytic terms. 'In exchange for the body he has had to sacrifice (the polymorphous pleasures of the pre-Oedipal period) he is granted access to the bodies of women, women whose bodies replace the place from which he came (the womb)' (p. 56). It is then not surprising, she argues, given the massive disavowal involved, that this process is 'steeped in hostility, resentment and aggression' and 'dwelling becomes the domain of hatred and murderous control' (p. 56). This connects directly with Gillian Swanson's concern to construct, by exploring the histories that have formed 'the enactment of our social life and the performative capacities of the self', an urban cultural agenda which would escape the pathologization and feminization of consumption 'to make visible, to develop and extend, the contours of women's citizenship' (p. 93). Her very complex argument about exchange, value and sexuality in the new relations between the subject and the social in the city space of the nineteenth century points to a clear relationship between the characterization of consumption as feminine and 'worthless' and a resistance to the modernization of city culture which had put male bodies into the circuit of economic exchange. Her discussion of the loss of value (the value of productive labour as a prerequisite of bourgeois masculine value) involved in the change from a productive to a consumer society and its links with the language of masturbation, prostitution and usury – all perceived in this period to be characterized by their lack of productivity – is a fascinating complement to the work of Wilson and Grosz in this section of the book.

John Lechte's chapter takes off in some remarkably different directions with some of the same imagery. Rereading chora as 'a harbinger of pure chance' (p. 100), Lechte relocates it in the context of the work of Lyotard and Serres in the history of science as 'detached from place' and able to 'be transported anywhere' (p. 101). Chora here takes on the connotations of indeterminacy and chance, an open not a closed system – the enemies of nineteenth-century science. Translating the chora into a number of material realities and practices, Lechte identifies it first (with Serres) in the indeterminacy of topological space in Turner's paintings, then in the

topography of Leopold Bloom's walk in Dublin in *Ulysses*, then with Baudelaire's flaneur 'the archetype of the one who is not at home', and finally with allegories of writing as artificial memory (Ulmer) and de Certeau's 'Walking in the City' – all seen as 'an indeterminate *chora* of incontingency' (p. 103). He uses these examples to pose the question: 'is it not the case that every truly modern city is a Tower of Babel?' His argument here is that every 'modern' city needs postmodern theory to explain it and he proceeds to prove his point by reading the Arch at La Defense and the Parc de la Villette in Paris.

Paul Patton's chapter, the final one in Part 1 of the book, sets about rereading some dominant 'imaginary cities', particularly the imaginary postmodern cities of Jameson, Harvey and Raban. Patton has problems with all three but likes Raban's version of the city best. Not as unfavourable to the postmodern city as the other two, Raban's city is about living with strangers, about the 'intrinsic theatricality' of city life. For Patton, one of Raban's most important points is in the comment that 'it is hard to live among strangers and still think of oneself as a citizen' (p. 118). For Patton, Raban's inability to conceive of citizenship other than in terms of the social conditions of smaller and less urban communities is a real problem, and he turns to Marion Young's very different account to find an alternative imagined city. Instead of emphasizing the potential for disorientation and loss of self in the postmodern city, she refuses the ideal of community, arguing that as an ideal it is both undesirable and implausible. She therefore cannot regret its 'loss'. Instead she proposes 'an ideal of the city as a metaphor for the politics of difference' (p. 119), and reconceives politics as a 'relationship among strangers who do not understand one another in a subjective and immediate sense' (p. 119). For her, public spaces are important conditions of democratic citizenship, offering access and the freedom to speak, 'a return of politics to the *polis*' (p. 119). For Patton, the undeniable postmodernity of this imagined city is in its acceptance of difference while its representation of a widely shared positive experience of city life is heterotopic in referring as much to a number of unrealized possibilities in city life as to any existing city. In designating the 'unoppressive' city as postmodern object *par excellence*, Patton is countering the tendency to react to the 'post' modern with nostalgia and gloom, making a point which is not dissimilar to that made by Diane Elam (1994) when she argued that postmodernity was not about undecidability: it was about having to make a decision every time, in each case, even when all of the old universal ground rules have disappeared. It is indeed 'being together with strangers' (p. 119).

It is not however just the place of woman in the city or the deconstruction of imaginary versions of the city that is the book's concern. It also foregrounds the politics of modernist and postmodernist urban planning and their consequences and difficulties for the realities of the postmodern cities that are critiqued and examined by the contributors to the book. The editors make the point that all the contributors are interested in what a postmodern politics and a postmodern urban planning and policy practice might be. They do indeed seem to be concerned to show how the 'heroic visions of modernist politics, that is of mass mobilization and emancipation of the oppressed' may continue to 'eclipse our view of the many possibilities of postmodern politics' and may indeed have functioned more as strategies of control than of liberation. This message seems to me to be clear in the chapters by Alexander Cuthbert on Hong Kong, Diane Austin-Broos on Kingston, John Connell and John Lea on Papua New Guinea, Alan Mabin on South Africa, Jim Masselos on Bombay, and Oren Yiftachel on the urban control or Arab minorities in Galilee.

Jim Masselos wants equally to question the 'nature of the global city, the

postmodern urban phenomenon' itself, writing of the Bombay riots as an illustration of the 'underbelly' of postmodernism – 'disorder, separateness, antagonism, destructive rampages against property, and lethal vengeance against people perceived as other, apart and different' (p. 214). This is a theme which emerges in different ways in a number of the chapters that focus on specific cities and problems. The point is made both poignantly and powerfully in Marcuse's chapter, the final chapter in the book, which foregrounds the functions of walls in the city. His argument is that 'postmodernism', in one of its forms, has become the 'tool of purposive action and public planning' (p. 243), that what is happening today is a reversal of the modernist agenda to impose order on the chaos that was the individual urban experience of capitalism, and constitutes 'the attempt to impose chaos on order, an attempt to cover with a cloak of visible (and visual) anarchy an increasingly pervasive and obtrusive order' (p. 243). It is here that Marion Young's anxieties about the desire for community as 'threatening to reinstate the structures of exclusion' (quoted in Patton p. 118) comes full circle. Whatever postmodernist trappings the city wears, it has not, it seems, discarded the inheritance of modernism and modern urban planning. That is nowhere more evident than in places, spaces, which have been mapped by the imposition of that planning in a colonial or neocolonial context – the chapters on Papua New Guinea and South Africa are telling examples.

The book deals with the concept of postmodernism itself in a fluid and multiple way, the editors refusing to be drawn into arguments about definition. They signal debates between a postmodern aesthetic, a socioeconomic condition of postmodernity, and postmodern paradigms of knowledge and theory. The contributions of Edward J. Soja, which frame the two parts of the book, nicely locate the continuities of the modern within and juxtaposed to the postmodern and the continuities between theory and praxis that the book embodies. His work narrates Foucault's recognition of the arguments that would emerge between 'the pious descendants of time and the determined inhabitants of space'. This book, like Soja's work on Los Angeles, demonstrates, as no arguments between history and geography could have done, that socially produced space, urbanized space, is precisely where discourses about power are transformed into actual relations of power. That work had and has resonances with a number of contemporary fields, not least feminist theory and cultural studies. Those resonances point to the importance of this book in its recognition that: 'A postmodern politics suggests many possibilities' and 'that the division between discursive and non-discursive terrains and between the "imaginary" and the "real" needs to be crossed' (p. 262). There are relatively few books around at the present time which cross that boundary as effectively as this one does.

Reference

Elam, Diane (1994) *Feminism and Deconstruction: Ms En Abyme*, London: Routledge.

Normal science? Soap studies in the 1990s

David Buckingham

- Jostein Gripsrud, *The Dynasty Years: Hollywood Television and Critical Media Studies* (Routledge, 1995) 344pp., ISBN 0-415-08598-5 £40.00 Hbk; ISBN 0-415-08599-3 £14.99 Pbk.
- Robert C. Allen (ed.), *To Be Continued ...: Soap Operas Around the World* (Routledge, 1995) 398pp., ISBN 0-415-11006-8 £37.50 Hbk; ISBN 0-415-11007-6 £12.99 Pbk.

Oxford English undergraduates are to be 'taught' soap opera. And gangster and horror movies and just about anything else that might fit the new 'language, media and film' option in the Oxford Eng Lit BA. Dr Margarita Stocker, who devised the course in collaboration with the holder of Oxford's Rupert Murdoch chair of language and communications (say no more) told BBC2's *Newsnight* it would provide 'a rigorous examination of almost anything'. So now we know. There is nothing so stupid, trivial or banal, if sanctified by the label of media, that it cannot be subjected to rigorous analysis.

(Melanie Phillips, 'The videotic age of the Philistine', *Observer* 6 August 1995)

Melanie Phillips's attack on the inclusion of contemporary media within one of the most traditional UK university English courses is likely to meet with a defensive – and perhaps rather weary – response from readers of this journal. In the wake of the 'culture wars' that have raged on British and North American campuses, her concerns about the ways in which 'visual culture is undermining the literary' and her vacuous insistence on literature as 'the transmission of enrichment' mark out a position that has been rehearsed to the point of self-caricature.

Faced with the two weighty tomes under review here, right-wing critics like Phillips might well be provoked to fits of apoplexy (in fact, I have a good mind to send them to her right away). Yet the response of many academics in the field might well be rather less intense. Soap opera has been widely legitimated as a field of study within academic media studies courses for at least a decade; and it is more than half a century since it was first a topic of research for social scientists. Indeed, the sense of challenge and intellectual adventure that arose from the attempt to incorporate popular forms within the academic curriculum – and is perhaps still present at the last frontier of Oxford English – has given way to a discourse that is institutionalized, perhaps even complacent. The exciting paradigm shifts of the 1970s and 1980s have been replaced by the 'normal science' of the 1990s. Yet what difference has this proliferation of academic discourse made, either to the academy or to the wider cultural field?

In some respects, these books could be seen to represent a second or third wave within soap opera studies. As ever, academic fashion tends to lag behind the protean world of popular culture, although what Stuart Hall has called 'the "moment" of *Dallas*' coincided fairly accurately with what might in retrospect be seen as the 'moment' of soaps in media studies in the mid-1980s. As Charlotte Brunsdon has argued (in a piece reprinted in Allen's collection), the creation of this 'little subfield of academic study' in the late 1970s and early 1980s was part of a wider political project within feminism – although, as she indicates, the awkward balance between celebration and condemnation has always lent that project a degree of ambivalence. Nevertheless, the study of soap opera and its audiences has been a site in which both academic feminism and cultural studies have begun to learn, as Brunsdon puts it, 'to address their others with respect'.

If soaps have become institutionalized within the media studies curriculum – and hence inevitably less fashionable – their popularity continues unabated. Many of the eighteen studies in Allen's collection point to the massive popularity of the genre in some very diverse cultural contexts: not only in the US and the UK, but also in India, Russia, Trinidad, China and Latin America, it would seem that the whole world stops for the next instalment of the continuing serial. While most of these studies have been published elsewhere, the global promise signalled by the book's subtitle is amply fulfilled, even if the most interesting studies (for example, Daniel Miller's work on *The Young and the Restless* in Trinidad, or Lisa Rofel's account of responses to the contemporary Chinese soap opera *Yearnings*) end up telling us rather more about the societies as a whole than about responses to the programmes. In some cases, the reliance on media coverage of soaps leads to a degree of superficiality (as in Stephen Crofts' analysis of the popularity of *Neighbours* in 'Thatcherite Britain'); yet in many cases there is an anthropological depth to the data that is very rewarding. Thus, Alison Griffiths's account of the Welsh soap opera *Pobol y Cwm* and its young audiences offers interesting insights in terms of wider debates about national identity; while Marie Gillespie provides a rich analysis of the role of 'devotional viewing' in sustaining the culture and religious belief of Indian families in the diaspora.

Put together, these studies should warn us against the tendency to essentialize the genre. Much of what is said here about US daytime soaps, for example, does not translate to British serials; and, as Ana Lopez indicates, there are significant differences *within* what we might lazily group together as 'telenovelas'. As Miller argues, 'the advantage of such ethnographic material is in preventing easy generalisations which tend to arise from the narrowness of many academic traditions' – and cultural studies is perhaps no less guilty in this respect.

Yet aside from this valuable cross-cultural dimension, one might be forgiven for asking what Allen's collection *adds* to our understanding of the genre. There are some useful overviews of national traditions (India, Latin America), and some gaps in the field are more or less adequately filled (acting and characterization, the representation of gays). There are some accounts of programmes one wishes one had seen (Ien Ang and Jon Stratton on the 'postmodern' Australian soap *Chances*) or events one wishes one had experienced (the vogue for the 1970s Mexican serial *The Rich Also Cry* in post-glasnost Russia). Yet in terms of broader theoretical debates, we find little more than received wisdom about the formal qualities of soaps – 'openness' and 'multiple subject positions' – and some very familiar arguments on such well-rehearsed topics as melodrama and realism, or the relation between pleasure and ideology. It is hard to avoid the conclusion that most of the significant things have already been said, and that all that remains is to fill in the details. Indeed, as one works through some of the less compelling contributions here, it sometimes seems as though the thrill has gone forever, and that soap studies have become as boring as Hitchcock and *film noir*. What, one wonders, is the purpose of this display of enormous scholarly erudition over the relationship of Betsy and Steve in *As the World Turns*? Is this lengthy theoretical peroration on the significance of recasting when actors leave a serial strictly necessary? And do the implications of new reproductive technologies for paternity plots in soap operas really *matter* – and, if so, for whom?

Jostein Gripsrud's book is directly concerned with such questions about the purpose of academic work on popular culture. Indeed, there is a sense in which *Dynasty* serves as little more than a case study for what the author grandly describes as an 'exploration of the theoretical foundations for media studies in the humanities'.

It is this self-conscious ambition that accounts for the excitement, but also some of the irritation, that the book will undoubtedly provoke.

While Allen's contributors share little more than a broad 'cultural studies' orientation – or at least a common hostility to the empiricism of mainstream research (which may amount to the same thing) – Gripsrud is much more upfront about his position. Early in the book, he calls for a re-evaluation of the work of Adorno, although more on the grounds of the later books than the now notorious 'culture industry' essay. In practice, this call is only partly followed through; and when one arrives, quite late in the book, at Gripsrud's comments about the ways in which *Dynasty* produces 'consumerist conformism' and an 'untroublesome viewing subject', it is hard to share his enthusiasm for the Frankfurt School perspective. Nevertheless, Gripsrud is insistent on the need for '*critical* intellectual work':

> Though socially marginal, the 'cultural capital' of intellectuals always separates them both from 'the people' and from those in positions achieved by economic capital primarily. They are, in their very marginality, privileged in their access to various forms of knowledge and reflective thought that are indispensable to any political project of emancipation, of social, political and cultural democracy. (p. 20)

In a move which is repeated somewhat tiresomely throughout the book, Gripsrud contrasts his approach with what he characterizes as the fashionable orthodoxy within media studies. The trendy hordes of audience researchers who apparently dominate the field are persistently condemned as relativists, who spend their lives 'celebrating' the 'infinite polysemy' of the text and the 'autonomy' of the viewer. Previous work on soaps is sweepingly condemned for its 'uncritical celebration of the genre' and its apologias for the industry, on the basis of what are clearly untypical examples. In Chapter 1, for example, Gripsrud goes to great lengths to demolish the straw person of Stanley Fish (not, one might add, a noted researcher on media audiences) as though he were somehow representative of this broader approach. In the process, media studies is represented as a much more homogeneous and uncontested field, and more easily swayed by the imperatives of 'fashion', than it actually is.

Although he is not the first to do so, Gripsrud does make an important argument about the need to integrate the various elements of media research – production, texts and audiences. Yet he does not help his case by persistently calling attention to the uniqueness of his approach, and denigrating those he wishes to define as the opposition. It is undeniably the case that there is a lack of sustained production studies, particularly when it comes to fictional genres such as soap opera. For example, while there are occasional accounts of the economic context of serial production in Allen's collection, this remains one of its most glaring absences; and in this respect, Gripsrud's account of the production of *Dynasty* does begin to fill a gap. On the other hand, his claim that his is the first sustained textual analysis of soaps is simply inaccurate; and his complaints about the dominance of a 'celebratory' approach to audiences are simply wide of the mark. If we look at Allen's collection, for example, there are several instances of detailed textual analysis (for example, Gabriele Kreutzner and Ellen Seiter on *Schwarzwaldklinik*, and Philip Lutgendorf's account of an Indian version of the *Ramayan*); and it is impossible to identify any single writer who espouses the 'celebratory' orthodoxy Gripsrud so energetically condemns.

Perhaps paradoxically, in the light of his call for a return to the traditional virtues of textual analysis and production study, the real strengths of Gripsrud's book lie in its account of the public reception of *Dynasty* in Norway. What appears at first sight to be a straightforward battle between populists and cultural elitists (albeit one that crosses conventional political boundaries) necessarily also invokes complex questions about gender politics, national identity and economic and technological change. Albeit a little reluctantly, Gripsrud concludes that the advent of such transnational popular culture in Norway represented a form of 'cultural democratization', and a necessary move away from Norway's paternalistic public service tradition.

By contrast, his account of the production context of the serial is somewhat limited (and indeed biased) by its narrow empirical base. As Gripsrud acknowledges, there is a real need for observational studies in this field, which look beyond the perspective of a small number of 'creative' personnel. Likewise, it is perhaps no great revelation to discover that *Dynasty* is somewhat less than a progressive text, or that it possesses a 'Reaganite political message'. Nevertheless, it is interesting to contrast the gendered dimension of Gripsrud's reading with that of female critics such as Kreutzner and Seiter (in the Allen collection). For Gripsrud, *Dynasty* is a fundamentally patriarchal text, based around the character of Blake and the 'moral norm' represented by Krystle; Alexis is little more than a marginal irritant, who never represents a serious challenge to their hegemony, and who is viewed in a more distanciated way. By contrast, Kreutzner and Seiter emphasize the subversive role of Alexis: she is 'the ultimate driving force of the narrative', who 'vehemently rejects the traditional construction of femininity as egoless, passive and powerless'. Gripsrud's contention that Krystle is the main identification figure for female viewers is, however, backed up with evidence in the form of press coverage and audience surveys; while Kreutzner and Seiter's reading may say more about feminists than about women viewers in general.

If we are to judge Gripsrud's study against the claims it makes on its own behalf, it emerges as somewhat wanting. While the book does address production, textual analysis and audience responses, it is debatable whether it manages to *integrate* these different areas of study effectively, or to *theorize* the relationships between them. Likewise, Gripsrud steers an awkward course between the celebration he so insistently condemns and the determinism associated with the Frankfurt School; but whether he emerges with a satisfactory synthesis of these positions – or a viable alternative to them – remains open to question.

Finally, in the light of Gripsrud's argument about the role of 'critical intellectuals', it does seem important to consider the relationship between 'academic' and 'popular' discourses about culture and the media. If intellectuals are by definition 'separated' both from 'the people' and from cultural producers, what kinds of relationships between them might be forged? Gripsrud is probably correct to complain of the 'over-identification' with popular audiences that has characterized some recent work in cultural studies – although it is very far from becoming the orthodoxy he implies; and he is also right to insist on the need for self-reflexivity, for researchers to reflect on their own social position and on their relationships to the phenomena they are studying. But beyond this, what forms of intervention might be made in public debates of the kind he describes?

Interestingly, Gripsrud identifies a significant shift in viewers' responses to the series in Norway, which partly reflects their developing understanding of the conventions of the genre (*Dynasty* was the first ever continuing serial to be broadcast there). The growing recognition that there would not be a final resolution of the

narrative meant that viewers gradually invested less of their emotions, and learned not to 'take it seriously'. Press coverage of the series also took on an increasingly ironic tone, shifting from condemnation or condescension to 'camping it up' – a reading which Gripsrud nevertheless argues is 'primarily middle class'. In this respect, he suggests, *Dynasty* may have functioned not only as a means for Norwegian viewers to learn the rules of the genre, but also as part of a more general training in 'camp' attitudes to television. As he acknowledges, his own role as a marginal academic contributor to these debates may have had similar consequences.

Yet as the study of soaps enters the era of 'normal science', the question of how it might relate to what Gripsrud calls a 'political project of emancipation' remains problematic. Is not teaching viewers to 'camp it up' simply giving them access to a particular form of cultural capital – and thereby reinforcing existing social distinctions? Is this (to borrow the slogan of the now defunct *Modern Review*) any more than 'low culture for highbrows'? What do we expect our students to *learn* about soap opera that they do not already know – and what difference do we think this will make? In the face of the contempt of conservatives like Melanie Phillips, we need to think harder about the political and educational dimensions of the academic study of popular forms.

Reflexive intellectuals

David Chaney

■ J. Frow, *Cultural Studies and Cultural Value* (Oxford: Oxford University Press; Clarendon Press, 1995) 190pp. ISBN 0 19 871127 1 £25.00 Hbk, ISBN 0 19 871128 X £10.99 Pbk.
■ I. Davies, *Cultural Studies and Beyond: Fragments of Empire* (London: Routledge, 1995) 203pp. ISBN 0 415 03836 7 £40.00 Hbk, ISBN 0 415 03837 5 £12.99 Pbk.

Two more books add to the now enormous collection of work that has grown out of the study of contemporary culture. These two, as do many in the collection, both have 'cultural studies' in their title but it is used as a point of reference in very different ways. Frow's book is a contribution to the practice of cultural studies; more particularly he is concerned with the possibility and legitimacy of judgements of cultural value in reflexive cultural discourse. This does involve engaging with some of the most basic categories in the discourse of cultural studies but not as a systematic review. Davies, in contrast, takes the project of British cultural studies more directly as his topic; he is concerned to trace a particular reading of the development of that project in order to speculate about how to go beyond where we are now. In both books the work of intellectuals in producing accounts of culture that have important social functions is recognized and given a central role in their analytic narrative.

Both books accept, then, for all their recognition of distinctive limitations, the significance of cultural studies, and engage with the implications of this rapidly evolving field; but the trajectory of their accounts is quite different and I shall therefore discuss, at least initially, each in turn. I shall begin by tracing the development of Frow's analysis because it points to aspects of contemporary cultural theorizing that have been relatively neglected and because his book is not easy to follow.

Frow begins with the terrain of culture in modernity – how can it be organized so

that it can be mapped, and more particularly how can we make distinctions between types of culture that also mark out distinctions of value or worth? These issues stem from a sociological appreciation that different discourses of culture are not autonomous but are grounded in social formations. Once it becomes generally realized that culture is socially constructed, as any other institutionalised sphere, then it is tempting to see cultural values as just the 'local knowledges' of particular communities. Frow is legitimately critical of the slipperiness of Raymond Williams's attempts[1] to formulate a sociologically aware use 'of imaginary social unities as the explanatory basis for accounts of cultural texts' (p. 13), but does accept 'the untenability in the late twentieth century of any categorical distinction between high and low culture' (p. 23). The consequential relativism of any map of contemporary culture that aspires to be anything more than a simple description 'may indeed be the end of one kind of story about the organization of culture [but]. . . . From another perspective, however, what follows then is not an end but a beginning' (p. 87).

The character of this new story is what Frow goes on to try to show us, but before we get there we must go back to the de-stabilization of cultural values. I have said that an appreciation of the indexicality (or one could also say the historicity) of cultural discourse is an intrinsically sociological insight. Moving from the limitations of Williams's conceptualization of culture, it is appropriate for Frow to discuss the work of Bourdieu at some length as an example of an attempt to specify the social determinations of cultural distinctions. While he finds much that is valuable in Bourdieu, he draws attention to the ultimately arbitrary and prescriptive ways in which Bourdieu constructs cultural categories in order to formulate his social correlations. Although he recognizes that it seems that de Certeau should not be seen as guilty of the same fault, because of his emphasis on the practices of cultural uses, he finds that for both intellectuals there is a presumption of authority in which 'there is a politically fraught substitution of the voice of a middle-class intellectual for that of the subject of popular or indigenous culture' (p. 59).

Frow quickly leads us on from the commonplace that cultural distinctions are social practices to thornier issues of the possibility of cultural theorizing. To accept too wholeheartedly the specificity of lived experience is to resign ourselves to the incoherence of a multiplicity of particularities, and yet to attempt to generalize is to appropriate popular experience to the alien concerns of intellectual theorizing. Frow is particularly caustic about the recurrent temptation among intellectuals to equate 'the popular' with 'the people'. He begins to suggest an alternative to the contradiction I have just outlined by arguing that ' "the people" is not a given entity which precedes cultural forms, but is rather entirely the product of cultural forms: that it is a fact of representation rather than an external cause of representation' (p. 84). It seems to me that the logic of this analysis is that, if we (as intellectuals) are to avoid the dangers of either sermonizing or re-describing through more pretentious language, then we have to begin with the reflexive character of intellectual practice. Frow accepts this challenge with an extended discussion of the social location of the class of intellectuals.

In order to begin to tell the story he has promised, Frow finds it necessary to engage in a discussion of the feasibility of class analysis – which he recognizes to be deeply unfashionable – leading to a further discussion of whether intellectuals can be treated as a class grouping. These may seem like digressions and it is certainly hard to keep a grip on the general strategy while engaged in these ground-clearing operations. But there is a lot that is useful in what he says about class as a category of social analysis. Frow's sensitivity to the reductionist implications of traditional class analysis results, as he acknowledges, in 'a considerably more complex map of

the structural conditions of class formation' (p. 105), but he is able to identify and defend a weak sense of a 'knowledge class'. The fruit of these labours is a final chapter addressed to us, his readers, as intellectuals.

In conclusion, we come back to the issue of whether the relativization of cultural discourse means abandoning the possibility of cultural values, a dilemma that he poses in the form of a double-bind: 'the impossibility either of espousing, in any simple way, the norms of high culture . . . or, on the other hand, of espousing, in any simple way, the norms of "popular" culture to the extent that this involves, for the possessors of cultural capital, a fantasy of otherness and a politically dubious will to speak on behalf of this imaginary Other' (pp. 158–9). The solution that Frow poses is through the proposal of a concept of regime of value which is irreducible to a social location but is grounded in social practices; an idea that requires us to rethink the positionality of social location – how 'we' as intellectuals use the resources of cultural capital to reflexively engage with the discourses of cultural distinction.

I think this book is the beginning of another story. It does engage with significant issues in the politics of cultural theory, and more particularly it requires a long overdue reconsideration of the theme of social determination. It is not, however, an easy book to read although the author is not unnecessarily obscure. There is relatively little of the cant of cultural studies, and the author, as a professor of English, shows an impressive grasp of relevant aspects of social theory. I cannot imagine many opportunities to use this book with undergraduate students but I think it will quickly acquire an important place in the syllabus of the many MAs focused on contemporary culture that now exist.

In contrast, Davies's book is not the beginning of a new story but rather gives the impression of being among the last gasps of an old one. This is another book telling the history of British cultural studies but this time from the perspective of it all being an episode in Marxist theorizing. The development of cultural studies is celebrated as opening the possibility of 'a theory that was grounded in a consciousness of practice . . . from the situation of the individual as part of a collective on the road to cultural agency' (p. 8). The story is then one of reflexive engagement among Marxisant intelligentsia with the demands of new cultural circumstances and their relative success and failures, concluding with the possibility of going beyond what has been accomplished so far. I describe the story as old because Davies remains locked in the confident presuppositions of intellectual hubris. The manifest failures of the stratum he so confidently invokes leave him untouched, and we read his reflections as the scurryings of a self-conscious theorist eager to keep at his labours on the philosophers' stone.

Davies shares with Frow a commitment to the centrality of intellectual practice in rethinking the study of culture. But there is none of the sensitivity to the arrogance of intellectual appropriations; rather there is an untroubled faith in the power of intellectual work. Thus, writing of *Policing the Crisis*,[2] he invokes an infinite regress of intellectual labour so that he sees the book as leading to 'a *rethinking* of the problem of class in a changing capitalism, but also (through its *reading* of Gramsci) provided a *reading* of the state' (p. 23, emphases added). Davies also shares with Frow a belief in the importance of an aesthetics for contemporary theory, but his approach here is also stated in an inflated self-important way: 'The idea of a political economy of artistic sensibility has never been more important' (p. 74). At his most irritating, judgements are offered, either as clever pirouettes which mean nothing – 'Structuralism is directly related to poetry as the creative voice of man (woman) kind, phenomenology to music as the reclamation of posterity' (p. 97) – or as the grim underside of ideological orthodoxy. Thus, writing of Cohen and Taylor's *Escape*

Attempts[3] he says: 'Its postmodernism consists in its celebration of failed utopias and misguided commitments in favour of the depressing banality of everyday life' (p. 88), and it is the use of the term 'misguided' that is chilling.

Although it is clear that I dislike the flavour in Davies's narrative style of reports from a boys' club, allied with a largely untroubled sense that the role of the intelligentsia retains the authority of a legislative function, I should also recognize the strengths of his book. He has a good sense of the distinctiveness of British social theory in the era he is discussing. Although it should be a familiar history he tells it from a number of contrasting perspectives that enable the reader to make new connections and see it from new vantage points. Above all, he remains committed to the idea, and demonstrates its relevance, that the seismic changes in the culture of the last fifty years of this century have profoundly destabilized the categories of social identity. It is in coping with the implications of this changing terrain that the possibilities of formulating a common culture have to be grounded.

Both books then are about the practice of cultural studies by a self-appointed intelligentsia. In so doing they are also about the limitations of social and political theory faced with the inward collapse of established critical discourses usually summarized by the catch-all notion of postmodernism. Both books are in their different ways important contributions to the reflexive concerns that must characterize contemporary critical theory. It is only through engaging with the sorts of issues these books raise that we begin to explore the potential of studies of contemporary culture.

Notes

1 See, for example, *Keywords: A Vocabulary of Culture and Society* (London: Fontana 1976).
2 S. Hall, C. Critcher, T. Jefferson, J. Clarke and B. Roberts (1978) *Policing the Crisis* (London: Macmillan).
3 S. Cohen and L. Taylor (1978) *Escape Attempts* (Harmondsworth: Penguin).

'What am I to fear?'
Ian Buchanan

■ Brian Massumi (ed.), *The Politics of Everyday Fear* (Minneapolis: University of Minnesota Press, 1993) 336pp. ISBN 0-8166-2162-4 £38.00 Hbk; ISBN 0-8166-2163-2 £15.95 Pbk.

Fear is everywhere, that much is obvious. Indeed, what 'aspect of life, from the most momentous to the most trivial, has *not* become a workstation in the mass production line of fear?' (p. viii). But simply establishing an inventory of fear mechanisms, together with their effects, and affects, is not enough. As this book rightly points out, inventories leave unasked the one essential question that cultural studies must try to address, and that is whether or not this phenomenon, fear, is actually constitutive of anything. If everyday life is saturated through and through by fear, does that then mean it is constituted by fear? And, if so, what does that mean?

Does fear in any way determine the state of our existence? That is to say, after we have pointed to the fact that medicine – to take only one example – insofar as it treats the body as 'fright site' appears to be motivated purely by fear, we have still

to ask whether this is a part of its essential condition, or merely a symptom of something still deeper, still hidden. By essential condition we mean, of course, precisely that elusive substance that Lyotard tried to put his finger on in his analysis of the present state and function of knowledge. In other words, what we are looking for is something that will define the times for us by somehow transforming it into a concept. In this way, what begins as history is by slow degrees turned into philosophy.

But it is in the gap between these two disciplinary extremes that cultural studies does its best work, and this is the risk it takes. According to its editor, this is where *The Politics of Everyday Fear* must be situated. What I like best about this book, which can be stated right away, is the fact that it can be treated in the singular, despite being an edited collection. There is a remarkable degree of coherence in this collection at the level of content, which the snappy magazine style layout accentuates and concretizes, that enables its exceedingly diverse material (Brian Massumi, Meaghan Morris, Steven Shaviro, Kathy Acker, Adolf Hitler and Charles Manson, to name but a few of the authors) to function as something similar to a 'project'. In my view the sum here is greater than the individual parts, and insofar as a book like this can be reviewed at all, it has to be in terms of the larger aim, or strategy, not the specific tactics.

So, what is it that *The Politics of Everyday Fear* is trying to do? In its original conception it intended to follow a fairly straightforward historical pattern and chart the 'frightful lines of continuity' of fear through history. But this procedure, it was realized, 'would have glossed over an issue of tremendous importance: rupture' (p. viii). Thus in its second and present phase it was modified to incorporate Foucauldian insights. Now it seeks to give fear a specific historical dimension, and in so doing determine its actual impact on what we might call, for the want of a better word, postmodern culture. And by postmodern, the myriad authors of *The Politics of Everyday Fear* seem to mean late capitalism, which is to say, consumption for its own sake.

Even so, its focus is not really a historical one, in that it does not aim to produce either a periodization or an overview. It remains philosophical, or at least something that might be called historico-philosophical, or philo-historical, because, beginning from the premise of an irreducible discontinuity between events, it seeks to articulate the ontology of fear-phenomena. In consequence, this volume can, according to its editor, be thought of as a 'contribution toward a political ontology of fear, post-"post" ' (p. ix). Why a devout Deleuzian such as Massumi should be interested in producing an ontology of anything is a complete mystery to me, but in any case such a procedure seems not only impossible in its present context, but more mystifying still, not what this volume is really about.

That this book might be about something besides political ontology can be discerned from its constitutive question, which the editor is careful to lay out very fully. 'If, in a sense, we have become our fear, and if that becoming is tied up with movements of commodification carrying capital toward intensifying saturation of the same social space suffused by fear, does that mean that when we buy we are buying into fear, and when we buy into fear we are buying into ourselves?' (p. ix). As can be seen, this question concerns something that would be better described as false consciousness, or perhaps *meconnaissance*, rather than ontology, since what it is pointing to is the radical disjuncture between what people think they are doing in their everyday life and what they are actually doing.

While the papers collected in this volume do not all address this one question, there is nevertheless a certain consensus which gives the volume a coherence usually

lacking in such compilations. That consensus is the view 'that we cannot in fact separate ourselves from fear' (p. ix). Here, Massumi makes a very interesting point concerning the *style* of *The Politics of Everyday Fear*, a point which I think is pertinent to much of what calls itself cultural studies today. He says the felt necessity to reinvent resistance 'is expressed in the performative nature of many of the texts. For if the enemy is us, analysis, however necessary, is not enough to found a practice of resistance' (p. ix). The analysis of fear, Massumi argues, is at one with the enactment of fear. To perform it, however, is, he implies, to transform it. But as all avant-garde performers know, moving outside of conventional parameters is a very risky business.

This claim that performance is a means of transformation can be found in the work of de Certeau as well as Deleuze and Guattari. These theorists (who figure largely though usually implicitly in this collection) are, as is quite typical of many postwar French intellectuals, ardent admirers of the avant-garde in art and writing, and perceive in it an enormous reserve of political force. For de Certeau, all performance is by definition the enactment of difference since no two performances can ever be the same. Therefore to consciously perform something differently is to multiply the powers of distinction. This is what he means by his idea of cultural metaphorization. By the same token, for Deleuze and Guattari, the active performance of difference involved in avant-garde literature is the means by which literature transforms itself, and becomes other than what it is; or to use their terminology, enters a phase of becoming-minor. Mindful of the specific nuances that separate these two views on avant-garde performance, one question still remains: How can we tell when a performance is working? (And what do we mean by working?)

The necessity of asking this question is raised by Sandra Buckley's piece, 'Censored', which is striking for what it is not. Her piece occupies a space originally allocated to an article by her entitled 'Japanese technoporn', which was to have featured a collage of text and graphics from *manga* comics. With the aim of disrupting 'the perceived autonomy of pornographic narratives', Buckley interwove fragments of '*manga* image-text with "found quotes" from other official and unofficial texts drawn from across the multiple discourses that inform the condition of "being woman" in Japan'. These 'other' sources included 'Japanese feminists, lawmakers, politicians, rape counsellors' (p. 171). The result was to have been a critical *performance* of *manga* that did its work without commentary. As was the case with *American Psycho* – fear-narrative *par excellence* – which similarly does its work without commentary, her piece was met by stiff resistance at the pre-production stage.

Unlike Easton Ellis's novel, however, Buckley's piece never managed to make it into print, despite having three shots at it. In the first instance a self-avowedly brave Canadian cultural studies journal got cold feet at the last moment and pulled the pin on Buckley's collage because it was afraid of the bitter backlash its publication would certainly draw from its feminist antipornography readers. In the second instance, this time with a US critical theory journal, it was the printer himself who prevented its publication by exercising his right (guaranteed by US constitutional law) not to print anything he personally found unacceptable. Ironically, in the third and final instance, it was the Japanese copyright owners who prohibited its publication by denying permission to reprint their material. Their reason, though not explicitly given, was that they did not want their material to circulate in any context other than the one for which it was intended.

Here we see just how tricky this thing called 'working' really is. If, from the point of view of the publishers of pornographic material, a critical journal is the wrong

context for its material to be published in, then from a critical perspective, that journal seems like exactly the right context for a critique of it to be published. In other words, such a move seems to work. Yet, while that rationale would probably be acceptable to most editors, what Buckley's experience shows is that it is only on the condition that the purpose of publishing pornographic material is critical, and explicitly so. That is to say, without an unambiguous commentary it does not work as it is supposed to work. The conclusion one might draw from this case study is that there is no place for art, or artistry, in the critical sphere. Interestingly, this 'prohibition' seems to stem from both sides, and is precisely fear-driven.

On the one hand, artists themselves – a generic which nowadays incorporates pornographers (who never hesitate to call themselves artists anyway), television producers, film directors, graphic artists, as well as the more conventional members of that professional body – do not want their material to be placed in a critical context for fear of being misunderstood, or worse still, understood too well. While on the other hand, editors of critical journals do not want their critics turning into artists, or masquerading as such, for fear of being politically unclear which is far worse than being politically incorrect. Little wonder, then, that in Australia at least, cultural studies seems to be moving further and further in the direction of risk analysis. And about the only thing preventing cultural studies from taking this – I think fatal – leap into quantitative social science is its sense of style (things really will have turned weird if a means of combining gonzo-journalism with sociology is ever found!).

But, for all that, the question that must be asked is whether or not Hunter S. Thompson's fear-crazed style really works in cultural studies' best interest. Is the risk of ambiguity, and the concomitant loss of rigour, really worth taking? What is the nature of the line that separates breathless impressionism from critical reflection? If *The Politics of Everyday Fear* is anything to go by, then I am afraid that cultural studies has stopped asking itself this question. My impression is that cultural studies is so afraid of being *one* thing, for that would be to buy into the power game of the disciplines, that it has all but stopped itself from being *any*thing. But then, on reflection, I wonder why it is that I am afraid . . . and what it is I really fear? What is fear?

Encyclopaedic
Ajanta Sircar

■ Ashish Rajadhyaksha and Paul Willemen (eds), *The Encyclopaedia of Indian Cinema* (London: British Film Institute), 568pp. ISBN 0-85170-455-7 £29.95 Hbk.

As an impressive body of scholarship has documented, the social formation of 'modernity' in Western Europe was crucially premised on the epistemological privileging of vision or, as Jean Louis Comolli describes it, a mode of looking at the world which equated 'I see' with 'I understand'. A whole range of social technologies emerged in Western Europe, reconfirming the new Renaissance sense of what it meant to be 'human'. Thus, simultaneous with the gradual emergence of the 'modern' city in Western Europe then with its impressive shopping arcades and promenades was also the emergence, over a period of time, of a host of new apparatus of vision from the telescope to the camera obscura (see, for example, Guliana

Bruno's *Streetwalking on a Ruined Map: Early Films of Elvira Notari* (1993) which attempts such a topoanalysis of early Italian cinema in the context of the 'new' city that was emerging in Italy at the time).[1] This dramatic shift in the visual vocabulary of Europe was, further, concomitant with new *geographical* terrains being made visible for the first time through the great voyages beginning with Francis Drake, Christopher Columbus, *et al*. The obverse of the project of 'modernity' inaugurated by the Renaissance, and the modes of looking that emerged as 'natural' through its conceptual universe, was therefore *this* enterprise of appropriating non-Western parts of the globe through journeys, explorations etc., culminating in the brutal histories of colonization.

It is only such a massive temporal-historical framework that can accommodate a work of scholarship as impressive as Ashish Rajadhyaksha and Paul Willemen's *The Encyclopaedia of Indian Cinema*. As one among a series of pathbreaking works, and here the most illustrious predecessor would undoubtedly be Edward Said's *Orientalism*,[2] this *magnum opus* is among those interrogations that enable us to rethink what we common-sensically assume to be the most pristine of all responses, the ultimate guarantor of 'truth'/'knowledge' – the sense of sight. By highlighting, as the editors do in their 'Explanatory notes' and 'Chronicle (of Indian History)', the specific movements in art history, politics, literature, within which the vocabularies of the different Indian cinemas found their articulation, the work implicitly points to the 'symbolic violence' occluded by the modes of looking that have been imposed as dominant on all parts of the world for about the last two hundred years. The camera, then, is no more guarantor of 'objectivity' than language is of a world outside representation. Rather, the laws of central perspective and their accompanying notions of 'realism' are modes of 'seeing' that have emerged out of entire histories of domination/contestation/change. (For an excellent documentation of this process in the specific context of India see Tapati Guha-Thakurta, *The Making of a New 'Indian' Art: Artists, Aesthetics and Nationalism in Bengal c. 1850–1920*).[3]

Thus, the *Encyclopaedia* is one among a series of studies which recognizes not only that 'modernity' was an imposition but also, as is being pointed out with increasing confidence, the gruesome implications of the perpetuation of Enlightenment notions of 'modernity' in the decolonized world. In terms of scholarship specifically debating the cultural politics of India within a similar mould, the initiatives among which the *Encyclopaedia* can be placed range from *Selected Subaltern Studies*;[4] *The Lie of the Land: English Literary Studies in India*;[5] *Interrogating Modernity: Culture and Colonialism in India*;[6] *Women Writing in India: 600B.C. to the Present*.[7] The aim of situating the *Encyclopaedia* among such a range of works, across the disciplinary spectrum, is to indicate that it emerges out of a moment of great social and intellectual ferment, as well-established assumptions of what it means to be 'Indian' come to be contested from a whole array of social/intellectual positions. Such a location of the *Encyclopaedia* also highlights a point made by the editors themselves in their introductory sections, of the desire to see cinema as a 'discursive form which is inextricably intertwined with a wide and complex network of industrial, institutional and cultural histories' (p. 14). For the reader unfamiliar with Indian cinemas, a useful parallel might be drawn with *The Cinema Book*,[8] which though on a different socio-temporal scale, attempts to place various kinds of filmic practices in Hollywood within a similar range of discursive networks.

Necessarily then, as part of its intellectual heritage the *Encyclopaedia* has to be placed *vis-à-vis* current debates on cultural practices as they have emerged within the

body of work loosely classified as 'theory'. The terms of engagement between 'theory' and cultural practices of the non-Western world were undoubtedly set by Fredric Jameson's 'Third World literature in the era of multinational capitalism'[9] and Aijaz Ahmad's response.[10] Since then a number of significant studies have emerged, historicizing the epistemological preoccupations of what currently goes under the name of 'postmodernism'; making evident the inability of much of even this so-called 'radical' body of thought to account for the diverse and deeply ruptured histories of non-Western societies. An excellent example here would be *Siting Translation: History, Post-Structuralism and the Colonial Context*.[11] Indeed, as has already been emphatically pointed out, under the facile guise of accommodating 'difference', 'postmodernism', in some of its manifestations, simply becomes the latest of aesthetic theories emanating from the West by which cultural practices elsewhere are appropriated (for example, see Kumkum Sangari, 'The politics of the possible').[12]

Within the context of contemporary India, however, the obverse of a critique of 'Westernization' has often simply degenerated into calls to chauvinistic indigenism in ways that have reached a crescendo in the recent past. In such a situation the critical methodology adopted by the contributors has been, as one of the editors puts it, 'consciously hybrid and "impure", calling on knowledges, values and conceptual tools which are neither nativist nor rootlessly cosmopolitan' (p. 8). As both editors have gone to some length to point out, there is no such category of 'pure' Indianness outside the continually changing and contested borders of collectivizes so defined by institutions of governmentality. Moreover, in a situation where calls to citizenship based on illusory linguistic and cultural homogeneities have resulted in the very real threat to life for millions of its people, the editors point to the inescapably hybrid nature of contributions that have been fed into India's filmic product. As Paul Willemen says, the *Encyclopaedia* unapologetically acknowledges contributions of personalities from Bangladesh, Germany, Iran, Hollywood and many others (p. 8). So also the wholesome inclusion in the *Encyclopaedia* of cinemas from regional/linguistic centres other than Bombay; the emphasis on the need for collective scholarship, and the acknowledgement of the very real inadequacy at present of critical histories of several of the diverse cultural-linguistic formations that constitute the 'nation'.

This then leads to other theoretical breaks that works of scholarship such as the *Encyclopaedia* enable us to make. Though consistently attempting to map film-histories on to the 'national' canvas, the editors of the *Encyclopaedia* accurately point to the problems of essentialism inherent within this category. The larger implication of such interrogations of the conceptual category of 'nationhood' is to suggest not only that nations are 'imagined communities' but that, in the specific ways in which the nation came to be historically imagined, it was fundamentally rooted within the unique social milieu of late eighteenth-century Western Europe; a combination of historico-social factors unlikely to be reproduced in pure form anywhere else. In obvious ways then, the imposition of the category of 'nationhood', a concept that was an integral component of the Renaissance sense of 'modernity', in social contexts *different* from Western Europe, can be said to be responsible for the highly volatile and provisional nature of alliances that have emerged in most parts of the decolonized world. As part of the many emerging critiques of notions of 'nationhood' in India, Ashish Rajadhyaksha sums up the impetus fuelling the *Encyclopaedia*:

When we started this encyclopaedic project, the aim was to provide a reference work on Indian film. In the process of its compilation, however, it developed a

variety of more complex and less easily defined ambitions, a crucial one was to chronicle a sense of India that would move beyond its most obviously available nationalist construct . . . Indian films are and always were read, and implicated in social transformations, in ways infinitely more complex than plot summaries or 'official' histories can claim to suggest. (p. 11)

Such interrogations of the category of the 'nation', for example, in India from the multiple axes of caste-region-religion-gender, also raise questions of significance for the *general* nature of the social sciences in the ways in which they often leave unexamined the relationships between the sense of 'self' and the sense of 'place'. Thus, in what is perhaps a unique diversion from common-sensical notions of an 'encyclopaedia', the editors of this work begin with an extensive discussion on the problematic and tentative nature of historical 'fact'; interrogating dominant equations between 'Indianness' and the location of this identity within a tightly defined geopolitical terrain.

Such sensitivity to the critiques of the intellectual legacies of the Enlightenment also structures the *Encyclopaedia* at the fundamental level of *form*. The *Encyclopaedia* is divided into two sections: a 'Dictionary' section which includes entries on film personalities, studios, art schools, genres, and so on, and a 'Film' section which includes decade-wise synopses of major films from 1910 to 1990. In terms of narrative function, the 'Dictionary' section may be said to be providing what can be considered to be the *morphemic* level of the language of Indian cinema against which are set provocative readings of individual filmic texts. To take a random example, the entry in the 'Film' section under *Indira MA* (1934) describes it as a film by Imperial Studios, starring Sulochana, where the East–West conflict is displaced on to a love triangle in the form of a conflict between a 'love' marriage and an 'arranged' marriage (p. 241). The incredibly dense patterns of meaning that might have been generated for its contemporary audience become evident to the reader if s/he refers to the entries under 'Sulochana' or 'Imperial Studios' in the 'Dictionary' section. While the first profiles the unique career of this Eurasian 'star' of early Indian cinema (p. 207), the second profiles the career chart of one of India's earliest and most successful film companies, especially through its marketing of the 'star' identities of personalities such as Sulochana, Prithviraj Kapoor, etc. (p. 102). The 'Dictionary' section, in this sense, provides the basic units of vocabulary with which to unpack the multiple significations that the plot-synopses gesture to. In this way, the *Encyclopaedia* also seems to obviate the need for prior acquaintance with Indian cinema, as even the 'uninitiated' can easily access for her/himself a myriad of interesting facts on over thirteen hundred films!

Necessarily, a work of such scope cannot be exhaustive. In fact the editors are perhaps too anxious to highlight the shortcomings of their project in terms of lack of empirical data, lack of scholarship on many provinces of the 'nation' due to the specific ways in which the national imaginary has come to be constituted, and so on. The unqualified commendation of such an effort is therefore not to suggest that the 'meanings' of the films profiled here have now been 'fixed' for all time. On the contrary, as the editors themselves repeatedly state, the *Encyclopaedia* should be looked upon as a research tool which, like all other research tools, needs to be continually updated, contested, changed. As new generations of readers bring to these films their own questions, as each historical moment renegotiates its own relationship with the 'past', the entries here will necessarily assume different shapes. Nor is the commendation simply a tribute that *all* 'firsts' in a field necessarily deserve, opening as they do entire pathways for others to follow. Film histories both within

the country and in other parts of the world have been written before. The unqualified commendation is richly deserved, one would feel, on account of the sheer scope of material covered, the openness with which gaps in knowledge are acknowledged, new questions invited and the hugely *secular* and *collective* nature of the project in our increasingly bigoted and individualistic world. Thus, rather than contest data on individual entries such as the accuracy of production dates or plot-synopses (whether or not *Deewar* may read differently from a psychoanalytic perspective), the *Encyclopaedia* emerges as a magnificent effort to think through the multiple, overlapping, sometimes contradictory but always challenging locations from which 'India' itself has historically been formed.

Notes

1 Guiliana Bruno, *Streetwalking on a Ruined Map: Early Films of Elvira Notari*, 1993.
2 Edward Said, *Orientalism*, London: Routledge & Kegan Paul, 1978.
3 Tapati Guha-Thakurta, *The Making of a New 'Indian' Art: Artists, Aesthetics and Nationalism in Bengal c. 1850–1920*, Cambridge: Cambridge University Press, 1992.
4 Ranajit Guha and Gayatri Spivak (eds), *Selected Subaltern Studies*, New York: Oxford University Press, 1988.
5 Rajeswari Sunder Rajan (ed.), *The Lie of the Land: English Literary Studies in India*, Delhi: Oxford University Press, 1992.
6 Tejaswini Niranjana, P. Sudhir and Vivek Dhareshwas (eds), *Interrogating Modernity: Culture and Colonialism in India*, Calcutta: Seagull Books, 1993.
7 Susie Tharu and K. Lalita (eds), *Women Writing in India: 600 B.C. to the Present*, 2 vols, Delhi: Oxford University Press, 1993–5.
8 Pam Cook (ed.), *The Cinema Book*, London: BFI, 1981.
9 Fredric Jameson, 'Third World literature in the era of multinational capitalism', *Social Text*, 15 (1986): 65–88.
10 Aijaz Ahmad, 'Jameson's rhetoric of otherness and the "national allegory" ', *Social Text*, 15 (Fall, 1986): 3–25.
11 Tejaswini Niranjana, *Siting Translation: History, Post-Structuralism and the Colonial Context*, Berkeley and Los Angeles: University of California Press, 1992.
12 Kumkum Sangari, 'The politics of the possible', *Cultural Critique* (Fall 1987): 157–86.

Notes on contributors

MEGAN BOLER completed her Ph.D. in the History of Consciousness Program at the University of California, Santa Cruz, and is an Assistant Professor at the University of Auckland, New Zealand . . . IAN BUCHANAN is a lecturer in the Department of English and European Languages and Literatures at the University of Tasmania, Australia . . . DAVID BUCKINGHAM is a Reader in Education at the Institute of Education, London University. His most recent publications are *Moving Images* (Manchester University Press, 1996) and *In Front of the Children* (British Film Institute, 1995) . . . ED BUENDIA is a Ph.D. candidate in the Department of Curriculum and Instruction at the University of Illinois at Urbana . . . DAVID CHANEY is Professor of Sociology in the Department of Sociology and Social Policy at the University of Durham, UK . . . STEPHEN DAVID is a Ph.D. candidate in the Department of English at the University of Illinois at Urbana . . . KEVIN FOSTER is a Lecturer in the Department of English at Monash University, Melbourne. His previous publications include work on the cultural production of the Gulf and Falklands war, Orwell, Australian Popular Culture, and African autobiography. His book on the narrative politics of the Falklands conflict will be published by Pluto Press in 1997 . . . HERIBERTO GODINA is a Ph.D. candidate in the Department of Curriculum and Instruction at the University of Illinois at Urbana . . . LINE GRENIER is Associate Professor in the Department of Communication at the Université de Montréal. She has published on French-language popular music in Québec in journals such as *Popular Music, New Formations, Communication* and *Ethnomusicology*. Her current research focuses on the genealogy of the *chanson dispositif* in Québec and its role in the development of local music-related industries . . . JOCELYNE GUILBAULT is Associate Professor at the University of Ottawa and has published extensively on traditional and popular music in the Creole-speaking Caribbean islands. She is the author of *Zouk: World Music in the West Indies* (1993) and is currently working on a book about the superstars of Calypso and Soca of the English-speaking Carribean . . . JOHN HARTIGAN, jun. is a graduate of the History of Consciousness Program at the University of California, Santa Cruz. He is currently an Assistant Professor in the Sociology and Anthropology Department at Knox College. His ethnographic study, *Cultural Constructions of Whiteness: Racial and Class Formations in Detroit*, is forthcoming from Princeton University Press . . . CAMERON McCARTHY teaches courses in curriculum theory and cultural studies at the University of Illinois at Urbana . . . ALAN McKEE lectures in Media Studies at Edith Cowan University in Perth, Australia . . . SHUAIB MEACHAM is Assistant Professor in the Department of Curriculum and Instruction at the University of Colorado at Boulder . . . ALICIA P. RODRIGUEZ is a Ph.D. candidate in the Department of Educational Policy Studies at the University of Illinois at Urbana . . . ROBERT RYDELL works in the Department of History and Philosophy at Montana State University, Bozeman . . . SANDHYA SHUKLA is an Assistant Professor in the Department of Ethnic Studies at the University of California, San Diego and is currently working on a study of Indian immigrant cultures in the United States and Britain . . . AJANTA SIRCAR is a Ph.D. candidate at the School of English and American Studies at the University of East Anglia, Norwich . . . K. E. SUPRIYA is an Assistant Professor of communications research and cultural studies at DePaul University . . . TERRY THREADGOLD works in the Department of English at Monash University, Clayton, Australia . . . CARRIE WILSON-BROWN is a Ph.D. candidate in the Institute for Communication Research at the University of Illinois at Urbana.

Cultural Studies 11(2) 1997 © 1997 Routledge 0950–2386

Routledge

The Black Culture Industry

Ellis Cashmore, University of Staffordshire

'This insightful study of the relationship between black culture, wealth, and race relations in the United States allows the reader to understand better, and more clearly, the nature and evolution of race relations in the United States, and how culture and art can be utilized by wealthy interests to manage race and race relations.' - *Professor James Jennings, Director of the William Monroe Trotter Institute at University of Massachussetts, Boston*

June 1997: 246x174: 216pp
Hb: 0-415-12082-9: £45.00
Pb: 0-415-12083-7: £13.99

Postfeminisms

Feminism, Cultural Theory and Cultural Forms

Ann Brooks, Massey University, New Zealand

In this clear exposition of some of the major debates, theorists and practitioners, Ann Brooks shows how feminism is being redefined for the 21st Century. Concepts covered include feminist epistemology, Foucault, cultural politics and sexuality.

June 1997: 234x156: 256pp
Hb: 0-415-11474-8: £45.00
Pb: 0-415-11475-6: £13.99

Prosthetic Culture

Photography, Memory and Identity

Celia Lury, University of Lancaster

Celia Lury describes the body's ability to act outside itself both mechanically and perceptually. She draws on a wide range of examples including phototherapy, accounts of false memory syndrome, family albums and Benetton ads.

International Library of Sociology
May 1997: 234x156: 248pp
Hb: 0-415-10293-6: £40.00
Pb: 0-415-10294-4: £12.99

Teratologies

A Cultural Study of Cancer

Jackie Stacey, University of Lancaster

'The book provides a timely and highly original perspective on cancer as a cultural phenomenon ... a brave and beautiful book.' - *Kathy Davis, University of Utrecht*

Teratologies is a distinctly feminist look at how cancer is imagined and experienced in contemporary society.

International Library of Sociology
July 1997: 234x156: 304pp
Hb: 0-415-14959-2: £45.00
Pb: 0-415-14960-6: £13.99

Routledge books are available from all good bookshops.
For more information or for a **Free** Sociology catalogue please contact:
Geraldine Joyce, 11 New Fetter Lane, London EC4P 4EE
Tel: 0171 842 2065
E-mail: info.sociology@routledge.com
Internet: http://www.routledge.com/routledge.